WINNER OF THE PULITZ

Booklist #1 Adult Nonfiction Book of the Year
Carnegie Medal for Excellence in Nonfiction Longlist
Winner of the Art in Literature: Mary Lynn Kotz Award
African American Literary Book Club #1 Nonfiction Bestseller

ONE OF THE YEAR'S BEST BOOKS

NPR · *Publishers Weekly* · *Booklist* · *BookPage* · *ARTnews*
Barnes & Noble · Chicago Public Library · Hudson Booksellers

PRAISE FOR

CHASING ME TO MY GRAVE

"A searing first-person illustrated account of an artist's life during
the 1950s and 1960s in an unreconstructed corner of the deep
South—an account of abuse, endurance, imagination, and aesthetic
transformation."

—Pulitzer Prize Board 2021–2022

"Rembert's art expresses the legacy of slavery, the trauma of lynching,
and the anguish of racial hierarchy and white supremacy while
illuminating a resolve to fight oppression and injustice. He has
the ability to reveal truths about the human struggle that are
transcendent, to evoke an understanding of human dignity that is
broad and universal."

—Bryan Stevenson, *New York Times*
bestselling author of *Just Mercy* and Founder/
Executive Director of the Equal Justice Initiative

"At turns harrowing and haunting, *Chasing Me to My Grave* is a testament to the rich cultural resources and the poetry of Black Southern life. Rembert's paintings, brilliantly composed, kinetic, and enchanting, are interspersed through his reflections about life in the cotton and carceral South. The language is elegant and vernacular, his observations are insightful and poignant. And through it all, joy, no matter how elusive, never disappears."

—**Imani Perry**, author of *South to America*, winner of the National Book Award, and *Looking for Lorraine*

"An unparalleled account of the devastating legacies of American slavery and a luminous self-portrait of one defiant artist's extraordinary triumph over white supremacy and segregation."

—**Douglas A. Blackmon**, Pulitzer Prize–winning author of *Slavery by Another Name*

"The power of Rembert's *Chasing Me to My Grave* is in the unvarnished truth, in the writing, the storytelling, the artwork, his life. Unvarnished literary and visual power."

—**Carol Anderson**, *New York Times* bestselling author of *White Rage, One Person, No Vote*, and *The Second*

"*Chasing Me to My Grave* is a singularly beautiful book, visually, morally, and spiritually. Rembert shares his powerful story, which spans consequential, multigenerational movements to resist and transcend white supremacist terror in its many forms, told and depicted with unflinching honesty and unique artistry. Reading this unforgettable memoir of the Jim Crow South, the viciousness of mass incarceration, and the sustaining power of love, it is impossible to turn away from the personal and national history it documents, all while Rembert's stunning visual art mesmerizes the eye and the heart."

—**Piper Kerman**, author of *Orange Is the New Black*

"*Chasing Me to My Grave* is one of the best social histories of Jim Crow that exists. Rembert's life story and richly reproduced auto-biographical paintings capture aspects of U.S. history that an archive never could. He makes trauma, tragedy, and pain beautiful through his art, not as a way to romanticize it but as a way to help us all have a deeper understanding of our past and present. It is a book that should be required reading for everyone in this country."

—**Elizabeth Hinton**, author of *America on Fire* and *From the War on Poverty to the War on Crime*

"*Chasing Me to My Grave* is both a literary and artistic triumph. Winfred Rembert's memoir of the carceral state in the Jim Crow South is a profoundly moving, devastatingly painful, and wonderfully transformative experience. Rembert's earthy prose, evocative images, and grace in the face of racial oppression is an inspiring true story that will forever change the way we look at the system of mass incarceration and unequal justice and those who resisted with love, beauty, and artistic brilliance. This book is a must-read for all who are interested in finding out the roots of our current racial crisis as well as the possibilities for truth, justice, and healing."

—**Peniel E. Joseph**, author of *The Third Reconstruction* and *The Sword and the Shield*

"Rembert cultivated a stunning visual language and aesthetic practice as a way of telling a story that is both deeply personal and also an archive of Black freedom struggles. Through art, he meditates on his experience of racial terror and captivity to expand our understanding of this nation's history of anti-Black violence and the force of Black resistance as loving, living, and world-making."

—**Nicole Fleetwood**, MacArthur Fellow and award-winning author of *Marking Time: Art in the Age of Mass Incarceration*

"*Chasing Me to My Grave* is a brilliant reminder of where we've come from as a country. We've come to accept William Faulkner's adage, 'The past is never dead. It's not even past.' But Rembert's account reminds us that it is in the remembering of the past that we keep it from becoming prologue. From the Jim Crow South to the chain gang to a life as an artist, Rembert reminds us of the terror and the possibility of America. That he became an artist while in prison says something about the gifts we bury, that he lived to tell this harrowing tale says something about the strength of this man."

—**Reginald Dwayne Betts**, author of
Bastards of the Reagan Era and *Felon*

"The remarkable thing about *Chasing Me to My Grave* is Rembert's willingness to be vulnerable, to share from the inside, and to use that to teach other people."

—**Paul Coates**, Black Classic Press

"*Chasing Me to My Grave* is a harrowing document of Jim Crow and its legacy, a testament to the pain and brutality of that era. It is simultaneously an ode to the power of love and art that lifts humanity above degradation. An immense achievement that will last the test of time."

—**Jason Stanley**, author of *How Fascism Works: The Politics of Us and Them*

"Winfred Rembert paints a world too little depicted and a reality we can't afford to forget. While testifying to this nation's long history of racial injustice, *Chasing Me to My Grave* is also a must-read story of Black struggle, solidarity, and love."

—**Albert Woodfox**, author of *Solitary*

"Winfred Rembert's story of redemption and survival is an essential record of the stark brutality of post–Jim Crow America and a reminder that this history is still recent memory. His life's work is a compelling example of the power of art to bring visibility to the dark corners of human experience and an object lesson on the incredible resilience of the human will."

—**Mark Bradford**, MacArthur Fellow and award-winning artist

"Winfred Rembert's life story is an American portrait and history lesson. This book seamlessly shares a Black man's journey of poverty, Jim Crow, racial violence, incarceration, love, family, and redemption through his powerful paintings. He brings to life in vivid color and with an exceptional style the stories so many us have heard from our fathers and grandfathers."

—**Kymberly N. Pinder**, Dean of the Yale School of Art, author of *Painting the Gospel: Black Public Art and Religion in Chicago*

"Just as Jacob Lawrence's vivid paintings commemorated African American communal life in Harlem, so Rembert's work enshrines the bold colors, characters, locales, and rhythms of life in his slice of southern Georgia. With squared patches of leather, dye, and a touch of something sacred, Rembert recreates a largely forgotten world of bustling commercial avenues and cotton fields, prison yards and Sanctified churches. *Chasing Me to My Grave* is a remarkable study of one man's endurance, passions, and artistic self-discovery."

—**Aaron Robertson**, author of *The Black Utopians*

"Many today would prefer we forget what it was like to live under Jim Crow—the fear, the lynching, the ever-present threat of the chain gang if you stepped out of line. Having done time on a Georgia chain gang, Winfred Rembert offers extraordinary firsthand testimony of survival in the face of the everyday racism and brutality of the South's criminal justice system. More than that, by carving his resilient spirit into compelling works of art, he has assured that we

will remember the deep imprint that system has left on our nation."
—**Alex Lichtenstein**, author of *Twice the Work of Free Labor: The Political Economy of Convict Labor in the New South*

"This is a book like no other, from Winfred Rembert's unique and uniquely powerful autobiographical paintings to his disturbing and courageous life story…By using carved, tooled, and dyed leather as the medium for vibrantly patterned scenes from his life, Rembert turned the scars on his body and soul into artworks of clarion witness and reckoning. With a foreword by Bryan Stevenson and superb color reproductions, Rembert's self-portrait in word and image belongs in every library."
—**Donna Seaman,** *Booklist* (starred review)

"A stunning portrait of hope in the face of evil, barbarity, and racism."
—***Publishers Weekly*** (starred review)

"An ultimately uplifting journey from the ugliness of virulent racism to the beauty of art."
—***Kirkus Reviews*** (starred review)

"*Chasing Me to My Grave* is a testament to the ways one man used his art to educate, delight and depict the trauma that arises out of memory."
—***BookPage*** (starred review)

"Captivating…Dynamic…Visually and narratively stunning."
—***Library Journal***

"It is Rembert's incredible story and arresting illustrations that make this memoir a must-read."
—***The Atlanta Journal-Constitution***

"An artistic eye shines through in his elegantly natural prose . . . Rembert's recollections are conveyed in both words and images. A sort of call-and-response rhythm emerges . . . the words providing insights and unseeable detail, the images deepening our sense of the emotional impact of the narrator's experiences."

—**Albert Mobilio,** *Bookforum*

"An illustrated autobiography of plain-spoken pains and moments of strength, alongside vernacular art that stops you short."

—*Chicago Tribune*

"One-of-a-kind memoir…A stunning piece of visual truth- telling…A stark reminder of our nation's ugly history, and the power in reclaiming such history through art."

—*Chicago Review of Books*

"Visually stunning…Rembert's brutally honest storytelling helps us see the sacrifice and grit it took for Black Americans to survive in the Jim Crow South, something he said should make families proud and want to talk about their history."

—**Debbie Elliott, NPR**

CHASING ME TO MY GRAVE

CHASING ME

TO MY GRAVE

AN ARTIST'S MEMOIR OF THE JIM CROW SOUTH

WINFRED REMBERT

AS TOLD TO ERIN I. KELLY

FOREWORD BY **BRYAN STEVENSON**

BLOOMSBURY PUBLISHING

NEW YORK · LONDON · OXFORD · NEW DELHI · SYDNEY

BLOOMSBURY PUBLISHING
Bloomsbury Publishing Inc.
1385 Broadway, New York, NY 10018, USA

BLOOMSBURY,
BLOOMSBURY PUBLISHING,
and the Diana logo are trademarks of
Bloomsbury Publishing Plc

First published in the United States 2021
This paperback edition published 2023

ISBN: HB: 978-1-63557-659-7
eBook: 978-1-63557-660-3
PB: 978-1-63973-146-6

Library of Congress Cataloging-in-Publication
Data is available

2 4 6 8 10 9 7 5 3 1

Designed and typeset by Sara Stemen
Printed and bound in China by RR Donnelley Asia
Printing Solutions Ltd

To find out more about our authors and books
visit www.bloomsbury.com and sign up for our
newsletters.

Bloomsbury books may be purchased for
business or promotional use. For information
on bulk purchases please contact Macmillan
Corporate and Premium Sales Department at
specialmarkets@macmillan.com.

To Mama, who held out her hands and took me

CONTENTS

FOREWORD

On a quiet Sunday afternoon in September 2013, I walked into the nearly empty Montgomery Museum of Fine Arts in Alabama. A colleague had told me I would find something extraordinary there, so I went. At the time, I'd lived in Montgomery for nearly twenty-five years and I don't think I'd been in that space more than once or twice.

I will never forget what I saw in the museum that day.

The art of Winfred Rembert stunned and silenced me. His paintings moved and overwhelmed me—it was an emotional experience I never expected. I saw the color and narrative construction of Jacob Lawrence in Mr. Rembert's work. A brilliant geometry of compelling scenes and dazzling ideas brought to mind Faith Ringgold or Charles Alston. I saw craft, skill, and originality in Mr. Rembert's use of stretched leather for a canvas. I thought of Elizabeth Catlett, Kerry James Marshall, and Carrie Mae Weems, but Mr. Rembert's work was unique. As I continued through the exhibit, what shook me most was the pain, the anguish, and the suffering he captured. But there was also love, strength, humor, and the power and complexity of the Black experience in America distilled into some of the most compelling art I've seen.

I initially thought that my strong response to Mr. Rembert's paintings was sparked by the evocative scenes depicting life in prison. I've spent my entire career in Southern jails and prisons, on death row with the condemned, behind locked doors and barbed wire. I've gone inside hundreds of cages where people have been sent to die; I've witnessed how people try to survive despite the brutality of captivity. Mr. Rembert's exhibit captured the weight and burden of imprisonment so powerfully.

But the longer I studied the paintings, the more I realized that what I saw went beyond insights into incarceration. Mr. Rembert's art expresses the legacy of slavery, the trauma of lynching, and the anguish of racial hierarchy and white supremacy while illuminating a resolve to fight oppression and injustice. He has the ability to reveal truths about the human struggle that are transcendent, to evoke an understanding of human dignity that is broad and universal.

On that Sunday, Mr. Rembert's art converted a conventional, quiet museum in Montgomery into something that felt like a dynamic Black church: a place of confession and repentance leading to redemption and salvation.

Winfred Rembert is a lot of things. He was born into poverty in Cuthbert, Georgia, and then as an infant given away by his mother to an aunt. It was hard for him to not be angry. He grew up picking cotton in the fields of south Georgia, denied all but a limited education. The humiliation of Jim Crow segregation and brutal racial inequality was a toxic force in his life that pushed him to activism in the 1960s. After a violent conflict, he was chased and eventually caught by a white mob and vicious police who assaulted and nearly lynched him. He ended up in prison and on Georgia's notorious chain gangs, where despair and suffering were ultimately overcome by education and the discovery of his extraordinary ability to make remarkable art.

Chasing Me to My Grave would be an exceptional memoir even if Mr. Rembert weren't one of the finest and most original vernacular artists in America. He tells a compelling and important history that this nation desperately needs to hear. Mr. Rembert narrates the story of America with unusual insight about the legacy of slavery and centuries of racial injustice. He recognizes that the great evil of American slavery wasn't involuntary servitude and forced labor—it was instead the insidious construct of white supremacy.

To justify slavery, white enslavers created a myth of Black inferiority. They persuaded themselves that Black people are less human,

less capable, less worthy, and less deserving of dignity and respect. This barbaric narrative of racial difference survived the Civil War. The Thirteenth Amendment to the United States Constitution abolished involuntary servitude and forced labor but it says nothing about the ideology of white supremacy. As a result, laws empowering Black men to vote and hold office and barring racial discrimination passed during Reconstruction failed to achieve equality for formerly enslaved people. Lawlessness and mob violence triumphed in disenfranchising Black people and subjecting them to decades of convict leasing, exploitative sharecropping, and abject poverty.

This was Winfred Rembert's America. A place where lynching and racial terror were used to marginalize Black people and sustain a racial order that left little room for transformational art. Yet his compelling artistic vision emerges just the same and there is something important to understand about his triumph. Winfred Rembert inherited more than pain, abandonment, abuse, and suffering when he came into this world. He clearly found love, kindness, strength, and a powerful dignity and compassion that shines through his work and inspires us.

When I left that museum in 2013, I was determined to learn more about him. I discovered that he was in New Haven, Connecticut, and I reached out. He was gracious and responsive and my organization, the Equal Justice Initiative, decided to honor him at our annual benefit dinner in New York City. He brought several of his works to the venue, to the delight of hundreds of supporters and activists.

As this book makes clear, Mr. Rembert is a gifted storyteller—charismatic, charming, insightful, and brutally honest about the realities that have shaped his life. I introduced him at the ceremony and he came to the stage full of life and energy. Several of his children and members of his large family were in the audience. Given his wealth of knowledge and understanding of Jim Crow, racial inequality, and the horrors of prison and the chain gang, there was no limit to what he could have talked about that evening that is

relevant to our work. So it was a total surprise when he opted to talk about none of those things.

Instead, he dedicated his remarks to the love of his life, his wife, Patsy. He was both effusive and shy as he praised her. He expressed his love and adoration for Patsy so honestly and genuinely, I saw couples around the room squeeze each other's hands. It was tender and romantic, generous and humble, and, most of all, beautiful. When Mrs. Rembert finally came to the stage after Winfred begged her to stand beside him, he beamed with joy and the audience cheered.

Art critics will have a lot to say about Mr. Rembert's work. His devastatingly honest depiction of Jim Crow America and savage inequality can't be ignored. He confronts racial hierarchy and the traumatic consequences of mass incarceration in his paintings. But what I realized on the night we honored Mr. Rembert is that his life is ultimately about love—a love of justice, a love of people, a love of community and family, and a love of art. His remarkable capacity for love is what makes him such an extraordinary artist. I'm thrilled that he's sharing his precious and powerful love with all of us in this remarkable book, at a time when the world desperately needs more beautiful things to discover and cherish.

Bryan Stevenson

PREFACE

Writing this book has been a lifelong dream of mine. Ever since I was released from prison, I have wanted to tell the story of *me*. I left Cuthbert, Georgia, in chains. It was 1967. I got locked up as a nobody. Prison made sure I was still a nobody when, in 1974, I was released. Some people in Cuthbert never knew what happened to me. I want people, especially the people I knew, to understand what happened and why I spent seven years on the chain gang.

I've been sharing my story, as an artist, for almost twenty-five years. My pictures are carved and painted on leather, using skills I learned in prison. Leather takes a beating, and whatever you do with it, it will hold its shape. You can carve it up and it will hold your picture. My pictures tell about cotton plantations, Jim Crow, the civil rights movement, and my time as a prisoner. They celebrate the people I knew and loved and how they lived. These are my memories of Black life in the 1950s and 1960s, and how those of us who left the South took it with us and kept it. I want to share my memories with people who lived through what I lived through. Even after I found success as an artist, in Connecticut and New York City, I dreamed of going home.

I want Black people to be proud of what their families sacrificed and how they survived. I want people who have lived in the South to talk about their history. I don't know how White folks in Cuthbert and this country are going to take this book. I want to say, and I hope, they will look at it as a good thing, but I've got a question mark by that. White people have been raised a certain way by their parents to think what they think.

I've spent years traveling back, in my mind, over all the things I've been through. I have not been alone on that journey. My wife,

Patsy, has been with me. She has loved me through it all and it was her idea for me to turn my stories into art. Memory can take you for a ride. Sometimes it comes to you in pieces. It may surprise you. It may hurt. I know that well because my memory is alive. The dates in this book may not be exact, but my mind is clear about what is important and I have been true to what I remember.

In this book I'm trying to tell my story as it was, as it really was, act for act and word for word. That includes using the word "nigger." It's an ugly word. Ugly is ugly. I understand that seeing that word written flat out on the page may hurt some people. My hope is that they will come to understand why it's there.

As a young person I was called "a nigger" so many times I answered to it like it was nothing. That's what happened. My story will not be as clear if I block out the word or even change a single letter. A substitute doesn't carry the same effect. To me, that means it isn't the same word. I've got to use the word just like I've heard it said so many times in my life.

I think about all of the people who went to their grave because they didn't want to be called "a nigger." Some people died because they wouldn't put up with it. They were killed. I want the reader to understand the effect it carries when you use that word and how degrading it is. So I'm using the word to educate. I want to tell about how being called that affected me, and I want the reader to understand that what happened to me was not so long ago.

Even though I have wanted to tell my story for years, I was afraid to draw attention to what happened in Cuthbert, Georgia, during my lifetime and to me. I was worried about whether people would believe me or care and whether the real people I name might in some way or other retaliate. I wasn't sure how to talk about my search for my mother's love or the bond I feel with Patsy. But my time in this world is up, so there is no better time. This may be the perfect time.

Winfred Rembert
September 2020

CHASING ME TO MY GRAVE

WALKING TO MY MOTHER

The railroad goes so far—just as far as you can see. It ain't got a crook in it. Those tracks go from Cuthbert up through Dawson and straight on up to Leslie. They start big and they get smaller and smaller the farther away they go. I want to paint a picture of those railroad tracks. I want to get that right. I'm definitely going to do that picture, about me walking along that lonely railroad by myself, trying to get away from the police. I was sixteen or seventeen years old. I can't remember exactly what the police were after me for. I got to really go back and get in my mind what they were chasing me for, but I know they were chasing me.

It wasn't the first time. I had been arrested before, when I was only eight or nine years old. I think I had got into a fight. Four girls and a boy, the Hawk family—they jumped me about something. The girls—Vivian, Evelyn, and one other sister—beat me up and teased me about it afterward. So I threatened them with one of Mama's shotguns. I shot in their window. It could have been something like that. That's the most I can remember.

Let me tell you something. After they arrested me that time, the sheriff brought me to the jail and turned *me* into the jailer. He gave me the keys and made it my job to decide which cell to put people in. Whoever they would arrest—Blacks now, no Whites, just Blacks—all the Black people that come in, I would take them upstairs and lock them in a cell, a separate cell for each person. Maybe sometimes, if there was a family or something like that, they would go in the same cell. But usually everybody I locked up was in a separate cell.

I had a bed on the first floor of the jail. Every time someone was coming in the jail, I could hear the keys—*clink, clink, clink*—and

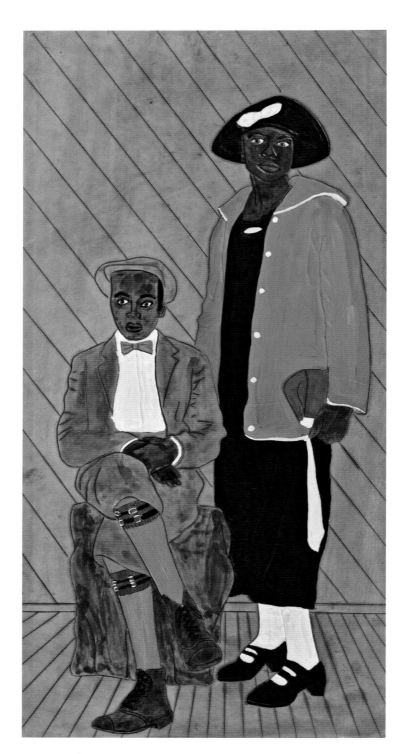

Mama and J.T.

I knew they were coming with somebody to be locked up. I would jump up out of the bed real fast. There'd be ten or so people in the jail at any one time, and as it happened, I mostly knew everybody I was locking up. My job was to decide where to put them.

This was a time when everybody was above the law—if you were White, that is. They just made up their mind about what they wanted to do with you and that's what they did. Like putting a young boy in jail and making him a jailer. I was their jail boy and that was it.

As it happened, Sheriff Faircloth was looking for me again. I don't know why. The police came to the house looking for me. I was living by myself in Mama's house at that time. She was living in Connecticut with her son, J.T. Mama was the woman that was raising me—she wasn't my birth mother. Her name was Lillian, Lillian Rembert, and I called her Mama. She was my mother's aunt, my great-aunt. Mama was a slim woman, straight up and down. She wore long dresses and short jackets. Her shoes had block high heels, not the ones that's skinny, and her dresses hung all the way down to her shoes. Mama's hair was fixed into a ball. She was a brown-skinned woman with nice-looking hair, but she pulled her hair back into a ball and pinned hairpieces on. The mailman brought those hairpieces and I remember watching her put them on.

Back then I always stayed alert. I was doing a lot of crazy things and running away from the cops. Mama thought I was going to get killed. Things were just going all crazy, and I didn't have a clear view of what was happening around me. Even when I was asleep, if I heard the least little noise, I'd wake up to see what it is. It was early in the morning, before daylight. I heard car doors shutting, and I struggled to peep out the window. I couldn't see a whole lot, but I could see enough to tell that it was an official's car with the sheriff sign on the side of it.

They kicked the door in and were calling my name—*"Winfred! Winfred! Where are you, boy?"*—like I was going to answer them! I thought that was funny. I don't know what made them think I was going to answer. I knew I couldn't laugh out loud, but deep down

inside I was laughing, even though I was also scared. I couldn't run out of the house because they were right there. I looked at the hole in the mattress. When Mama would make up the bed, she would stick her hand in that hole and fluff up the mattress.

You know, back in the day, they made mattresses out of cotton. You would stuff cotton into these big sheets, sew them up, and use it as a mattress. It was called a "tick mattress." People would do things to get by. They weren't able to go out and buy a mattress. Mama made her own tick mattress. When the candy man come by, I'd sell candy for him and he would give me a prize every time I gave him the money. That prize might be a tablecloth or a pillowcase. Mama would sew them all together and stuff cotton inside.

I put my arm in that hole, and when I did that, I tore the mattress. So I jumped inside that cotton, dug in, and pulled the cover all the way over. I was inside that tick mattress. The police were walking around with their flashlights shining. There was no power, since I was living there by myself and I didn't care nothing about no electricity. There were no lights on and that saved me.

As soon as the police left the house, I ran down through the woods to the railroad, a half mile away. I figured no one was looking for me there. I ran down the hill to the railroad fast. When I got there, I stopped and looked all the way down it. My idea was to find my mother, my real, true birth mother, Nancy Mae Johnson. I didn't have no money, no nothing, nobody else to turn to and say, "I'm in trouble, I need your help." All my resources were worn out. My mother lived in Leslie, and I was going to walk that railroad until I found her.

Now when you're walking the railroad, it looks like you're making no progress. Don't matter how fast you go or how much time has passed. That railroad is right in front of you. I was hoping I could jump the train or something, but no train come along. I did get a ride for a little ways. I came off the railroad at a small town and struck up a conversation with a guy who took me a few miles—four or five miles I'd say. Then I was back on the railroad again. I walked

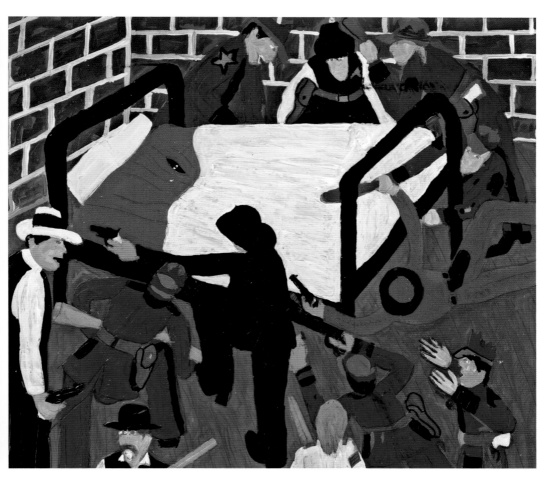

Inside the Tick Mattress

all the way down that railroad looking for my mother. It took me all day and part of the night to travel those fortysomething miles. I sat down for a little while, and then I walked and walked. I didn't have any food, but I was determined to get there. I had a big determination, and things I wanted to do, I would get them done.

It was dark when I got to Leslie. When I finally got to that town, I asked all these people whether they knew Nancy Mae Johnson, and they did. They knew her. I met a man named Ed Woodard, who was sitting on his porch. He said to me, "I remember you. I remember your mother having you. Sure, I know your family, son. I know your mama."

His son—they called him "Honeyman"—took me in a car to my mother's house. I was a tired and hungry guy. I approached the house and knocked on the door. One of my half sisters answered, and my mother was there behind her. The first thing my mother said to me was, "What are *you* doing here?" She said it grossly! She spoke to me *grossly* like she didn't want to see me. Just think about that. You're facing your mother, and she puts you down before she invites you into her home. I wanted to see some sign from my mother that she loved me or cared something about me. Instead she said, "What are *you* doing here?" When she said that to me, I wanted to turn and walk away to somewhere in the world where no one knew who I was. I felt like a nobody. I felt like nothing.

I come all the way. Walked. To see you, Nancy Mae. I come to see you and to feel your love. But you didn't welcome me.

My mother gave me away when I was three months old. Her husband went away in the army and he didn't come home like he was supposed to. So she got involved with another man. I think she didn't want her husband to know she'd had me. She got scared and gave me to her aunt before he came back. She came to Cuthbert to see me maybe twice in my life after that. Still, I figured she could help me get out of trouble. But I got an uneasy feeling as soon as I saw her. Maybe she thought I would stir trouble in her home, with her husband not being

my father. I told her that I was in trouble and I needed somewhere to stay for a while. I didn't know what else to say.

It turned out her husband, Jerry, was a nice guy, a real nice guy. He was a farmer and a bus driver. He would drive the school bus, come back, park the bus, and go to work in the field—his own land. He would sell his crops. One day I was jittering around in the shed, just playing, and I found his money. It was a lot of money, especially for me, coming from nothing. If I had to guess how much money it was, I'd say fifteen hundred dollars. I took that money and I bought me some pants, shirts, and shoes. And my mother, she was just *blown away*. She came to me and grabbed me: "Where is that money?! Where is that money?!" She was just *going off* on me. And her husband walked up and snatched her hand away from me. He said, "Don't do that. Don't treat him like that. If he got the money, he'll give it to us." And I did. I gave him the rest of the money because of the kindness he showed. I wasn't used to getting kindness like that. That money I took was all the money he made from a whole year's work, selling his peanuts, corn, and cotton. He could have been upset and showed harshness, but he was just as kind as he could be. I don't understand why he was so forgiving. I probably had spent close to a hundred dollars. I gave the rest back to him, and ever since then the two of us were tight, all the way up to his death. He was better to me than my own father.

I always had a love for my mother that I could never express. I loved my great-aunt Lillian, and I got great love from her. She showed me all the love she could muster up, but it wasn't a mother's love. I looked around and I saw the togetherness of other families. I didn't have that. Looking for my mother, walking down that railroad, that was just an excuse to see her. I thought, *Here is a chance for me to get some love from her.* But I didn't get it. I didn't get the love I was looking for. I saw her many times after that. She never denied me of coming there, but she never showed me any love.

I stayed around there for about six months, maybe more, because I had nowhere else to go. I met people in Leslie. That didn't

take me no time. I'm a person who can make friends. I met this principal, a Black principal—all the schools in Georgia were segregated back then. At the time I met him, he was a basketball coach at the high school in Americus, which was a twenty-minute bus ride from Leslie. The kids in Leslie went to Americus for high school. His name was Mr. Robinson and he saw some good in me. He saw me playing basketball and he thought I had talent. He wanted me to come and play basketball at his school and he took me in. I was living with him, trying to go to school and being a basketball star— about ten miles down the road from where Jimmy Carter, who was a state senator at the time, was running his family's peanut business.

Mr. Robinson had these silver dollars. I stole them and spent the money. His wife came home—somebody must have told her that they saw me coming out of the house, and I wasn't supposed to be coming out of the house—and she sent the police at me. The police came and got me, locked me up, and charged me with larceny. What happened next was that Mr. Robinson came down to the city jail. He didn't get me out when they first arrested me. He let me stay there until my trial date. Then he came to the courthouse and he said, "Guess what? I found my money. You got the guy in jail for nothing. We made a mistake. You can't lock him up. He's a good guy." So instead of walking me to the courtroom, they turned me loose.

When I walked to the door, my mother was sitting there. The sheriff looked at her and he said, "Who are you?" She told him I was her son and he said, "What are you doing here?" You know, he was wondering what a Black woman is doing in his courthouse, and maybe he's not liking the fact that she's there. She said, "I just came to see what was gonna happen to him."

The sheriff turned me loose and I went on back with Mr. Robinson. I sat in the car with him and I couldn't look him in the face. I just couldn't look at him. I had betrayed his trust. Even today, I hurt so bad about that. Me and my wife, Patsy, went back to Leslie years later. I wanted Mr. Robinson to know I had changed, that I'm not who I used to be. I wanted to tell him that to his face. That was

my goal, but Mr. Robinson had passed away. I waited too long. I didn't get a chance to let Mr. Robinson see who I am and what I've accomplished. I feel so bad about that because he was a real good man. He was *excellent*. He could have been my daddy, he was so good to me. He even taught me how to use the bathroom. He said, "Whenever you use the bathroom, before you flush it, look back and see whether there is any blood or anything in your stool." Mr. Robinson got sick. It could have been detected sooner, but he didn't look at his stool. He said, "Don't be ashamed. Check your stool." Now what man is going to tell you that?

I would say, when my mother came to the courthouse that day, that is the only time she ever showed any care, but she was so hard, she couldn't say it. She was so hard, she still couldn't show me any love. She was *that* hard.

Now I got to know my mother's father, my grandfather, and maybe I can understand, by knowing him, some of the things he did that might have rubbed off on her. Mama and I used to go and visit my birth mother sometimes at my grandfather's house. We called my grandfather "Bigdy." He was tall, about 6'4", and he was intimidating. He looked like he was ready to jump on you.

We would all meet at Bigdy's house and my grandmother would cook a big dinner. We would talk and laugh and have fun. My grandmother—her name was Willie—would serve us. Back then Black men would have their wives serve when company came to the house. That's the way they did things. My grandmother was all dressed up like a maid. She had on an apron and a head rag. If you walked in the house, you would have thought she was a maid, but she was Bigdy's wife.

My grandmother would serve Bigdy like a king. He would get his food before anybody else. Bigdy didn't like every part of the chicken. He wanted his special piece. She put the chicken on the plate, and then the rice, and then she brought the gravy. One day Bigdy looked at the gravy and he jumped up from the table.

He screamed out, "You know I don't like my gravy this color." He grabbed the gravy bowl and threw it with the gravy in it—hot gravy. The bowl hit the wall and gravy splattered everywhere. It could have hurt somebody. Bigdy went on and on about that gravy and my grandmother starting crying. Oh, she was jittery.

I didn't feel much about it at the time. I was too young. But as I looked at it, when I got big enough, I thought it was a cruel thing to do. If I had to describe Bigdy, I'd say he was mean. Anyone who could throw gravy like that—that's a mean person. I don't know if things like that had something to do with the way my mother was, but I think they did.

When she was older, Willie was not well. Mama would take me and my sister Loraine to the house to sit with her. Willie would be up all night, moaning and groaning. Loraine remembers her hollering stuff like, "Don't put me in the hole," and "Somebody's going to get me"—all night long. She would throw things too, anything she could get her hands on. Loraine tells me, "To be honest with you, Winfred, I thought it was some type of witchcraft. I really did. I don't know whether your granddaddy was messing around with witchcraft out there, but sometimes people will do evil things." That's how Loraine took it. But if I had to say, I'd say it had something to do with the way my grandfather treated Willie.

I think some of Bigdy's ways rubbed off on his daughter, my mother. I looked at the way my mother treated my sisters and my brother, and I thought she used mental cruelty on them. She had her husband's sister living there, who had dementia. My mother treated her like a dog, just hollering and screaming at her all the time. And when my mother hollered and screamed, it scared the poor woman. She was running all over the place, trying to get away from my mother.

I had no business going back to Cuthbert, but I did. I went back because I loved Cuthbert. I loved it because of Hamilton Avenue and the juke joints and the people there. As a young boy, all that was

really appealing to me. I was willing to take the chance of giving up my freedom just to have that part of my life back again. Those juke joints had a hold on me. And the people that were older than me that I hung around—singers and dancers and entertainers—they had a hold on me too. I really enjoyed being around them.

I was back in Cuthbert and I was standing at Butch Jordan's café. The police were looking for me and I didn't know it. I was just standing there. They rode up there and got out of the car, walking nonchalant. As soon as they got close to me, they grabbed me. I wanted to run, but they were too close on me. They grabbed me—"*I got you, Winfred!*"—but they didn't handcuff me. They took me to the police car and put me in the back seat. Just when they got ready to close the door, I looked down and there was a piece of cardboard lying on the floor. Instantly, before they shut that door, I stuck the cardboard into the door to keep it from locking.

They rolled up Hamilton Avenue and turned up Blakely Street, going up toward the old Confederate soldier statue on the town green. Then they stopped. I opened the door and rolled out on the ground. They pulled off, and I got up and ran back down to Hamilton Avenue, like a jackrabbit, to the poolroom for refuge. When they got to the jail, I wasn't in the car. Imagine that!

I missed the love of a brother, and a sister, and a mother. I've been missing it my whole life. I looked around at other people and it always looked to me like the love of a family was just a beautiful thing to have. I had a friend named Robert Carter. We called him "Poonk." Poonk's mother sometimes took me in. Poonk says she could see that I was a loose kid in a small country town that had nowhere to go and nothing to do. I wanted the love that a mother shows her child. I thought about my brother, my sisters, my birth mother, and the cuddliness that I never had. I wanted my mother to show me some love. When I was walking that railroad, I imagined my mother opening the door. I felt she'd be anxious to put her arms

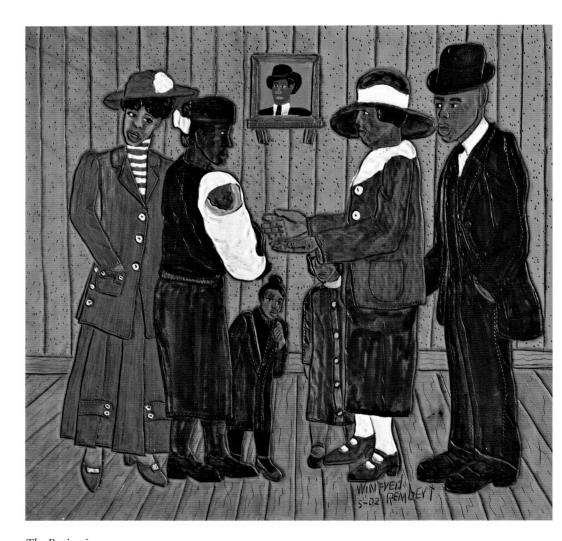

The Beginning

around me. I felt she'd be happy to see me. But it wasn't that way. I didn't get her love. And I might as well face it: It will never happen. Ain't nothing I can do about that. Nothing I can do.

Here I am now, seventy-four years old, an artist. I paint on tooled leather. In 2002, I did a picture, on leather, of my mother giving me away to Lillian Rembert. I wanted people to know where I came from. Lillian's son, Boy, is standing there across from his wife, Candy Lee. Candy Lee is all dressed up. That's the way she was. I wonder what was going through everybody's mind. I know nothing good was going through Candy Lee's mind, and I imagine my mother was scared. She knew her husband, Jerry, was coming home and she didn't know what he was thinking. Or maybe she did know what he was thinking. When he first heard the news, he could have been not liking it. It could be that's why my mother gave me away. The picture shows my mother, Nancy Mae, handing me to Lillian. And Lillian— Mama—reaches out to take me.

I want to do another picture of my mother, in front of the fireplace. That's where she fell dead. She was putting wood on the fire and she died of a heart attack. My mother was always poking around in the fire. Her sister-in-law, Pearl—the one with dementia—slept in that room where the fireplace was. She stayed in the bed all the time, and she was in there when my mother died. My mother tried to make sure everybody was warm, including Pearl. I can imagine how it was in front of the fireplace. It was an old country room in an old country house, all wood, a little better than a shack. There were four main rooms and another room built in the back. There were two fireplaces, and one of them was in the middle of the house. The house was heated with that fireplace and with gas heaters that ran off propane. I can imagine my mother putting wood on the fire, or maybe poking around in the fire with the poker iron. I don't know what I'd rather paint—the poker iron or the wood.

I never tried to paint that journey, looking for my mother, but I have always pictured it in my mind. Not just every now and then, but frequently in my life as I go along from day to day. I didn't want to

touch it until I felt like I could really do a good job. I want that rail-road to be just like it was when I stepped on it and looked down it. For some reason, even now, I never thought that I could get it right. I don't know if I could sit down and put it together like it really was.

I want to do it on paper first. If I draw on a sheet of paper, the actual size of the painting, I could try to get it exactly right before I put it on leather. I may have to do five or six drawings before I pick the right one for the final cut. I don't think I could sit down and go from beginning to end right like that, but I think I could start.

FROM CAIN'T TO CAIN'T

Georgia is a flatland state. There are a couple of mountains and valleys up in North Georgia, with two big-time parks where people spend their vacations, but the rest of the state is flat. You see a few pine trees—Georgia pines—along the edges of the fields. The land is red clay, and that red clay dirt under your feet will mess up your shoes. Plenty of times, I went out for the evening and when I got to where I was going, I had to wipe my shoes off. The dirt is so red, I don't know how they grow anything in it, but farmers plant all kind of produce: sweet potatoes, corn, soybeans, peanuts, and cotton.

A cotton field at picking time is a beautiful sight, when you're riding down the road looking at it. Nothing but white as far as you can see, going off the horizon into the ocean, and there ain't no ocean there. The most delicious wild fruit you ever tasted grows along the roads surrounding the fields: blackberries, dewberries, and plums. The biggest plums—red, blue, purple, and yellow—grow there, just wild, but so sweet in the month of June. Wild grapes grow in the trees too, so high you can't get them. You just got to hope you can pull a limb down. They call them "scupadine grapes" or "bullets." People love them so much they go up in the trees and pick them. If you go down to Georgia in scupadine season, you'll see trucks out along the road, and people will sell you a little basket of grapes off the back end for a couple of dollars.

When the sun goes down, the end of the cotton field looks like it's on fire—a big fire of orange, yellow, and red, fading away into the trees. It's just beautiful. You see the sun set when you are out there picking, because they want you to keep going as long as you can still see your way up the rows. I got a painting about that sunset. It's

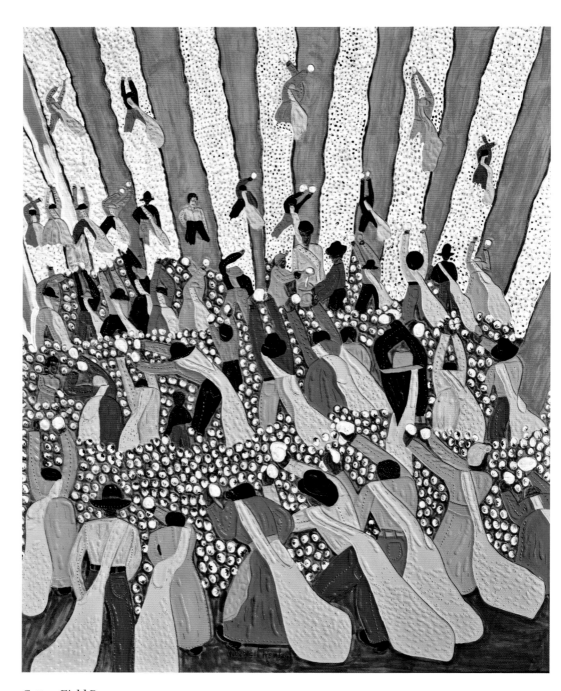

Cotton Field Rows

called *From Cain't to Cain't*. You can't see when you go, and you can't see when you come back. It's dark. Somebody would ask you, "What time you getting off? What time you leaving the field?" You'd say, "From cain't to cain't," and they'd know what you're talking about. That's a *long* day.

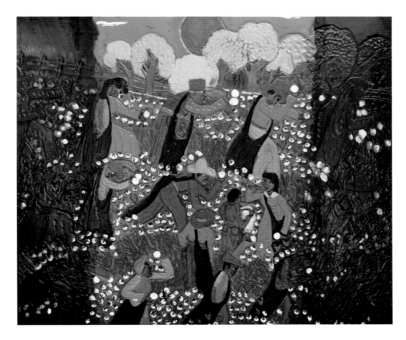

Cain't to Cain't II

The cotton field was the first thing in my life. The very first thing I remember. You know, kids look up and the face they see is their parents? Looking up at his parents is the first thing a child is *supposed* to remember. Not me. It seemed like I opened my eyes to cotton. I remember the cotton over the top of Mama. Just as far as I could see, all the way around, there was this white sheet of cotton. That's the very first thing I can remember in my life. I opened my eyes and I saw that cotton, and it was a beautiful thing. When you get out there picking in it, though, you change your mind about how beautiful it is.

OVERLEAF: *The Overseer*

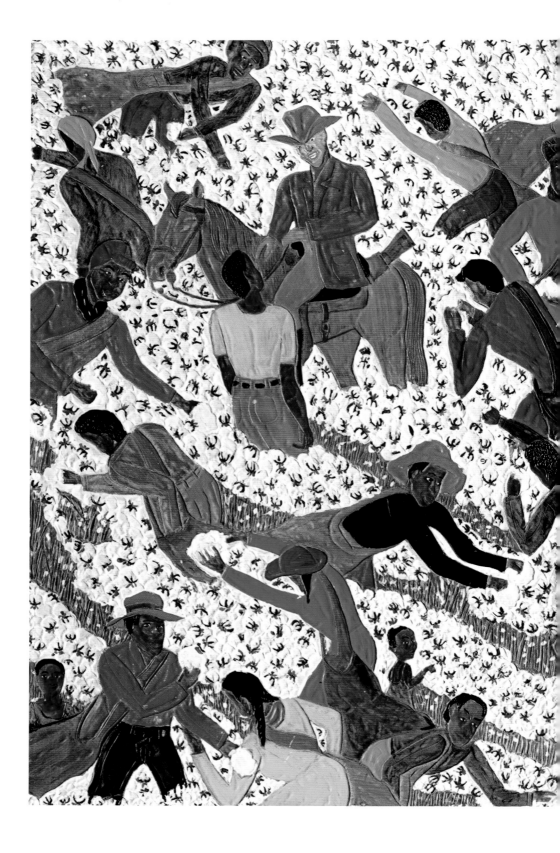

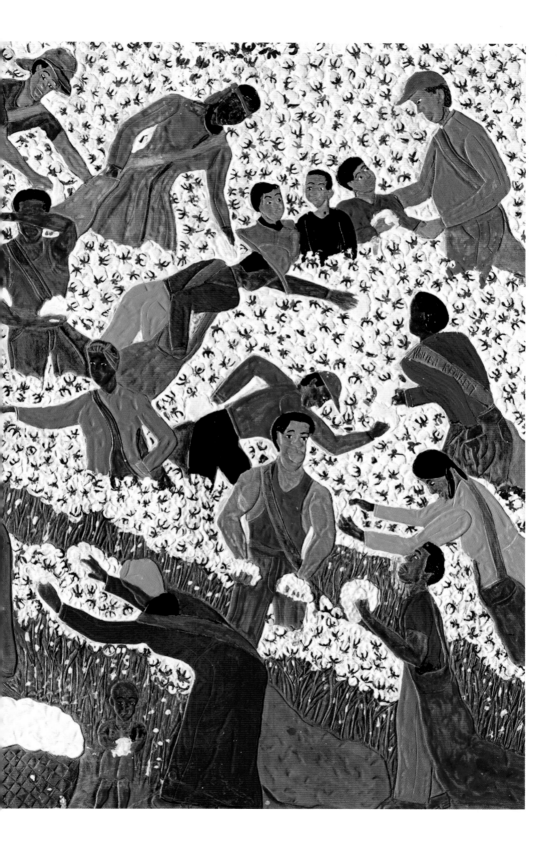

I was too young to pick cotton when I first went out there. I had to have been about four years old, just a little child. Mama had me riding on her cotton sack. The rows were so long, sometimes it would take you a whole day to go up a row. I remember how hot it was. The sun was shining hot, ninety or a hundred degrees, with no trees for shade. All you had was your hand to put over your eyes, so when you looked up you could block out the sun. I painted that too, people in the field looking up like that—cotton in one hand, shading the sun with the other.

Mama had a plantation house. That's where we lived. When I was a baby, sometimes Mama would leave me in the house with my sister Loraine, who is seven years older than me. She told Loraine to hang a white sheet on the line outside if anything was wrong with me so she could see that sheet from the field. Other times she would put me under a tree next to the field while she was working. One day, I'm told, a snake smelled the milk from my bottle and crawled over. He didn't get a chance to bite me, though, before somebody got him. Loraine was picking cotton in the field that day. She's still scared of snakes just from the memory of it.

When I was five or six, I had my own sack to pick in. Of course, I was just going through the motions. I wasn't picking much cotton at age five. But Mama was picking *a lot* of cotton. Let me tell you, Mama could *pick*. She could easily make four dollars per day. And the people she knew were picking right beside us. That's the way they did it. All the people you associate with would get rows beside each other, and you would pick together. If there is anything good about the cotton field, it was listening to Reverend Alexander and his family sing. Reverend Alexander had a big family, a lot of children, and they could sing. I could hear them right now. I could close my eyes right now and hear Reverend Alexander and his family singing church songs in the cotton field. That's the only good thing I see out of the cotton field—that singing: "Amazing Grace," "I'm Going Home on the Morning Train," all of those beautiful Southern hymns.

Just before dark or later, they come around to weigh up, to see how much you made that day. If it was dark they turned on the truck

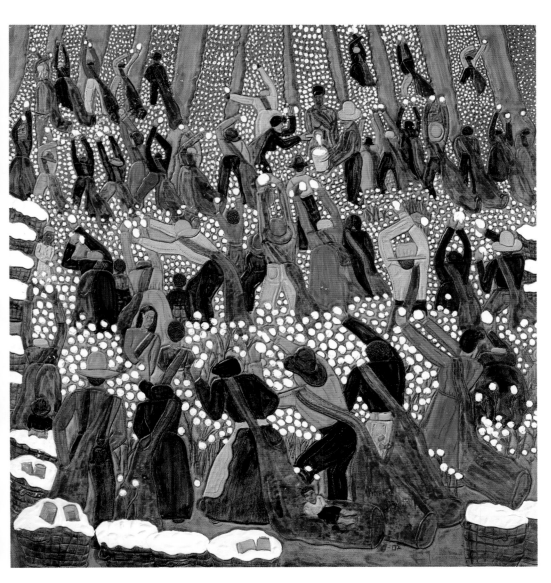

On Mama's Cotton Sack

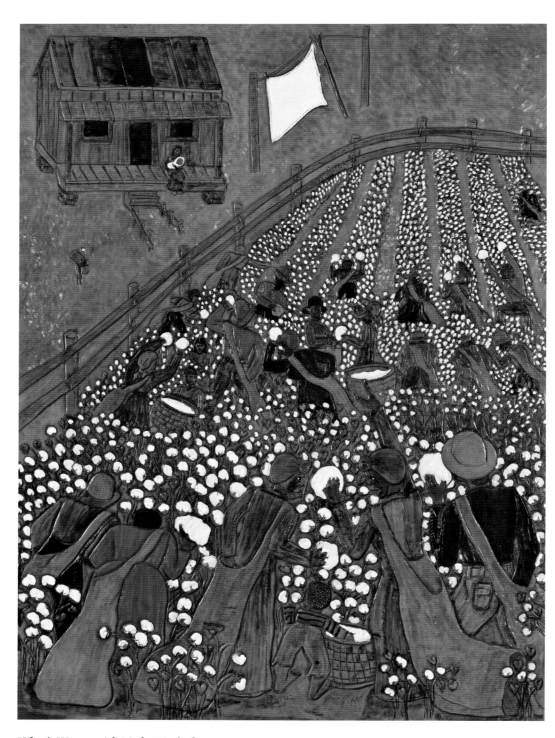

What's Wrong with Little Winfred?

lights. The owner had the money in a cigar box. When I picked cotton, it was two cents a pound. Most people made two or three dollars a day.

The cotton field is tough. You got a person, a Black person, hired to push you on. "Y'all come on now! Get up! Ain't nobody doin' nothing!" This Black guy, he gets paid a little more from the boss man—the plantation owner—by doing that job. And every now and then you got a White overseer coming by on a horse or in a truck, trying to make sure you're working hard. And you ain't never working hard enough—for them. Now when the Black folks see the overseer, they do get faster. They pick as fast as they can.

In 1945, 1950, the owner of the plantation owned the plantation and you too. They still had you in a slavery-like situation. They controlled everybody who lived on that plantation. You couldn't leave the cotton field because the money you owed was holding you there. The house you lived in was holding you there. Every plantation had a store, where you would get things on credit. The money you owed at the commissary store was holding you there. You just couldn't get out of that loop, that line of debt. If you picked cotton, you owed money. You could never get out of debt.

Women gave birth in the cotton field too. That was a tough thing. Some older lady who was used to seeing births was there to help someone having a baby. She would wrap the baby up in her apron, put him under the cotton stalks, and that mama would go back to work. At the time, I didn't think anything about that. I thought maybe it was the right thing to do, because nobody said it wasn't. Women had their babies and they'd go right back to work, right then and there. It's a *mental* "have to." It's a thing in your head that says, *I got to go back to work. If I don't go back to work, the White man ain't gonna like it.* That's what you're telling yourself. It's more about the White man than anything—what is he going to say *to* you or *about* you?

There were twenty or thirty people living there on the plantation. You get up in the morning, go out into the field, and you work

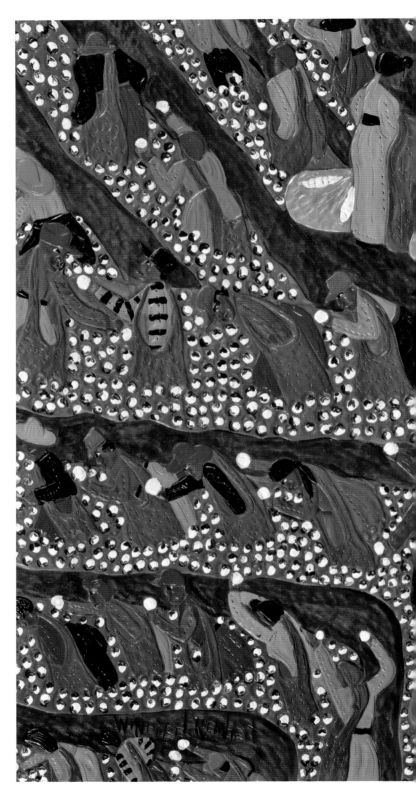

Pay Off Time

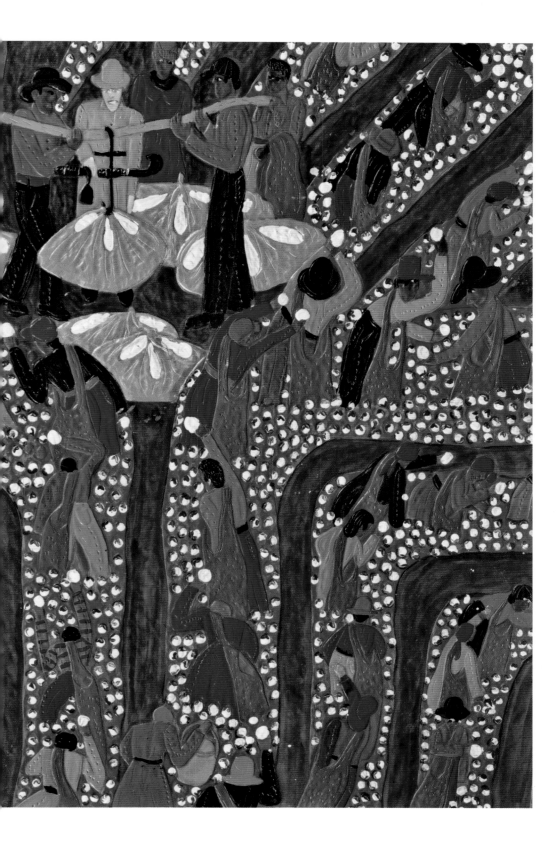

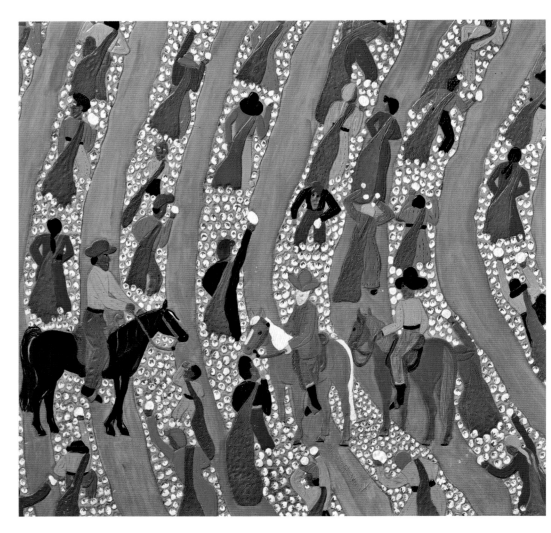

Overseers in the Field #1

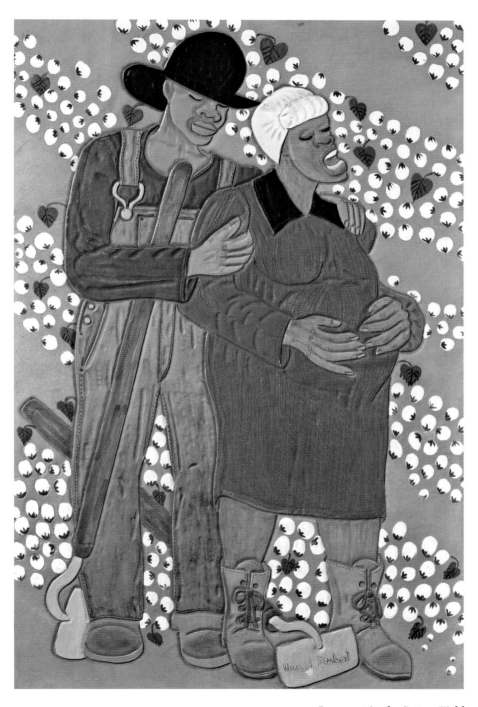

Pregnant in the Cotton Field

all day. If you were thirsty, you had to wait until the water boy come by with the water. He comes around with a dipper, you dip it, and you drink. The water boy had a bucket with one piece of ice in it. That piece of ice was just about as big as the bucket—it wasn't ice cubes like we do it now, little pieces all cut up. It was one piece of ice inside a wooden bucket. That water was cold and good. I saw people fall out when they drank that water. I guess they wanted it so bad, and drank it so fast, it went to their head. I'm guessing, now, because it didn't mean nothing to me as a child to see them fall out like that. I just kept doing what I was doing. And in a few minutes they were back working.

My wife, Patsy, knows what I'm talking about. She remembers people's bodies starting to shut down with sunstroke. But people back then had all kinds of things going on with them and they didn't go to the doctor. They just lived through it. Someone would come and put a cold rag on their forehead. Patsy sighs when she hears me talking about the cotton fields. "Oh, don't take me back there."

I went almost all my life—until the last twenty years—without going to the doctor. I didn't think Black folks needed to go to the doctor. If something was wrong with us, we went through it, or we had some kind of home remedy we would use. There's a tree in Georgia called sweet gum. People used to make furniture out of it because once it's dry, it gets hard as steel. When it's green, though, a young limb bends and it can make a good bow and arrow. One day I went with Mama's axe into the woods. I wanted to cut some sweet gum wood to make an axe handle for my axe. The very first swing I made down on that sweet gum tree, that axe bounced back like I hit a piece of rubber. When the axe slipped, it went straight through my shoe and split my big toe. The wound was deep. I went home and said, "Mama, you going to take me to the hospital?" She said, "No, not for that little cut." She reached up in the stove, where you put the wood in, got some soot, and rubbed it on the sore. Then she went out in the barn and got some spiderwebs, put those spiderwebs on there, and wrapped my foot up. The next thing you know, my foot

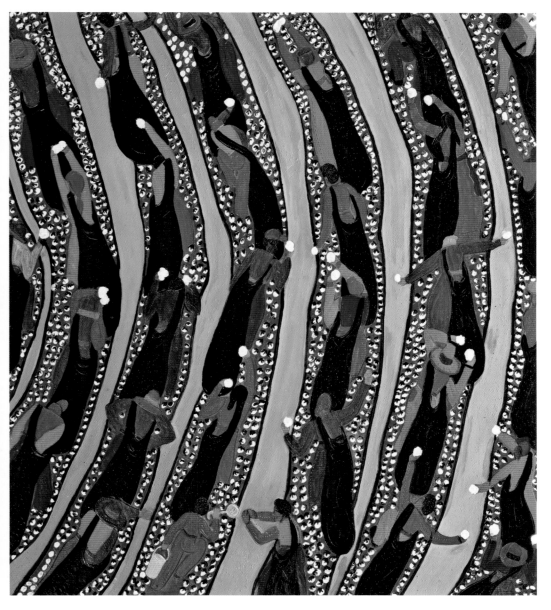

Picking Cotton/Colors

was well. I never will forget that. That toe stuck back together like it was never cut.

It would have to be life-threatening before Black folks would look for a doctor. We stayed away as much as possible because we knew the White doctors would not treat us well. They didn't care what kind of pain we might be in. When you're Black, you're afraid of every doctor you go to, so you suffer through things. That's the reason I don't have teeth. I didn't go to the dentist because I was too scared. When you're Black, they don't give you the right amount of Novocain. Our folks had some kind of stick—bitter gum—they would rub on your gum if your tooth hurt, to make it numb. It doesn't get rid of the whole feeling, but it helps.

Mama was something. When we had a stomachache, she would take a spoon, fill it up with sugar, smooth it off with her finger, put a drop of turpentine on it, and make us eat it. That's what she'd give us, and it worked great.

I managed to go to school one or two times a week. I had to walk to get there, and it was four miles away. One day the plantation owner came and told Mama, "Lillian, it's time for him to start picking cotton. He don't need to go to no school. He need to learn how to work and plow the mule." Mama said, "Yes, sir," because she was intimidated by White people. The White folks were really holding her in place. Later, when she got off the plantation and moved into town, her attitude changed a little bit. She wasn't as afraid as she had been, and she could speak out on things, like about how Black people could get out of the slavery-like situation of Jim Crow by going to college. I never heard her talk about that in the country.

After that I didn't go to school so much. And when I did go, I was so far behind, I didn't know a thing. Still, I tried to learn. I had a teacher named Miss Prather. She felt my need. She kept me after school. Miss Prather was the greatest. She said to me, "*Wiiinfred*, I want you to stay after *claaass*. I have something I want you to do."

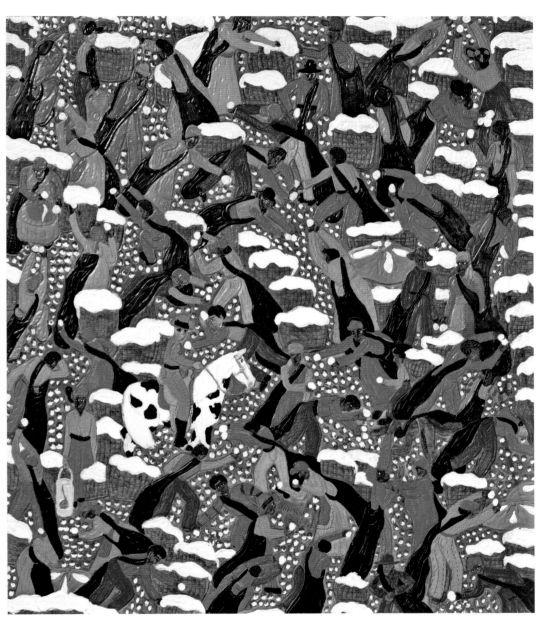

Cain't to Cain't

School Days 1956-57

Me, age 10

"Yes, Miss Prather."

"*Wiiinfred*, you're just the greatest artist. And I want you to do my bulletin board. I want you to draw a picture of every kid in the class. You know the boy who took your girlfriend away from you?"

"Yes, ma'am, Miss Prather."

"Well, you can make him as ugly as you want."

She knew I could draw because when she was walking around in class teaching, and everybody was doing their work, I was drawing. I was drawing because I wasn't learning. I had nothing else to do. I didn't know what she was talking about. She was up at the board doing the problems, and I didn't have no idea what she was talking about. So I would just sit there and draw. She would look,

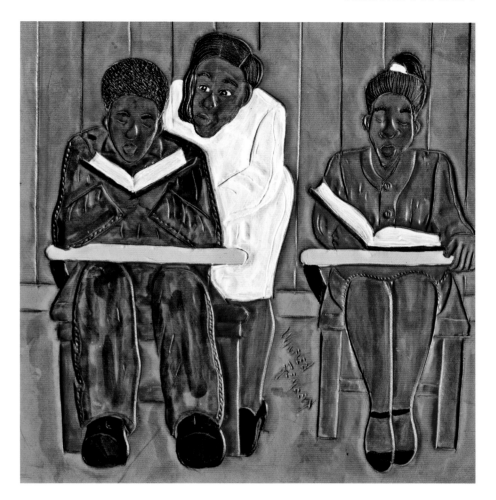

Miss Prather and Me

but she never said anything. Sometimes she asked me to put wood in the stove, to give me something to do. She never embarrassed me. I stayed after school and I did that bulletin board. Ever since then, Miss Prather was like my mama. She invited me to her house, and I went there with her daughter, Grayceda, who was in the same class.

Miss Prather tried to teach me things, but I couldn't hold it. I was too far behind. I just couldn't learn it. I remember one thing, though, I never will forget. Miss Prather said, "$A = $ pi r squared." Like

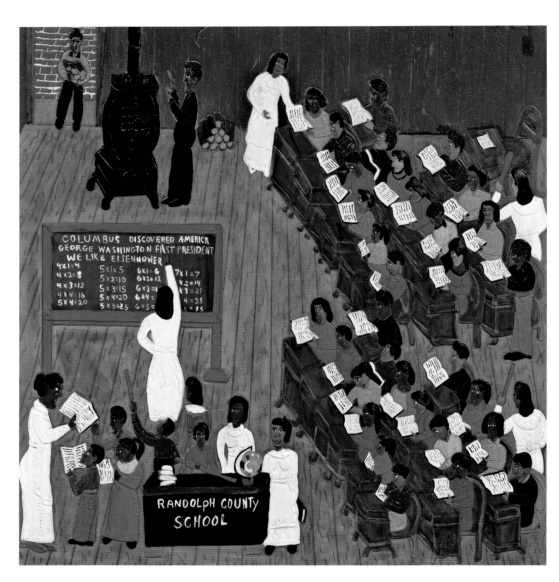

The blackboard reads:

COLUMBUS DISCOVERED AMERICA
GEORGE WASHINGTON FIRST PRESIDENT
WE LIKE EISENHOWER

4×1=4	5×1=5	6×1=6	7×1=7
4×2=8	5×2=10	6×2=12	7×2=14
4×3=12	5×3=15	6×3=1	×3=21
4×4=16	5×4=20	6×4=	4=28
5×4=20	5×5=25	6×5=	5=35

RANDOLPH COUNTY
SCHOOL

The Wood Boy

I knew what she was talking about! I never will forget that. It was all about the area of a circle. Oh, God, seems like I should have known that, since I'm an artist.

One day, when I was six or seven years old, I was messing around in the yard, playing with the dogs or something, and the plantation owner said to me, "Come here, nigger." He had a smirk on his face. He was proud of what he had to show me. He took me to the barn. Sitting there in the barn were some jars. The plantation owner said, "You see those jars?" I looked at them, and when I first looked, I couldn't recognize what they were, but as he spoke, I began to see that they were jars with people's private parts in them. There were men's private parts in jars like pickled fruit.

I remember him saying, "These belonged to Old Bill. These here, they belonged to Old John. Here's Old Tom." He had him some *trophies.* He said, "Don't let that be you." That's what he said, with an emphasis: *"Don't let that be you."* I understood that maybe if you didn't come to work on time, or missed coming to work, they'd kill you and cut your private parts off. If you didn't want that to happen to you, you'd go on out there and work. I really didn't want my private parts in a jar. He scared me. I thought I better get to work somewhere and be "spry," as they call it. I left out of the barn like a bullet.

I never mentioned it to anybody. You couldn't talk about that. You might have been able to talk about it where the NAACP had set up their headquarters in Cuthbert, because you were safe there, with all those Black guys. But I don't think they knew about it. I never told them. Maybe I should have. I thought about it as a boy, but I was scared to say anything. Even to Mama. I knew it was wrong, but I didn't really know what it meant. After I began working with the civil rights people, though, I began to realize what it was for. That kind of thing was designed to keep you humble. You know, if you are a young boy, that can scare you pretty bad, and it stays in your head. They did things like that to terrorize you when you were old enough

to keep it in your memory. But you didn't talk about any of it. You could get killed for talking about it.

I wonder what happened to those men. You know they had to die. You can't live if somebody does that to you. You can't live.

Patsy lived in Ashburn, seventy-five miles east of Cuthbert. She remembers people going to work and not coming back home.

The mother of one of my boyfriends was going with the boss man—against her will. It wasn't something she wanted to do. It was something she had to do. One day the daddy of the boy who was coming to see me went to work and never came home. The tractor was left in the middle of the field. The boy had to quit school because his daddy was nowhere to be found. Nobody knows where the man went. Ain't heard from him. Ain't seen him. They searched everywhere they thought he might have gone.

That was in the sixties. You know they killed him. They killed that man. They took him away from his family. You go to work, and the White overseer is there in your house, having sex with your wife. She couldn't say nothing and you can't do nothing about it. Your life is on the line. There is nothing that the man could do or say. And if that man said something—that's why he died.

His wife got a child from the White overseer. The boss man got her pregnant. That kind of thing happened a lot. Like one of my relatives, who is half White. Her daddy was the landlord of the house where her mother lived, but she didn't acknowledge him as being her dad. He took advantage of her mother. Her mother was young when he raped her. She was only thirteen years old when she had the baby. Everybody knew who the father was and what he'd done, but you couldn't do nothing about it.

One day he came and tried to kill that baby. The grandmother held him off with something they call a "cutter." He come there talking about how he was going to do something for the baby, and the grandmother said, "No, you can't get the baby. You'll have to kill me to get this baby."

My uncle John took the baby and her mother to Atlanta. They had to leave—around midnight that night—so the baby could survive. That little baby is now grown. She is more than eighty years old and still lives in Atlanta. I called her one time and I said, "That man got a lot of money. You know he's your daddy. You could prove it and try to get some money from his estate." She said, "I don't want nothing that man has. He tried to kill me. I don't want nothing he got."

When I listened to Patsy's story about her relative, I thought: What's going through that man's mind when he's looking for a child that's his own seed to kill it? He don't want it to live, yet he laid down with that girl. What's going through his mind? I would love for him to tell me. The only way I can understand it is that he slept with the girl, but she was nothing to him. Patsy thinks he probably didn't want his wife to know. I told her it wasn't just that. I said I was pretty sure he slept with some more women, including women of his own race that he wouldn't do that same thing to. He didn't want nobody to know he had a Black child. That was disgraceful to his race of people. He couldn't tell his friends.

"But they were all doing it," she said. "*That's* what's disgraceful. It's not like he was the only one doing it."

"Listen, those White women didn't care too much if their men slept with Black women. To them it was a nothing thing—'Oh, he was with that nigger, and it just don't mean nothing.' It was just a recreational thing. But if he did it with a White woman, it probably meant something to them. I think some of the White women looked at it like that." That's what I told Patsy.

"Oh, that's crazy," she said. "I can't make no sense out of none of it." But I understand something about it. There's a thing between White men about Black men and White women. Some White men don't like to think about Black men and White women. The plantation owner goes in the barn every day and he's looking at them balls as he walks by. He's looking at them balls, and he so proud. He's got a trophy like he's run a race and won. What is he thinking every time

he's looking at them? "I got the balls of this nigger. He ain't going to sleep with a White woman." I think that's what he's thinking.

That's what they ask you about when they got you and they're fixing to kill you or beat your butt. They want to know what you think about White women. When I got older, they beat me and threatened to kill me, and they asked me that. They wanted to know did I even *think* on them terms. You so badly don't want me to sleep with your White women that you would *kill* me. You would *kill* me if I desire your woman or look at her passionately. Of course, I said, "No, no, no." But guess what? Some Black men desired White women. They couldn't get that out of their heads. I think it was because they couldn't have them. So they desired. It shouldn't be that way. Cuthbert, Georgia, got them that way. There are some Black men who have gotten killed for sleeping with White women, or because someone thought they did. They are in their graves right now.

I think there may be some White women who think the same way too. "Nobody wants me to sleep with this nigger, but I just got to sleep with him." They know that they are desired and they may want to sleep with some Black guys just as bad as the Black guys want to sleep with them. But you will never know it because it won't come to pass.

You meet a White woman, in Cuthbert, Georgia, coming down the street, and you can't look at her. You have to look away. That's what the Whites want you to do. Or you cross the street. When you are a young boy, you learn the things you can do and you learn the things you can't do. You don't want to die. So you turn the other way.

HAMILTON AVENUE

Sometimes I get into those thinking moods. I get to thinking about Cuthbert, Georgia, and my mind goes in and around town. Then I'll remember a certain person and something great that he did, or something that he did to draw attention to himself, and I'll say, *Oh, I remember him. I'm going to do a picture of him.* And I do something I know about him. I have to *know* something about him or I won't do the picture.

Every person I do, I got a movie about them in my head. The movie plays and that starts me putting a character down on paper. I picture which position to put him in, what I want him to be doing, and whether I want him looking mean or sorrowful or happy. What do I know this person as? If he's a dancer, do I want to have him doing specific moves? If he's a joker, I'll use a little more hand expressions in the picture. I'll have him holding his hands and arms up, like you do when you tell a joke, and I might use lines to show movement. If he's a bad guy, I might put eyebrows on him in a way to make him look mean. I have to remember things about the person. Was he a person that had a lot of movement? A lot of folks down South use hand expressions and body movement. The expressions a person uses, does he use those expressions all the time? And, yes, most people do. I have to look at that kind of thing, I have to know it, if I'm going to do a person. At least I'd like to know it, so when I do a picture I get it right.

The name of Mama's son was John Thomas, "J.T." for short. "Boy" was his nickname. J.T. had a juke joint in Cuthbert. He lived with his wife, Candy Lee, in the back of it. He was a moonshiner and he sold a

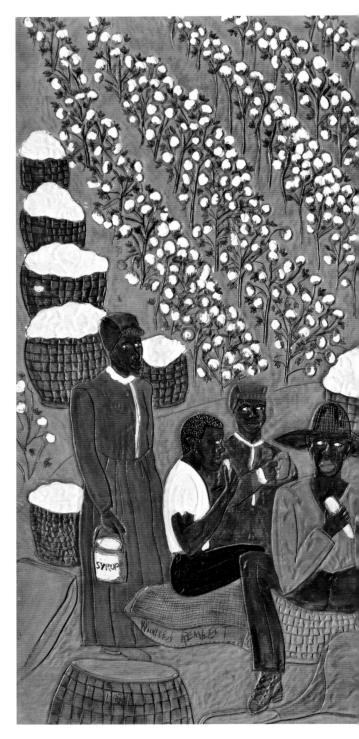

Dinnertime in the Cotton Field

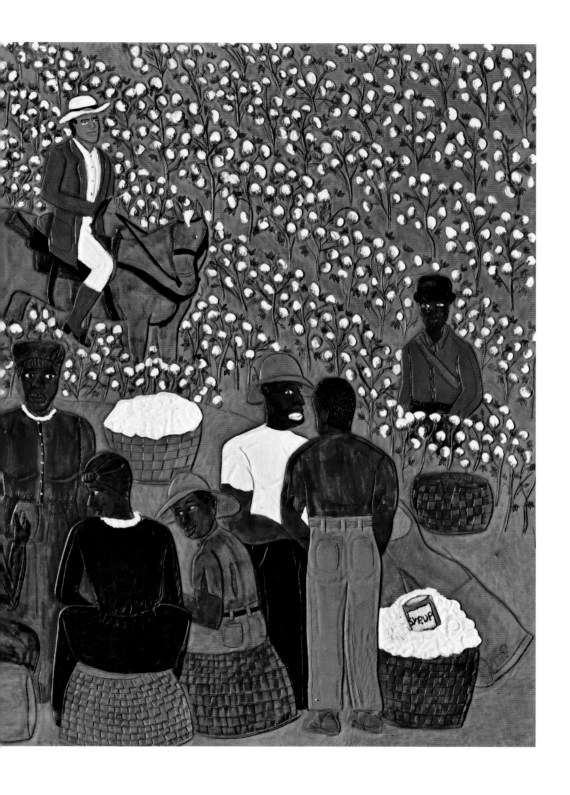

lot of whiskey. Mama wanted to leave the plantation. She said, "Boy, I need to get out from here." J.T. took some of his whiskey money and he built Mama a house in town.

Me and Mama were still picking cotton. Every day we had to go out to the fields. Before day in the morning, a big truck would come around and pick up the workers. Mama and I would sit on the porch waiting. She'd have our lunch in her hand. You'd see the lights on the truck, coming down the road. Sometimes there would be a big canvas on top of the back of the truck, in case it rained. When it was hot, they would take the canvas off. In the truck there was one seat—a board— built all the way around. Mama would grab me by the hand and say, "C'mon, Winfred, I'll get you a seat." She made sure I got a seat.

Lord have mercy, waiting for that truck was a bad feeling, because I didn't want to go and I knew it was going to be night when I got back. I didn't want to pick cotton. I wanted to get out of there, and when I was about thirteen years old, I ran away from home. I ran down to Hamilton Avenue. I wasn't looking for no juke joints or poolrooms. I didn't know what a poolroom was. I just wanted to get away from those cotton fields.

As a freshly ran-away kid, I didn't have nowhere to live. I slept in cars. There was a big cemetery on Hamilton Avenue. I slept in that cemetery a lot of times. Some of the tombstones were made like a bed with a pillow on it. The small headstone was a pillow. The big headstone was a bed. I lay my head on the pillow. That was a hard sleep, but you can get used to it. When you're in trouble, when you're forced to do things, you can do them. If you have nowhere to go and nowhere to sleep, sleeping on a headstone is a good sleep. Other times I slept here and there. My friend Poonk remembers his mother opening the door in the morning and finding me curled up on his front porch asleep. His mother brought me in and made sure I had something to eat.

I made friends with a guy whose name was Johnny Frank James. They called him "Duck." Duck was an uneducated kid, just like myself, and right around my age. He didn't have no schooling

whatsoever. He just went around from day to day, same as I did, hoping to meet somebody who could do things for him, like give him some work.

One morning Duck said to me—"Let's go to the Curvey. You got a fishing pole?" I didn't, so he said he would ask his mama whether I could use one of her poles. I don't know whether she said yes or not, but Duck got the pole and gave it to me. It was not a modern fishing pole. It was a fishing pole styled on a stick with a string on the end of it. And the bobber on that fishing pole was a snuff jar top—a cork that was round like a fifty-cent piece.

The Curvey was a swimming hole. There was a railroad track up high. Water ran underneath the railroad track and fell about twenty feet down. It made a big hole over time, and water stood there. Kids would swim and fish. The more rain fell, the bigger that hole got. I don't know where the name "Curvey" came from—it's just what everybody called it. It was a place where kids who didn't go to school would hang out. Some were playing hooky and some just didn't go to school at all. Some of my schoolmates—Eddie C. Howard, Charlie Brookins, and Poonk—never went to the Curvey. A lot of parents sheltered their kids back then, in Cuthbert, Georgia.

Duck and me went down to the Curvey to catch some fish. I had never fished before. That was a challenge, and anything that was a challenge was good for me. I love a challenge. I like to do things that are out of the ordinary. Man, did I like the Curvey—seeing kids, talking, having fun, and fishing. Kids would stay there during school hours—at eight or nine o'clock in the morning everybody is coming, and they'd stay there all day. I even saw kids cooking fish on a stick. They'd build a fire, put the fish on a stick, and hold it over the fire.

Duck took me to places on Hamilton Avenue. He said to me, "C'mon, I want to take you to the poolroom." Duck could shoot pool real good. He took me to the poolroom and introduced me to a guy named Jeff, who owned the poolroom. Jeff fell in love with me on the spot—I had that knack of people liking me. He said, "Listen, you want a job?"

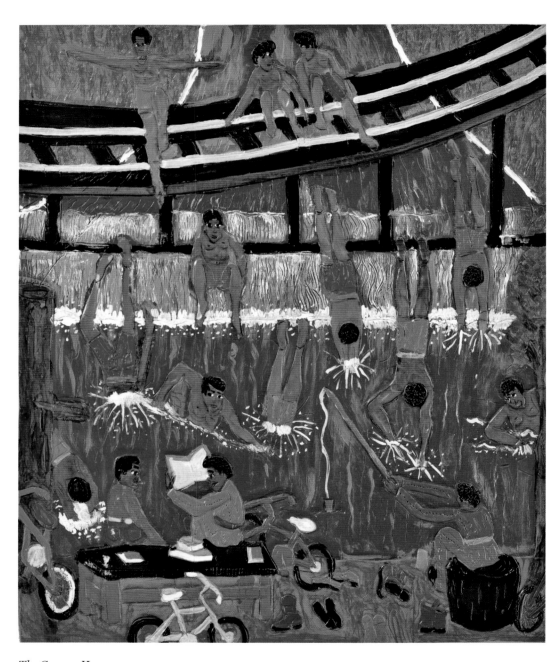

The Curvey II

"Yeah, I want a job."

"I want you to run the poolroom for us."

After a week or two, and I was doing all right, he said to me, "There's a bunk bed in the back. You can sleep in there." And that's what I did. I ran the poolroom for Jeff, racking the balls and collecting the money. One time I took ten dollars out of the poolroom money and I turned the rest in to Jeff. The next day he said to me, "I know you took money from me. I've been doing this job and running this business for thirty years. I know how much I make per day. I'm never off more than a dollar or two. I know you took money. But that's all right. Everybody makes a mistake."

The cotton field was out of my life, and Duck introduced me to the world. He was hanging with me every day. He took me to all the juke joints and introduced me to the people—all the Black people who were prospering in Cuthbert. They all had something to do with Hamilton Avenue. They would come down there to sell their products and stuff. It was a place for Black people. Everything on Hamilton Avenue was Black—except the cemetery, which was a White folks' cemetery—and I never knew Black folks could have businesses.

Hamilton Avenue was lined with juke joints, and almost everybody sold moonshine. There was Sturgis Night Club, and Bragg Brookins's juke joint. Black Masterson had a place. There was Sadie Mule's and the Dirty Spoon Cafe. There was Bubba Duke and Feet's place. And up the street from Bubba Duke's, in the corner of a little alley, was Brur Barnes's barbershop. Brur Barnes would cut your hair with a hand clipper. Boy, he was terrible. He would just tear your head to pieces. He was all over your head, and he could never get it straight because he was drunk all the time. I would sit in there in his chair looking at him cut other folks' hair before he'd get to me. He would cut down to the skin here and leave some hair there. That's just the way he was—not a perfect haircutting guy. He had a lot of customers, though, and Mama believed in taking me there because Miss Julia, his aunt, lived right in back of us. So we had to go and get my hair cut by Brur Barnes, just for the life of it.

The Dirty Spoon Cafe was a juke joint for adults. They wouldn't let kids in there. I guess they kept more rules and regulations than anybody else. I would look in the window, though, to see all the people in their fancy dress. The best-dressed person was a man called "Egg." He would wear those three-piece suits with a vest over the sleeves. Sometimes the sleeves were sewn right into the vest. That was kind of cool, and it started me to look for that kind of stuff. You couldn't find those clothes so much around Cuthbert. You could go to Columbus, though, and find some nice out-of-the-ordinary stuff. In fact, my whole life I've been looking for suits like the ones Egg used to wear, and I'm still looking for them. All the other people up in that club were fashionable too. I didn't know anything about New York and Broadway back then, but as I look at it now, and if I had to compare it with something, that's what it looked like. It looked like you were in a club on Broadway, with all those bright colors that you wouldn't normally wear, iridescent colors, and the women had on these fancy hats.

Egg was an excellent dancer. He was disabled, but he could dance. He used to swing those girls, and I was standing there in the window looking at him do it. I learned how to swing dance, watching Egg through the window. I wanted to dance like him. I already knew the chicken, and the jitterbug, and the slop. I had those down pat, but I had never learned how to swing a girl like Egg did. He was swinging those girls, and he could spin and be on time, catch them and pick them up. It was just a great thing to watch. The Dirty Spoon Cafe was a place you could see that kind of dancing. For years, when I would go to parties, I'd look for a girl who knew how to swing dance. I can tell if a girl can swing. I'd see her movement on the floor and I'd go over, tell her I can swing, and ask her to dance with me, and we'd get out on the floor and start dancing.

Around the corner on Andrew Avenue, and way back off the street, sitting on a mud hole, was Cat Odom's Cafe. To get into the café people had to walk around the mud hole and try not to get that red mud on their shoes. That was one of the drawbacks of his

place. Cat Odom was a big-time shot dealer, selling shots of whiskey. His place was a cramped little joint, shoulder to shoulder in there, mostly older people, and they played all kind of games. I didn't spend much time there, because there was no room for dancing.

Bubba Duke and Feet's, now, anyone could go in there, adults and kids. Feet's name was Randall Wiggins. I can't think of Bubba Duke's name. He died about ten years ago. He was older than Feet, but Feet died first. They had a very nice place on Hamilton Avenue. It was called the Big Apple Tea Room. My friend Eddie C.'s parents let him go there, but they wouldn't let him hang around other establishments. Eddie C. remembers being obedient: "My mother didn't want nobody putting nothing on me. You know, people would claim you did this and you did that—White people, I'm talking about. She didn't want me involved, and I didn't go. But the Big Apple was run by people my mother and father knew."

The Big Apple was the best place to go as a teenager, if you loved dancing. There was good soul and R & B music on the jukebox—Major Lance, Rufus Thomas, Gladys Knight, B. B. King, James Brown—and they would play it for you. You didn't have to put money in the jukebox. All they wanted was for you to buy soda pop, milkshakes, and floats.

Bubba Duke and Feet were both real tall guys, and they used to play basketball. Every evening, Monday through Friday, we went to a place in the field where they had a basketball hoop. It was a dirt court. The best basketball players in the area would go down there. Every chance I got, I went there to play basketball with those guys. You had to wait your turn, and nobody was going to pick you to play unless they thought you could help them win. I'm not a tall guy, so I decided I had to have a game that didn't depend on how tall you were. I decided to outfinesse them. I had an edge—I was "wrong-handed," as we called it back then. It's a difficult thing to play basketball against someone who's left-handed. I found a way to shoot the ball, because I was hard to guard. So that was my strategy: to be a finesse player.

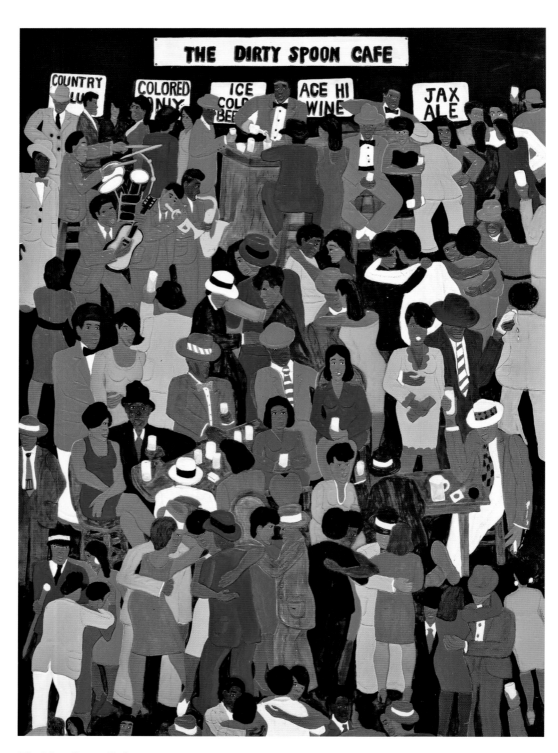

The Dirty Spoon Cafe

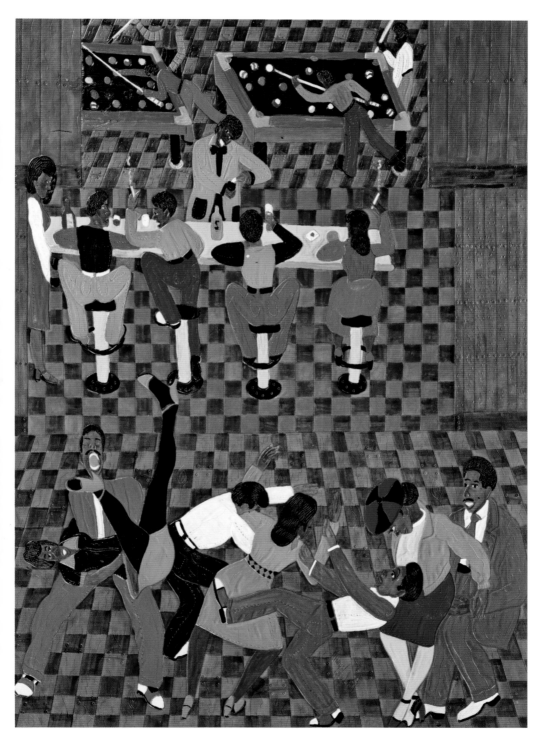

Homer Clyde's Place

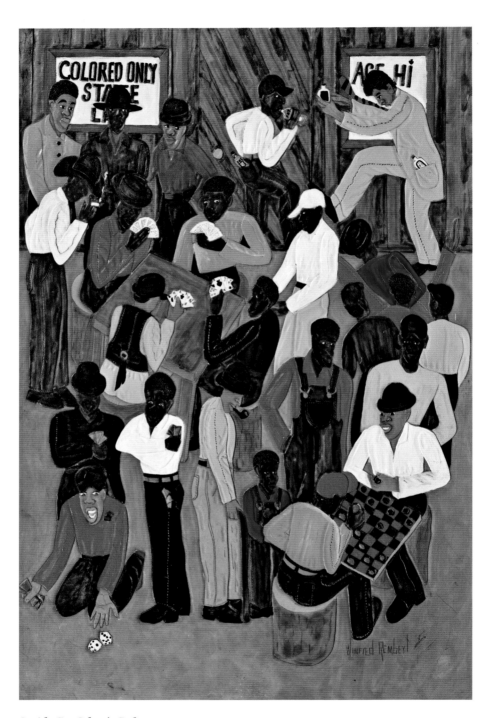

Inside Cat Odom's Cafe

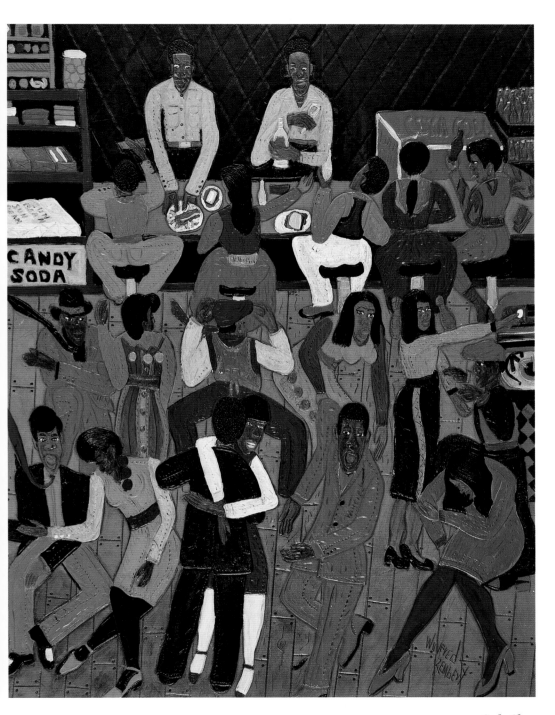

Soda Shop

In my life it was the same thing. In my life, I've thought, *I got to find a way to make myself successful by getting out of what has been planned for me into something I want to do myself.* Patsy has always told me, "You got a lot of talent. You could do a lot of things, Winfred. You just got to *do* them." Bubba Duke and Feet thought so too. They thought I should be in school playing for the basketball team.

There was this little guy who use to come to Bubba Duke and Feet's. They called him "Honor." He would just sit there all the time and watch the girls. He couldn't talk. He never said anything, but he would sit there. He couldn't laugh either, but he would try. He would smile and try to laugh. Honor was autistic, and Bubba Duke and Feet knew he had a problem. They would go up to him and they'd say, "Come here, Honor. You want to dance with this girl?" But Honor couldn't dance. He wasn't a dancer. He would just hold a girl's hand. He would smile and they would do their little dance movements while they were holding his hand. Bubba Duke and Feet started that and everybody thought that was real good for Honor. That's the kind of place it was.

Miss Annie Bell, Joe Mack's wife, had a juke joint called Joe Mack's Cafe. I could hear her juke joint from the house where I lived with Mama, once Mama finally got off the plantation. When I wasn't sleeping in the pool hall, or hiding in the cemetery, I stayed with her. I was a good dancer, and I danced in Joe Mack's Cafe all the time. And Miss Annie Bell would tell me when the jukebox guy was coming so I could tell him what records to put in the jukebox. When the place was heating up, it was time to go over there. That music was calling me. When that music—that *boom didda boom*—started, *maaaan*...and James Brown squealin'. That juke joint was calling me, yes it was, and I just couldn't sit still. I'd say, "Mama, I just got to go up there and see what they doing at the juke joint."

There was this old guy who hung around Miss Annie Bell's place. His name was Jessie Deloney. They called him "Poppa Screwball." Poppa Screwball was the best dancer in the world. He

was better than Egg, even better than Bill "Bojangles" Robinson. Bojangles wouldn't have liked him. They could have a floor full of kids out there dancing, and Poppa Screwball would break through that door, he would slide out there on one foot, and everybody would stop dancing to look at Poppa. And, boy, he was working. And what was so great about Poppa—I'd never seen anybody do this, professionally or whatsoever—he had sayings with his dancing. He talked when he was dancing. Poppa'd be dancing, then he'd stop and he'd say, "I got a girl live down on Highway 51." Then he'd make another move. "Down on Highway 51, she got gold in her mouth. She got gold from ear to ear." That means she got gold on every tooth. "She got gold from ear to ear. And she got a *Roman seat*." You know what that is? A big ass! And that's as far as I'm going with Poppa.

Poppa had a daughter named Tot who drank a lot. Tot Saul. She was a big light-skinned Black woman. She carried a razor inside her dress and she threatened a lot of men when she was drinking. I've seen Tot beat up on some grown men, that's how big and healthy she was. She wasn't fat, just big and healthy, big arms and thick chest. She lived in a little shack right close to Joe Mack's Cafe and she sold moonshine. After I moved to New Haven, in 1987, I went back to Cuthbert, quietly, a few times, and she would get crazy if I didn't come to see her. She wanted to talk about "back in the day." I kind of liked that, so I would go by her house.

Now Tot's sister married a guy named Nelson Johnson. He was a cabinetmaker, and he did beautiful woodwork in his house. Nelson nicknamed himself "Nigger Ned." I don't know how he came up with that, but everywhere he went he wanted people to call him that. A few years ago I took my friend Phil McBlain to Cuthbert, and we were talking to Ned. Ned said to Phil, who is White, "Call me 'Nigger Ned.'" I laughed and said, "Go ahead, Phil, call him 'Nigger Ned,'" and Phil said calmly, "No, I'm not going to do that."

Nigger Ned tried to court my sister Loraine. He used to come to the house to visit her, and Mama put a mirror on the wall so she could sit in her bedroom and see what Ned was doing in the living

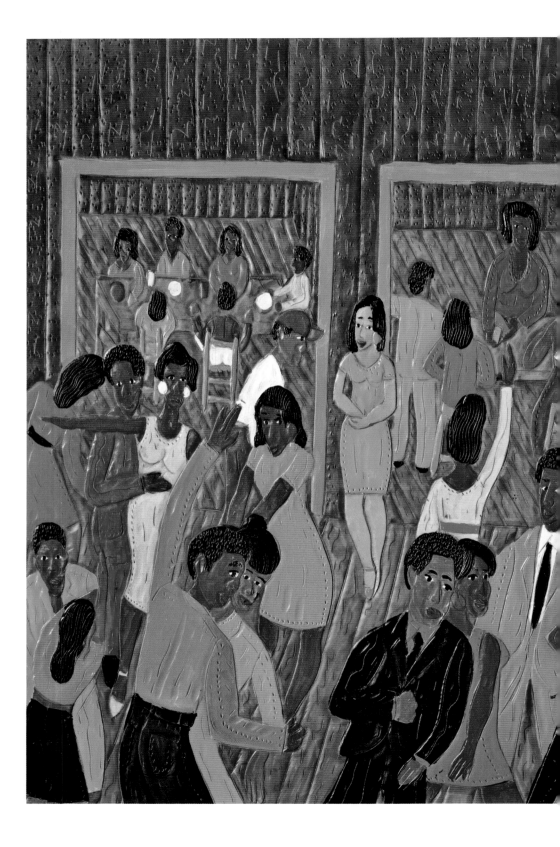

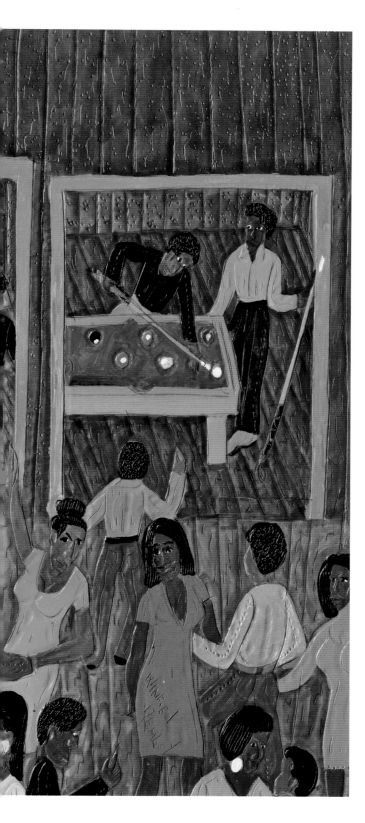

Bubba Duke and Feet's Pool Hall (Winfred Dancing)

room. Ned wanted to make a move on Loraine, but he couldn't do it because when he looked up in that mirror, he was looking right in Mama's face.

Poppa Screwball was the best. He was an *entertainer*, a backwoods, country-boy entertainer. Mama had a part in raising him, because he didn't have no good home. He stayed with Mama, before she got me, until he got to be a grown man.

Now Poppa was a logger, cutting trees down in the woods and loading them on a truck. He would put this chain on there to hold them and keep them from falling off. Then he would take them to the sawmill and cut them up. One day the chain broke. The logs fell on top of Poppa—big, long trees, thirty feet long—and broke both of Poppa's legs. He got well, but after that he walked with a limp. And wouldn't you know it, Poppa was a *better* dancer after that. He was amazing. He walked bent over, but he could straighten himself up when he started dancing. He could slide out there on the floor with them broke legs and you would never know that his legs were ever broke.

There was Black Masterson's place. Black Masterson copied himself from the TV show *Bat Masterson*. He was the only Black guy I knew that could walk around town carrying a weapon, *visible*. He had on a Western suit and a derby, and he carried a pistol, just like the cowboy days. One day he asked me, "Did you ever see a nigger with this much money?" and he pulled a wad of bills out of his pocket and spread them out in front of my face. I'm talking about a pocketful of money, and he was right. I'd never seen a nigger with that much money. He had enough *nerve* to say that kind of thing, and when he walked around town, he was strutting like a rooster. He was just so proud of himself.

Black Masterson had a reputation for hitting people with a horseshoe that he carried around in his hand. If he'd get in an argument, he would throw that horseshoe and it would hit you upside the head before you knew what happened. Not too many people would

hang out at his juke joint. I went there a couple of times, though, because I started a dance group and we went around to all the juke joints. There were five of us, like the Temptations, and we had a little act. There was Sylvester Starling; he had a nickname, they called him "Hog." Eddie C. Howard, they called him "Juicy." There was Robert "Poonk" Carter, a boy named Albert Bass, and myself. We would go all around, every which way, dancing. Juke joint to juke joint, all over town. People would put money in the jukebox when they saw us coming in the door because they wanted to see us dance. And that's how we ended up in Black Masterson's. He put money in the jukebox to see us dance. Sylvester "Hog" Starling, Eddie C. "Juicy" Howard, Robert "Poonk" Carter, Albert Bass, and me. Albert died in a swimming accident. It was very sad. After that we didn't put anybody in his place. We continued the dance group, with just the four of us.

The guys called me "Pike Head." They said I would shoot the basketball like a pike. I had a classmate we called "Sugarlump," and he was the one who started the "Pike Head" thing. One day Sugarlump said, "Look at that pike head nigger shoot that ball," and I carried the name ever since.

We took up dancing, as Poonk tells it, because we didn't have nothing to do when we were coming up. We used to stay up at night, on his front porch, practicing dance steps. We got to be really good at it. There was a TV show in Columbus, Georgia, every Saturday morning. The emcee called himself "The Deuce," and the show was called *Rockin' with the Deuce*. They would invite people from the area to come and dance. My dance group frequented that show. We would go there and tear the place *up*. The Deuce had a group too, called the Deuce Dancers. There were four or five of them, just like we had, and they were good. We watched them closely. I was doing the choreography for my group, and I'd say, "OK, boys, we're going to put this in there. We going to add this and that kind of thing the Deuce Dancers don't have." We would go up there and do them little special moves and, I'm telling you, we turned the place *out*.

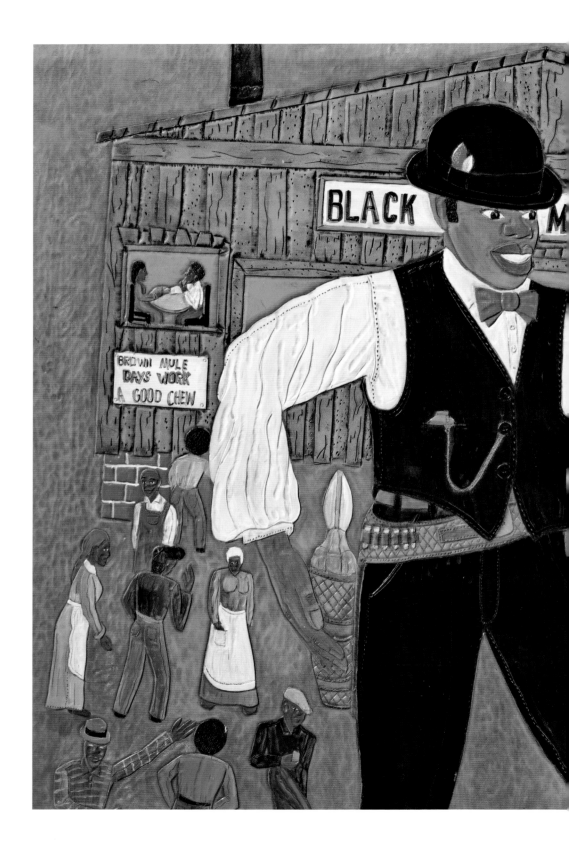

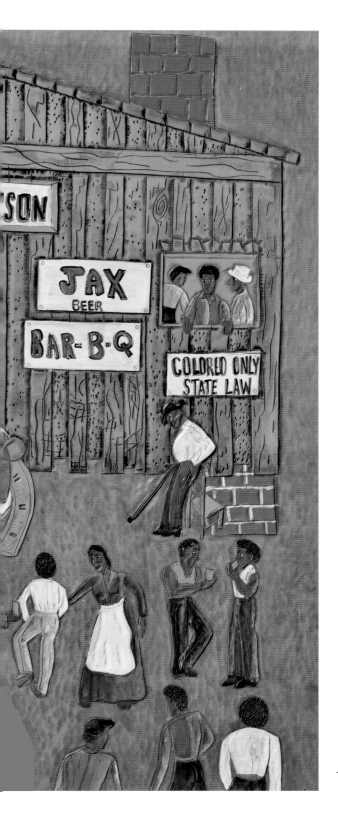

Black Masterson

*

In Cuthbert, I met a girl. I'll call her Pugie (pronounced Poo-gie). She was a nice-looking girl, about 5'3" and shaped like a Coca-Cola bottle. She was older than me—six or seven years older. She was a really nice dresser, and I liked that about her. She carried a woman's bag and wore high heels. Pugie had a crush on me. Every time I saw her she was by herself, and she was watching me all over the place. I felt kind of nice about her being older, with a crush on me. She followed me everywhere I went. Juke joints here and there, where I danced. She would be there, in front, waiting until the juke joint closed. Then she wanted me to go with her—sometimes I did, sometimes I didn't. There was this empty building very close to Mama's house where people would bid on cows and hogs. It was fixed up nice, with seats for the cigar-smoking big shots to sit and bid. We would sneak in there and stay until three or four in the morning.

Pugie and me were a secret. I was a young boy, maybe fifteen years old, and she had a lot of experience on me. She could have got somebody else if she wanted to, but she really liked me. I'm talking about really *really*—to wait until the juke joints close, one o'clock in the morning, waiting, and she give me that look. Never said a word, just gave me that look.

Duck had a brother named Super. Super was an excellent pool player. He was the only guy in Cuthbert who could beat me shooting pool. There was another guy, though, that came through Jeff's poolroom from out of town to repair pool tables. Jeff said to me one day, "The best pool player in the world is coming through tomorrow to fix the pool tables. His name is 'Raincoat Red.'" Raincoat Red wore a raincoat and he looked like an Indian. "Don't play him," said Jeff, "'cause he'll beat you." Now when Jeff said that to me, it got me going. I just had to play this Raincoat Red. So Raincoat Read come in to fix those tables, and I walked up to him and I said, "Excuse me, Mr. Red. I'd like to play you."

"Can you play?"

"Yeah, I can play."

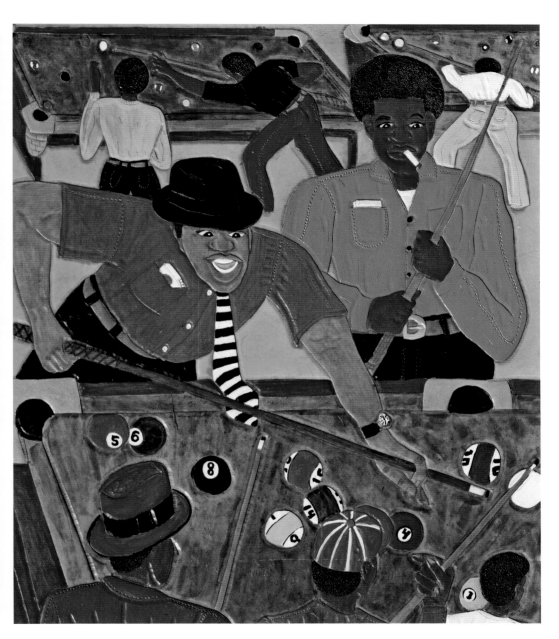

Winfred's Pool Room (with Raincoat Red)

We were going to play a couple of games of eight ball. He told me to crack the balls and I did. Then he began to shoot. Raincoat Red was playing balls all over the table, sinking them every which way. He played game after game—two or three games—and the whole time I'm just standing there. I never even got a chance to shoot. The last thing Raincoat Red said to me was, "Boy, I didn't get a chance to see you shoot. I don't know how good you are," and he walked out the door. That was something. I even did a picture of him, leaning over the table shooting, with me standing there watching him.

Perkins Funeral Home was owned by a man named Alex Perkins. People called him "Buddy." Buddy Perkins would come to the poolroom every day about ten o'clock a.m. If he didn't see me, he would go straight to the jail to see if I was locked up. One time when I was sleeping in a car, the police got me and took me to the jail, and Perkins came and got me out. Grayceda Prather, my teacher's daughter, recalls her father and Buddy Perkins being real close. She remembers Perkins helping kids in the neighborhood, and that when people couldn't come up with the money to pay for their loved ones to be buried, he'd do it and not even charge the family. He had a big part in Cuthbert politics too. He was outspoken and he knew a lot of influential people. Grayceda told me about a time when there was an incident, a Black man had been accused of something, and Perkins had to go to court to testify. "If Mr. Buddy Perkins had not testified, that man would have gone to jail. He paved the way for people here in Cuthbert."

Hamilton Avenue was just fantastic. It has a hold on me, even now. Being introduced to Hamilton Avenue was the best thing that's ever happened in my life. It was and still is. I never had such a good time. I go there now and look at the old buildings falling down, places I used to go, and there's nothing but memories. I think the reason Hamilton Avenue meant so much to me, in my youth, goes back to the love part of my life. I mean, not receiving my mother's love. I think my mother followed me, in my mind, everywhere I went. I needed her love. So when I was getting that love from the

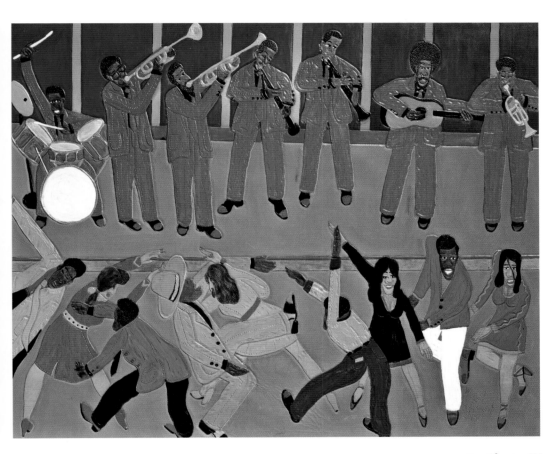

Ben Shorter IV

people, I was getting something I never had. The people treated me so well, it was like I was a movie star or something. Everywhere I went during that era, every place I went in and hung around, I got that love, that kindness from the people.

Johnny Frank James. I don't know what happened to him, but I do know he took me and introduced me to things I had never seen before, all the life that I never even knew existed among Black folk, and White folk too. That was a *big* thing in my life. It was like I busted out of a paper sack. I had been locked inside a different world. I couldn't go nowhere unless the White man said I could. But I had strength enough to cross over that invisible line that was holding me. I had strength enough to walk out of there and to walk away, and I walked into Duck. He introduced me to another world, a world other than picking cotton, a world I didn't know was there.

I can't understand how Duck entered my life like that. He was just another person, a friendly guy. We were buddies and then he was introducing me to Hamilton Avenue and it opened up my life. I rate that over my success as an artist. Hamilton Avenue came into my life and made me a different person. I was able to put the cotton field behind me and never go back. I found something that was so different and so good. A lot of good things have happened to me, but it seemed like Hamilton Avenue was the best. Nothing can match it. Nothing. I walked from one world into another when I came out of the cotton field and discovered all those smiling faces, all those people doing well and not picking no cotton.

THE EVERYDAY LIE

Hamilton Avenue is a straight street. There's not a curve in it. It's just as straight as an arrow. It starts off in a place called McDonald Woods, which is a Black community, but not all of Hamilton Avenue is Black. On the upper end, not far from McDonald Woods, is a community of White folks. There was a store on that upper end of Hamilton Avenue called the Wilson Brothers. It was owned by three White guys who were very prejudiced. All of their customers were Black, and they hated Black people.

One day, around 1951, soon after Mama moved into town, we were in the Wilson Brothers store and one of them said to her, "Lillian, I see you got your grandson with you."

"Yes, sir, Mr. Wilson."

"Lillian, guess what? He'll never be a damn thing in his whole life. Is that right?"

Mama stopped for a second and then she said, "Yes, sir, Mr. Wilson, that's right."

We got our stuff and left.

I think Mama answered Mr. Wilson in a defensive way. She couldn't say, "No, sir, Mr. Wilson, he's going to be a lawyer." Or, "He's going to be a doctor." She couldn't say I'd be successful. She had to downgrade my life in order to satisfy the Wilson brothers. That really told me something as I moved on in my life. Though I didn't see it clearly at the time, I understand it very well now. It told me that in the eyes of some people, I was nothing, and that it was a losing battle trying to be somebody.

On the lower end of Hamilton Avenue, there was a sign, just as you are going downtown, and the sign said "Nigger Corner." It had

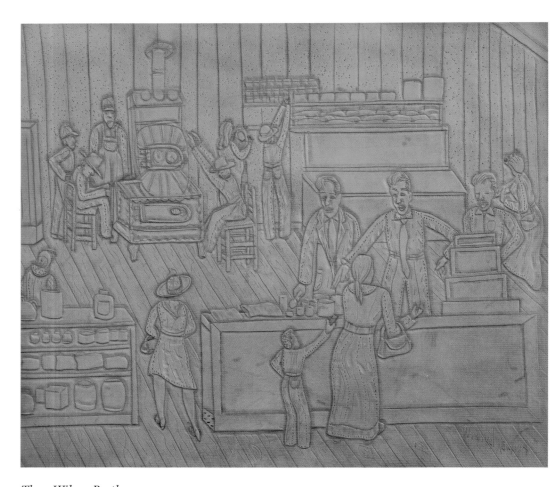

Three Wilson Brothers

an arrow on it, pointing which way to go. What was known as Nigger Corner was downtown. The Black-owned shops were on Hamilton Avenue, and the Whites owned all the Nigger Corner stores. There was a part of Nigger Corner where White folks shopped and another part where Black folks shopped, just like everything else when it comes to Black and White. Blacks would shop there because they had some things you couldn't get on Hamilton Avenue, especially meats. If you wanted to borrow some money from White folks, or get some groceries on credit, that's where you would go, to the White-owned shops on Nigger Corner. Even the Ku Klux Klan had a restaurant there. They had their flag up—a Confederate flag—and they wouldn't let you come in the front door. They had a little hole in the back door that they'd open, and that's how they'd serve you. I didn't pay it no mind. People would be waiting in line at the back window, and I thought that was the way it was supposed to be.

Farther down the street was a drugstore, which had a soda fountain. My classmate Rita Etheridge went there with some White girls and tried to order a soda at the counter, but they wouldn't serve her. That's the way it was. The grocery stores even had a special soda they sold to the Black man. The Coca-Cola was a White man's drink. The Black man's soda was called Lotta cola. *L-O-T-T-A*. It was a sixteen-ouncer, bigger than all the rest of the sodas—big enough to look dumb. "There go that nigger; he's drinking a *lot* a cola!" God almighty.

I painted *Saturday Shopping Day* to display Black life. I thought people might like to know about it. When I was a child, Mama would take me downtown. I loved all the characters. You've never seen so many Black folks on Saturday morning. If you were looking for someone that you hadn't seen all week and you wanted to see them, that's where you'd find them. Some of my first memories of Cuthbert are of Mama taking me to Dedie Mack's. McPherson's General Store had groceries, including country sausage and live chickens and, on the side, there was a toy department. Mama would go there to shop for groceries, and Dedie Mack didn't care if I played with the windup trucks and trains. When I got bigger, I thought he would stop me and

OVERLEAF: *Saturday Shopping Day*

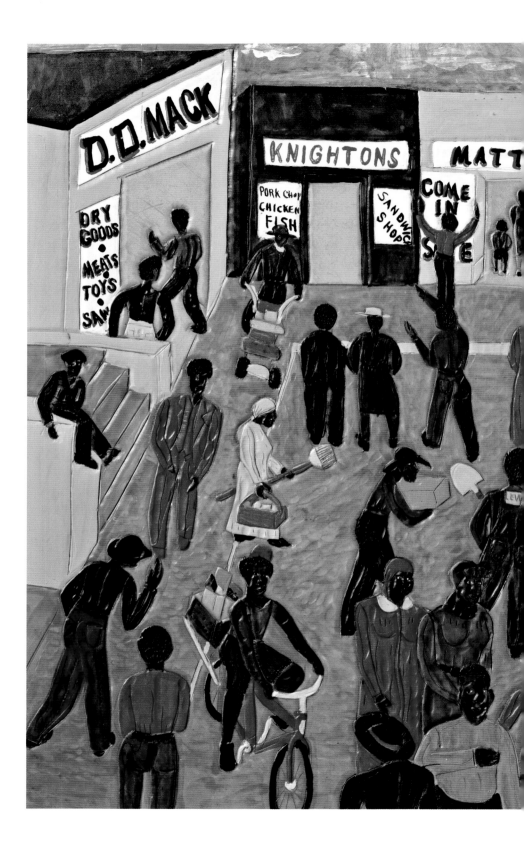

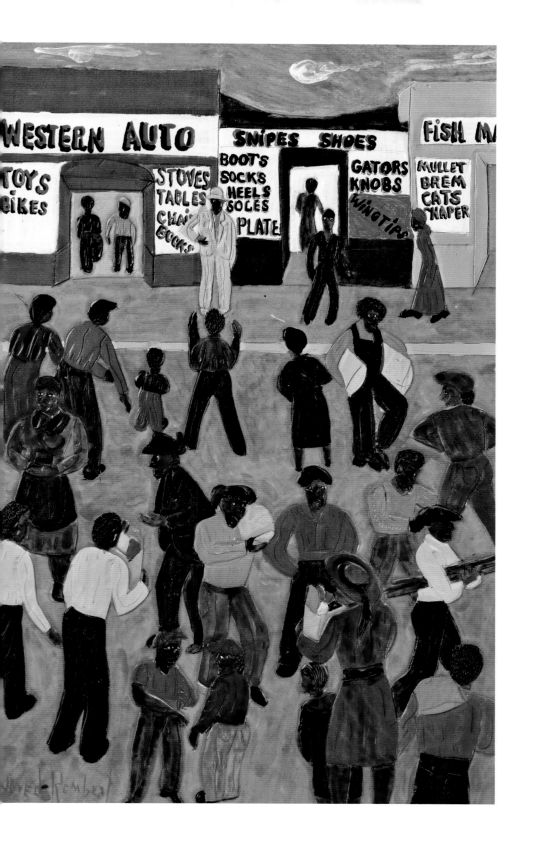

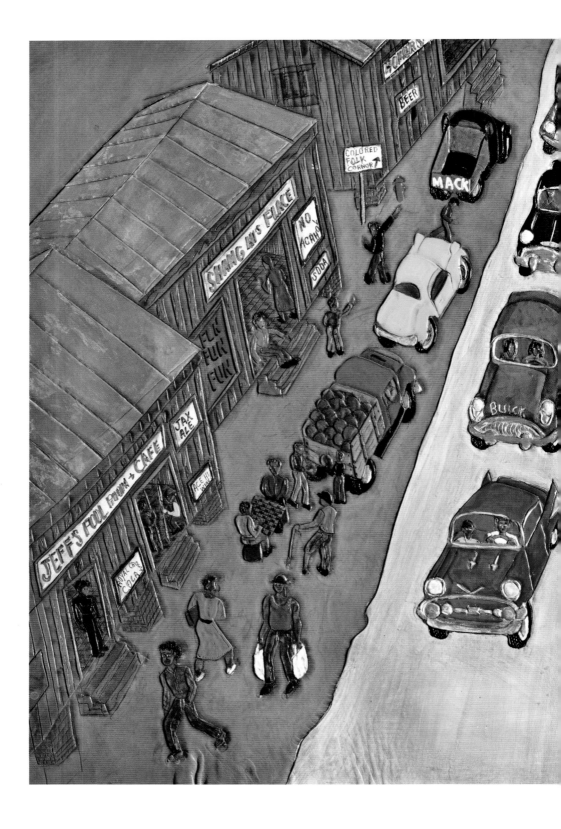

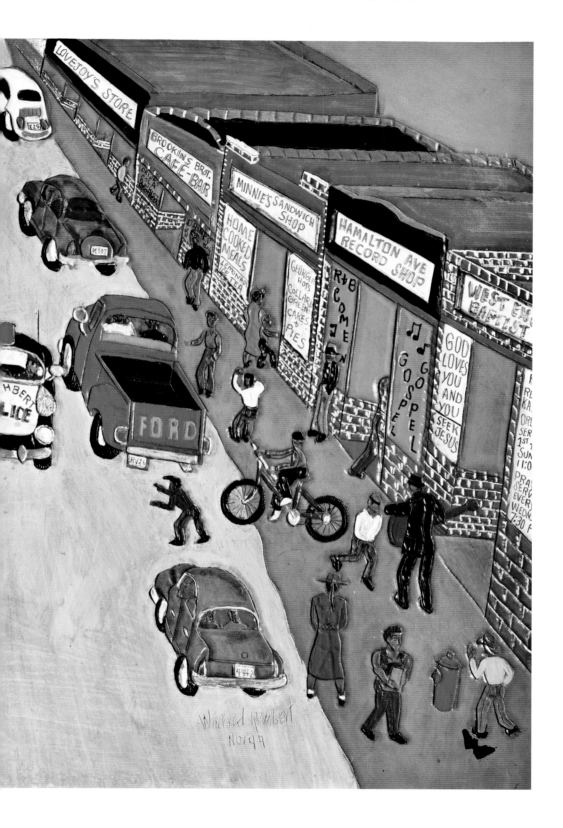

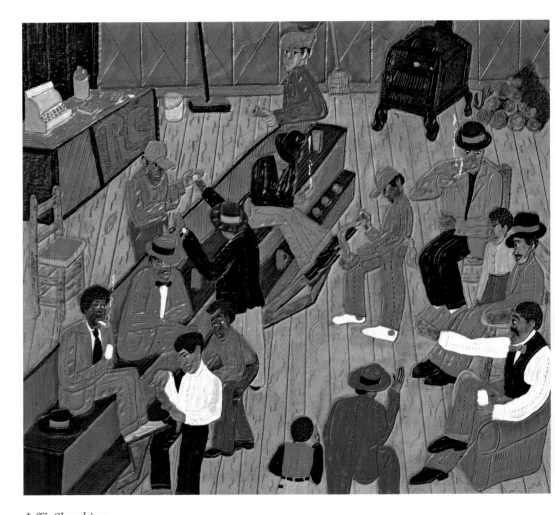

Jeff's Shoeshine

PREVIOUS PAGE: *Hamilton Avenue*

the other Black kids from playing there, since he was a prejudiced guy, but he never stopped us.

Back on Hamilton Avenue, down the street from his pool hall, Jeff also owned a shoeshine parlor, which was very good. I used to go in there and shine. We had a good business of shining shoes, and Jeff would give you a percentage of what you made. On Sunday morning, people would get their shoes shined because they were going to church. Having your shoes shined on Sunday morning, in Jeff's shoeshine parlor, was a big thing in Cuthbert, Georgia.

One Sunday morning this White man came in. The place was packed with Black folks. This White man came in and he kicked this Black guy all over the place like he was a football. The White man was kicking him, calling him a nigger, and the Black man didn't fight back. It was a bad scene. The White man kicked and beat the Black man all the way out of the shoeshine parlor, and even though the place was *packed* with Blacks, not one person helped him. The guy was kicked out of the shoeshine parlor and people just went back to shining shoes.

Can you imagine that? A White man can come into the shoeshine parlor and beat up a Black man, and I'm standing there looking, with fifteen other guys. Picture that in your mind. I'm standing there with my shoeshine rag in my hand and I'm just looking at that White man, and he's going *crazy* in there beating up this Black man, in my face—right in my face. I'm scared to do anything, and I'm looking around for some of those *adult* guys to do something, because I'm just a boy, shining shoes. I'm looking for some of those other Black men to do something to stop this man, but they didn't. You know you want to help, your heart pours out, and there's nothing you can do but just stand there and look. What if I had hit the White man? Or grabbed him and threw him down? What would've happened? Would some of the Black guys have tried to stop me? What else might happen? That was just a situation where you couldn't tell what would happen. If I had hit this White man, I would've had some kind of problem. That's the way I was looking at it. And guess what? The people didn't even conversate about it.

I carried that with me. I learned something from that. I learned: stay in your place and you're safer. You won't get into trouble. I'd like to think some of the older guys should have helped him, but when you jump into something like that, you have to think about the aftermath. What would happen next—hours after, or days? Would the White man go and get a lot more White folks and come back and tear up the place? The afterward is what you have to worry about. I was old enough, and I had sense enough, not to butt into that. White folks did what they wanted to do. It may be hard to understand if you never lived in that world. People looked at you as *nothing*. They think they can do anything to you and it's all right. As my friend Charlie Brookins tells it, "Parents tried to keep their kids close to home so they wouldn't get in trouble with White people and wind up in jail, or missing, or dead. Sometimes people disappeared and no one knew where they were." If you didn't live in that world, *thank God.*

When I was a little boy, just old enough to be walking by myself, I was walking along a dirt road, near Annie Bell's café, just before you get to the Wilson brothers' store. I heard a sound, and I had been around enough time to know a pickup truck sound when I hear it. I hear a truck sound, and it's coming behind me hard, making a lot of noise, like the muffler had gone on it. It pulled up beside me and hit its brakes. I'm going to say two men in the truck and three or four little boys, my same age, on the back of it.

The driver said, "Come here, nigger." Back then I was small enough not to deny that I was a nigger. I knew myself as a nigger. Nobody had told me I wasn't a nigger, and a lot of people had told me that I was. So when he called me a nigger, it didn't mean nothing to me. I walked over to him and he said, "Nigger, can you whistle?"

"Yes, sir, I can whistle."

"Whistle, then."

I was scared. I tried to whistle and I couldn't get that whistle out.

"Go ahead and whistle!"

You should have seen me trying to whistle. I was trying to whistle and I just couldn't get it out. The White man started laughing. He looked back to the little boys behind him in the truck and said, "I told you a nigger can't whistle 'cause his lips is too thick." It seemed to me he was putting emphasis on what he was saying so they wouldn't forget it. They drove off and I had tears running down my cheeks.

I tried to stay out of White folks' way. There was a laughing barrel on the town green. White folks call you—"Come here, nigger!"—and you walk over. You have no idea what they're talking about. One of them would tell you a joke, and you'd have to stick your head in that barrel and laugh at the joke. It would be some old crazy joke about yourself, something you didn't want to laugh at but they thought was funny, and you'd have to laugh. I never had to laugh in the laughing barrel, but I saw people getting humiliated in front of their family, in front of their wife and children. And you could be punished if you didn't laugh in the laughing barrel. They had some crazy name for the crime of refusing to laugh in the laughing barrel. They'd give you six weeks and make you clean up around the city. They had a lot of six-weeks crimes in my hometown. Now what would you rather do, stick your head in the laughing barrel or go to jail for six weeks?

There were a lot of things that degraded Black folks. In downtown Cuthbert was something they called "the calaboose." I've never seen it anywhere except in Cuthbert, Georgia. The calaboose was a small room built onto the back of the town hall, across the street from the county jail. It had four cells and a dispatcher's office, where you could pay your fines when city hall was closed. Now if you were staggering around drinking, or you looked drunk to the police, or you got into an argument with another person, they would put you in the calaboose. You'd stay there the entire weekend, until Monday morning, when they'd take you to the county jail and you'd wait to see the judge. I saw it happen to some of my friends—or my friends' parents, let me put it like that. Maybe not my friends themselves, but

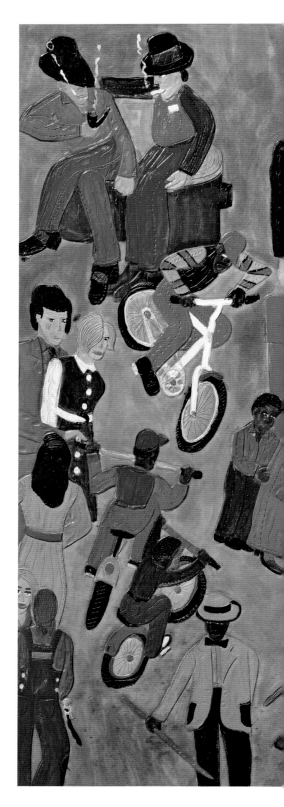

The Laughing Barrel

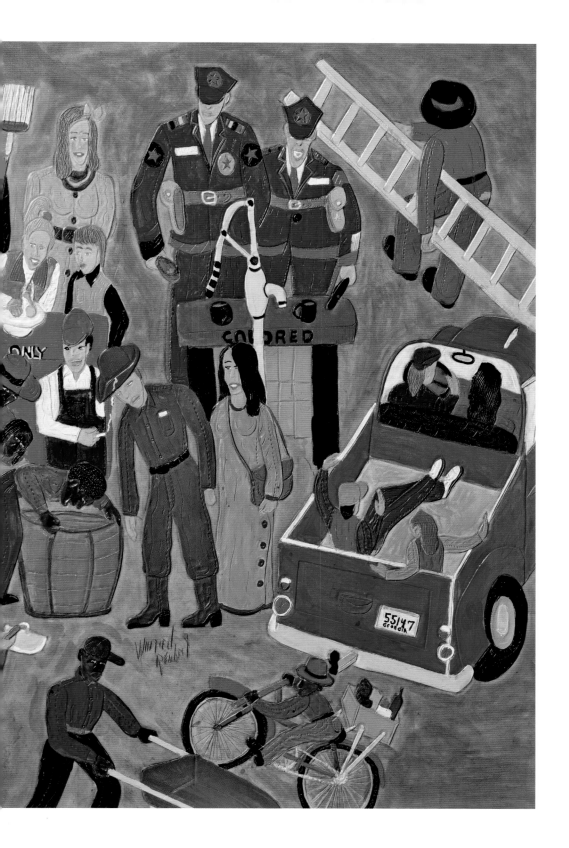

their parents got locked up in the calaboose. There was no bond. You couldn't sign a person out. Once you got locked up in the calaboose, you were in there until Monday morning, automatically.

How did they come up with all that? Is there a group of White folks who just sit around every day and figure out what to do and what to say to a Black person to degrade them? How do they come up with all these things? Who came up with the word "nigger" and gave it its meaning? They'd also call you "Auntie" and "Uncle," "coon," and all that kind of thing. The older I got, the more I wanted to stay away from downtown Cuthbert, because there were always some hecklers around the square, in the laughing barrel area. All those White folks, standing around in the town square on the green next to a statue of a Confederate soldier, thinking about what they could do to Black folks. They had nothing better to do? In fact, last time I was down there in Cuthbert, that statue was down on the ground. Someone had ran over it and broke it. A couple of White people from Andrew College took me there to show it to me. I pretended, sort of, that I hated to see it go down, but I was happy.

There was a movie theater down on the square. They had all the Blacks on the top and the Whites on the bottom, which seemed to me stupid. The Blacks would throw things down from the balcony—ice and all that kind of stuff—on the White folks. Sometimes the police would come upstairs to where all the Black folks were. "Which nigger throwing that ice down there?" But they know damn well you're not going to say, "Yes, sir. I did it." And they always come at you from a confrontational point of view. The Black man's *always* wrong.

In 2010, I met a woman named Daphne Muse, whose father, Fletcher Henderson Muse Sr., was born in 1920 and grew up in Cuthbert. Daphne spent time in Cuthbert when she was growing up. "Cuthbert was rough," she says. "Every single day, those Black people in Cuthbert had to figure out, *How am I going to navigate this today?*" Daphne's husband asked her father, in 1996, whether he could record his oral history. Her father's response was, "No, absolutely not." There were too many secrets and he was not willing to revisit the pain.

*

I can't understand why White people went through so much to degrade us and to hurt us—all that to keep us from becoming anything in life. Why was that so important to them? Why don't you want me or any other Black person to be somebody? What made you that prejudiced? What makes you hate another person in that manner? I always wondered that, and I still haven't come up with an answer. Why is it so important to say those things to a Black person and to hold him back? Why do you not want me to go to school? Where did you come up with the idea that a Black person is nobody? I'm still wondering. Poonk—Robert Carter—calls it the "everyday lie"—people living every day as though White people are superior.

Poonk joined the military after he graduated from high school. He served in Vietnam and came back to Cuthbert in 1969, after his first tour of duty. He walked into a store and asked for a pack of cigarettes. The shopkeeper looked at him and said, "Can't you say 'sir' to me?" Poonk was so angry, he picked up the cigarettes and threw them at the guy. He was that angry because he was tired. He explained to the man what had happened, about Vietnam, all that he had been through. The guy looked at him kind of funny and Poonk left. Throwing that pack of cigarettes was risky, but after living through a war, coming back to the South was too much. Poonk was just tired.

When Mama moved to Cuthbert, the house her son J.T., "Boy," built for her was in McDonald Woods, on the upper end of Hamilton Avenue, and I was living there with her. J.T. used to come and visit us every Friday. One time we were walking down Hamilton Avenue. Two White policemen come up behind us. Boy's back was turned and they snatched him around. They hit him in the face with their blackjack—a whip of leather strips sewn together around a piece of metal. They hit him in the face with that and his eye fell out. His eye fell right out of his head. Then they said, "Whoa, wrong nigger!"

We ran to the hospital, but the doctor didn't even try to save Boy's eye. The eye was hanging and the doctor took a scalpel and cut it right off. That was cruel. It was so cruel. And Boy had to go on without an eye for a long time, fifteen to twenty years without an eye, until he got a glass eye. I remember that glass eye coming in the mail. They didn't bother to bring it to him. They shipped it. He put it in every day and took it out at night, and he said the doctor told him the longer he put it in water, and if he kept it there in the night, it would grow veins in it. They told him some old stupid stuff like that. "If you put it in water every night, it will soon get veins." J.T. was supposed to believe that and, well, he did believe that.

I carried this all of my life, all of these things that happened to me—seeing Black people getting beat up here and there, seeing Boy lose his eye—all of those things I kept inside of me. My thing around Whites was to be humble. Even if you didn't want to be humble—be humble just to get out of the situation. You could be thinking you want to hurt somebody, deep down inside of you, but in order to get out of the situation, so you don't go to jail or get beat up, be humble. But being humble did not express my true feelings.

I didn't realize that by keeping my story inside so long, it would change my life and make me sick. I didn't realize that keeping it inside of me would interfere with me like it has. I think it hurt me to keep my story inside of me. I can't sleep. I have nightmares. I'm reliving all these things I've seen. I think it would have made a difference if I had been talking about it and telling somebody, if I had been out there, all spry, approaching people and talking about what Black folks went through in Cuthbert, Georgia, and what happened to me. Maybe I would be able to sleep at night.

Back then I tried to please White folks. When they talked to me, I knew I had to say, "Yes, sir." I knew how they wanted me to talk. When I was walking down the street, I would carry myself in a humble way. I would fold my arms and look down when they talked to me. I wouldn't look at them in the face. That's what they wanted, and that's what I did, until I got older. When I got older, I got nerve enough not to do that. When you realize that you are being treated

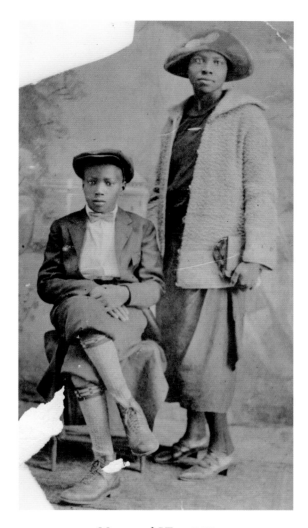

Mama and J.T. c. 1925

wrong, you change your way of looking at things. You may make up your mind that you're not going to put up with that *as much*. You don't exactly *quit* doing it, but you limit the way you do things. You begin to carry yourself differently. When you approach White people on the street, you keep looking at them. You may even turn around and look at them, when you pass them. You build a reputation in the White folks' world when you get enough nerve to do that. "That nigger is crazy, you see how he looking at us?"

DOLL'S HEAD BASEBALL

I collect toys because I never had toys when I was a kid. The only toys I had were the ones I made. Some of my favorite toys now are Teenage Mutant Ninja Turtles, remote-controlled. I take them out on the beach and let those guys surf. They really surf! I'm also a Star Wars collector. I got interested in Star Wars on account of Obi-Wan Kenobi. He was one of the most powerful Jedis, the best Jedi that ever was, even more powerful than Darth Vader. The reason I like him is that he uses his mind rather than his Jedi stick. He uses mind tricks to get what he wants rather than hitting somebody with his sword or shooting them. Like Obi-Wan could approach Jabba's worker and say, "Go get your boss, Jabba the Hutt. Go get him." Suppose the worker says, "Jabba don't want to be disturbed. He says for me not to disturb him." Obi-Wan might say, "Oh yes, you will. You will go and tell your master that someone here wants to see him." And then the worker would say, "Oh yes, I will disturb him."

I have some of the very first Star Wars characters, the little short ones. I got them back when they only cost a dollar. I also have the larger, twelve-inch figures that have a lot of features. It's a nice collection. I have these two Yodas that run across the floor and talk. You can say, "Yoda, teach me to be a Jedi," and he'll talk back to you. "Jedi?! You wants to be a Jedi? Hold your hand up and command." You hold your hand up and he backs away.

A few years ago I bought some BB guns at a tag sale. One of them is a Red Ryder. I never had a Red Ryder when I was a boy. A Red Ryder was the top-of-the-line BB gun. If you had one, you were cool. A lot of the White boys had them, and I knew I couldn't have one. I wasn't even going to *think* about that, but I wanted one so

bad. I had a couple others I found in the junkyard, and I could fix them. When I was seven or eight years old, I could make a handle out of wood for a broken gun.

I made other toys too. My first toy I made from a bicycle rim. You bang all the spokes out of it so you have the rim by itself. Then you get a stick, a green stick, not wider than your finger. You put the stick in the groove of the rim and guide the rim along as it rolls. Sometimes it got away from me and I'd have to run and catch it. I used syrup cans to make something called a "takalaka." That takalaka was a nice toy. You pry the syrup can open and the edge has a lip on it. You string the cans together with wire and use the wire to make a handle. I'd run and pull it behind me. Now when I get to soft dirt, that's where the fun is, because when I run with the takalaka in the soft dirt and turn a curve, the lip of the takalaka catches the dirt and sprays it out with a twirling pattern. Oh, that was pretty.

My best toy was a wheelchair cart. I was in the dump and someone had thrown away a wheelchair. I brought it home and whirled around in it. I rode down the road in it and I'm thinking, *If I'm going fast, I got no way to control this wheelchair*. So I took the front wheels off, made the front end longer, and put bigger wheels on it. I put a rope on each side so I could pull the wheels and turn the cart. I was sitting in that cart, going down Blakely Hill. Kids were looking at me and they wanted to ride so bad. I was over the top.

I can't remember ever seeing a baseball game with a real baseball before I was ten years old. We couldn't afford to buy a real baseball, so instead of a baseball, we used a handmade ball of rags or a doll's head made of rubber. We would collect the heads from old dolls when we could find them. We would take the head off a doll, stuff some newspaper in it. On Sunday afternoon, about two o'clock, Blacks would get together for a game of doll's head baseball. Folks would come from church and gather in the field. Some people would

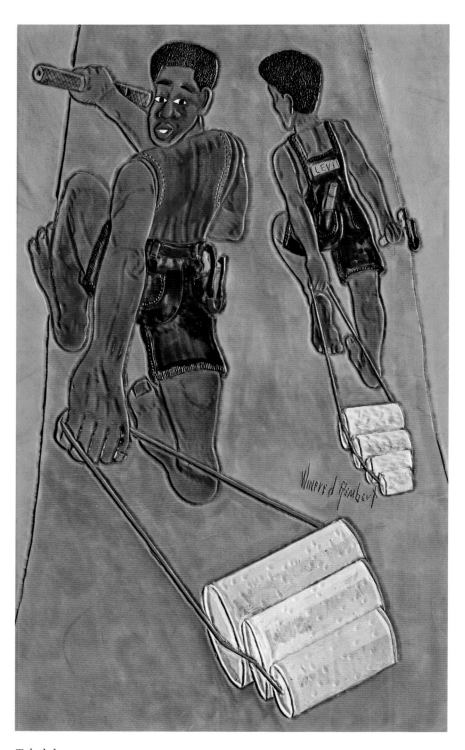

Takalaka

walk, others would come by mule and wagon, and a few would even drive. Doll's head baseball was a big thing for us.

I wasn't old enough to play with the best players, but I sure got lots of joy watching. The players were real hotshot players. I guess you could call them the Harlem Globetrotters of baseball, with their trash talking, fancy base running, and batting stances. They were a lot of fun to watch. They would smack that old doll's head and some guy would take off running and make a behind-the-back catch. My favorite was when it was hit to third base. The third baseman would scoop up the head, throw it to the shortstop or second baseman, and one of them would tag the runner or throw him out. After each fancy play they would do a dance, with each player trying to outdance the other. That really pleased the crowd. I can see that in my head right now. Today when I see football and basketball players dancing in the end zone after a touchdown or a dunk shot, it seems like they've copied their moves from watching doll's head baseball.

Our gloves were made of paper shopping bags. We had a way of folding the bag so it would end up shaped like a glove. We were good at finding ways to substitute for what we didn't have. Sometimes when the batter hit a pop-up, the fielder would snatch off his glove real quick, open it up into a bag, and catch the ball with it. Those guys were crazy. I wanted to play so bad, as a little boy, with those grown men, but I never got the chance. When they were done, though, I would run out there on the field, grab a doll's head, and screw around with it. I could juggle three dolls' heads and got to be pretty good at it.

You know, I thought I was a talented guy, and I wanted to be seen. I wanted people to see me do things because I wanted to be the best. I wanted somebody to say, "Did you see that guy? Did you see him?" In my head there's something, even today, telling me I can be the best at anything I do. I'm not saying that from a bragging point of view. It's just what I want. I want to be the best. I compare other people's artwork against mine, in my head, and I say to myself, *My work is different. I don't think anybody can beat it. My work*

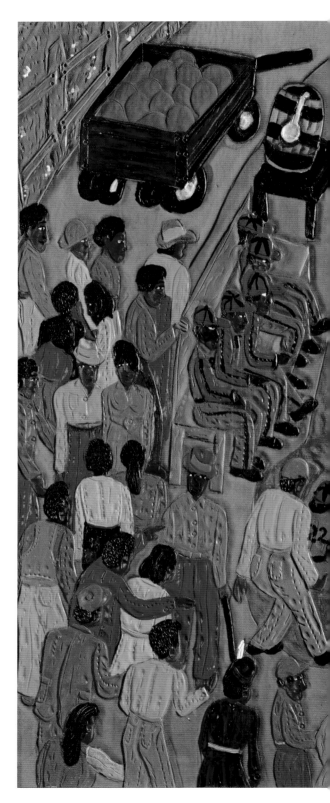

Doll's Head Baseball

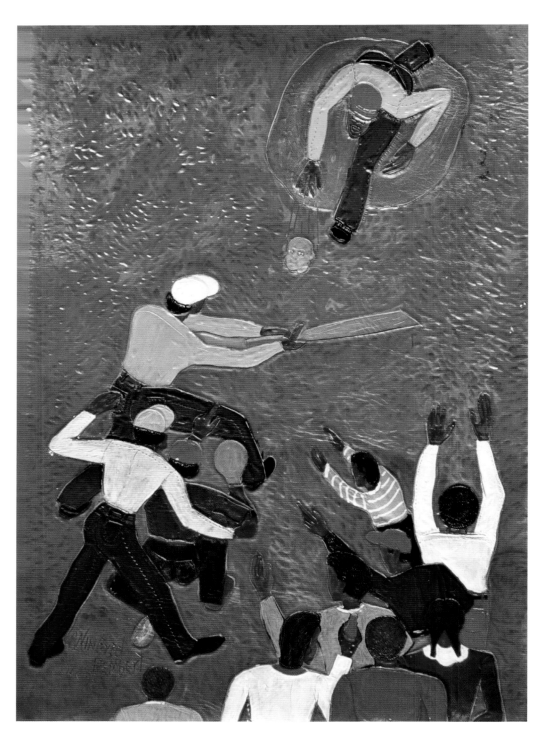

Doll's Head Baseball

is so different that you have to pay attention to it. You have to say, "What is this?" When I'm gone from this world, somebody is going to say, "He could really do his leatherwork." Guys make saddles and do leatherwork on them, guys make bracelets and earrings too, but none do leatherwork like mine.

White folks loved to watch us—to see what we played and how we did it. They would ride by in their cars and see us playing doll's head baseball. They'd go down the road, turn around, and come back. They would park their cars and just stand there watching us. "What's that they doing?" Each player would name a doll's head after his plantation owner: Mr. Knighton. Mr. Mattox. Mr. Shivers. Mr. Dunlop.

"Here come Mr. Sealy—throw him down here. *Let me give him one!*"

"Mr. Sealy—he's in there for a strike!"

"Jack Cravey. Send him down here. Look at Cravey go!"

"Cravey is a *hooome* run! Throw him here! Throw him here!"

"I got you, Mr. Cravey."

Yep, those boys were the Harlem Globetrotters of baseball. If White folks could see them now, it would be worth millions. They were so entertaining. Mama used to tie up a bunch of rags and make them round like a baseball. I don't know how she got it hard like that. And she would soak the balls in kerosene, all night long, take them out the day of the doll's head baseball game, and give them to the guys. They would light one and hit it. That thing would go through the air like you shot off fireworks—you talking about fun! Next guy would catch it, still burning, and throw it to a third guy. They would pitch it too, still burning. I don't know how Mama made them so they wouldn't tear apart. On New Year's, they would light those balls and throw three or four at the same time. Patsy remembers how good those balls looked, so good going through the air in the evening. Even though Patsy and I lived in different places, we did some of the same things.

On the Fourth of July, or maybe family reunions, Patsy's people would kill a hog, clean him out, break him—cut down each side so he would open out—and they'd sit up all night to barbecue him on the grill over a slow fire. The women would cook Brunswick stew—a big black washpot full of it—and English peas, corn, tomatoes, okra, stuffing, ice potato salad (we used to say "ice" instead of "Irish"), egg salad, chocolate cake, coconut cake, sweet potato pie, pumpkin pie, and lemon meringue pie. It was a banquet. Once a year in the summer they'd have that kind of feast. That Brunswick stew—I beg Patsy to make it even now. She makes it for Thanksgiving and for Christmas. It's too good. She puts a hog's head in there and cooks it until all the meat falls off the bone. Then she mashes it up until it's squishy. Good Lord, that thing is good. And her folks would make sure everyone got tenderloin from the hog. They'd cut out a piece right down the back with no bones. They'd slice it up and toss it into a big pot full of boiling grease. The pot had legs on it, and they'd build a fire underneath and all around it. You drop that tenderloin in there with that hot grease—oh my God! In five minutes it's ready. Talk about good. Cracklings…oh, Lord have mercy. Those were the things that gave me relief.

IN DEEP

It was 1961 or 1962. I was working in Jeff's poolroom. One day I was surprised to see all these Black folk, especially adult Black men, coming in the poolroom. They were all sitting around, having a meeting and talking about civil rights. I never heard people talking about civil rights before. They were NAACP people, though I didn't know it at the time. I thought they were coming in there to shoot pool, but, lo and behold, they were talking about civil rights. It turned out, if I got it right, that Buddy Perkins, the funeral home director, was the headman of the NAACP in Cuthbert. Jeff was some kind of official too, and Jeff's poolroom became the meeting place for talking about ideas, businesses, and civil rights.

Black people in Cuthbert had to sacrifice to make a change. In the 1950s, Ben Shorter Sr. was president of a voters' league in Randolph County. The authorities in Randolph County would not let Black people vote. I remember Mama talking about wanting to vote, and it was obvious that she was afraid. Ben Shorter and some other folks from Cuthbert—Ulysses Davis and Charlie Will Thornton—worked with an NAACP lawyer named Dan Duke to get Blacks onto the voting rolls. As Ben Sr.'s son Wesley tells it, "During the time my father was meeting with a lawyer from Atlanta, they would meet at our house. The lights would be turned out and they would meet in the back room. There were people outside for protection because of threats by the Ku Klux Klan and others."

The voters' league was successful in court, but after that Ben Shorter lost his job as a mechanic. Charlie Will Thornton lost her job as a schoolteacher. Ben was also the leader of a swing band that had been very popular in our part of the South since the early thirties.

Wesley's brother, Ben Shorter Jr., told me that when his father played in some White places, they couldn't come through the front. He talked about how they all had to come through the back to set up, and how he sat there in this chair waiting on his dad to get through playing. After the voting rights case, it was several years before Ben Sr. was able to get gigs in Cuthbert again.

Ulysses Davis's granddaughter, Naomi Jenkins, lives in Cuthbert today. She remembers sitting on her grandfather's knee in the Albany law offices of C.B. King. "Somebody could threaten your life or threaten your livelihood. It just so happened that my grandfather was a carpenter, so he was able to maintain. You shouldn't have to die for things to be equal and fair, but people died. You should not have had to lose your source of income, but people did. It was very very difficult. The fear was greater than you could ever imagine. Charlie Will. She is my hero. She was very outspoken. She was never able to teach again in Randolph County, simply because of her stand on equal rights."

I had never been to a demonstration or a sit-in. It was all new to me. The NAACP guys talked about how, if you go to the marches, you'd get in the fetal position to keep from getting kicked in the stomach and to keep the dogs from biting you. They taught us to cover our heads if the police were beating on you with those billy clubs, and to fall on the children to protect them. Those were the conversations. My buddies Charlie Brookins and Eddie C. Howard came by the meetings too. Their parents didn't want them to get involved, so they had to slip out of the house. Charlie says there was no way his parents would have allowed him to go to the demonstrations that were going on in Albany. "It was real dangerous back in those times. White people had guns and they were killing Black people in those marches, far more than you would ever think about or that you saw or heard in the news. It was unbelievable. Stuff you read about in a book is on the good side. My mama would have killed me if I had left and went over to Albany."

Later on, at the meetings, people talked about Americus. Americus was a tough one. They had this terrible sheriff named Fred Chappell. He was a mean monster. He was above the law. He *was* the law. He was worse than Bull Connor, the commissioner of public safety in Birmingham who attacked the Freedom Riders. This guy wouldn't bend. This sheriff was kicking Black folks' butts every chance he got, hitting them upside the head with his nightstick and giving orders to turn the fire hose on. Back then they would deputize just anybody that was White and give them a badge, and I'd be willing to bet that some of those people wearing the badge and turning on the hose were Ku Klux Klan.

I heard about the demonstrations in Americus in the early days of the Americus movement, and sometimes I would ride over there in a car with guys from Cuthbert and we would sit around in a place on Cotton Avenue called the Bryant Pool Hall. We would play pool and listen to people talk about strategy and what was happening. In 1962, SNCC (the Student Nonviolent Coordinating Committee) started a voter registration drive. Americus had a population of thirteen thousand. Over half of the people were Black, but there were only three hundred Black people on the voting rolls. Sam Mahone was a high school student at the time. I didn't know him back then. I met him in Albany in 2010. He talks about how he escorted people to the courthouse to register. One day, when he was seventeen years old, he took ten people down to the courthouse. Sam was standing across the hallway from the registrar's office, waiting until each person had a chance to register, when Sheriff Chappell attacked him from behind. "I didn't hear him coming or anything. He knocked me down, literally, with a fist to the back of my neck. I immediately curled into a fetal position, as we were trained to do, to protect our most vulnerable parts, like our head and our midsection, and he commenced kicking me."

People who witnessed what the sheriff did would go back and tell others what had happened. Some people who were standing in line even left the courthouse without registering. As Sam tells

it, "There was intimidation from the moment you walked into the courthouse, not just from the sheriff but all the Whites who held office there. They were just menacing people who came in there. They did not want Black people to vote."

People got arrested for trying to buy tickets at the "White" window of the movie theater. The demonstrations got bigger after that. The police brought in dogs and burned demonstrators with electric cattle prods. After the civil rights bill passed, in 1964, there were confrontations over segregated restaurants and a swimming pool. Some SNCC workers, including Sam Mahone, were beaten with tire irons and baseball bats by a White mob after they were refused service at the Hasty House restaurant.

Now you had a lot of people in Cuthbert who were afraid to demonstrate. They didn't want to jeopardize their families or businesses. They didn't want to take a chance on losing any of that. They would come to the meetings, but they wouldn't go to the marches. And you had this other group that would put their life on the line. It turned out that was the group I fell into. I was a young boy, nineteen years old, in 1965. There were fifteen to twenty of us ready to go. We got into a big gray bus that looked like it used to be a school bus and we rode to Americus, which was about forty-five miles away. We gathered at the Bryant Pool Hall there on Cotton Avenue. Cotton Avenue was a Black street, with all Black businesses—Black clothing stores, Black poolrooms, Black restaurants, Black funeral home. It's the main drag for Black folks who hang out in Americus. It was familiar to me because I frequented the place when I thought I was a good pool player.

People were gathering around there from Americus and every which way, too many people to fit into the poolroom, so some were standing around on Cotton Avenue. The leaders say where we're going to march, and they told us what our strategy was. The strategy was to obey orders—when the authorities say move on, then we move on. We

marched from Cotton Avenue down to the main street in Americus. Cotton Avenue ends right at the main street downtown. That's where we went. It was a peaceful demonstration. People carried signs. The police were there, and the fire department, but they didn't intervene. People sang freedom songs like "We Shall Overcome."

Even though it was peaceful, the demonstration was scary. Angry-faced White folks were standing around with their weapons. It was like they were just waiting to jump us. They had guns and axe handles, and we had nothing to fight back with, not even a stick. I had never participated in anything like that, and I wasn't really demonstrating like I was supposed to. I wasn't up front, ready to take a beating. I was holding back, somewhere in the middle of the crowd. I was more watching than anything. I didn't want to take a chance on getting bit by a dog or hit with a billy club. But while I was there, and afterward, I thought about it and decided that if I was going to go, I might as well get out front. So, the next time I went, I didn't hold back. I jumped off the bus and started yelling, "Come on, y'all. Let's do this!"

A big crowd was gathering. People came in together, from every which way. This time, the strategy was that when they ask us to move on, we won't, because we want to get our point across. We want to integrate. We started marching down the street, singing and demonstrating. It was a slow march, just nice and slow, so we know we're going to get into a confrontation. I'm talking about when they come and ask you to move on, and you don't move on. You might *slightly* move on, but you don't move to the pace that they want you to move.

The first thing they bring out is their dogs, holding them back some, but they are threatening you. I really didn't want to get bit by those dogs. Then here come the fire department with the hoses. A lot of people get hurt when they turn the fire hoses on you, and I'm pretty sure people got hurt that day, but all that was a little farther down the street. I was up at the other end where the dogs were.

What happened next is that some civilian White folk showed up with shotguns. No uniforms. Some used their guns as billy clubs and

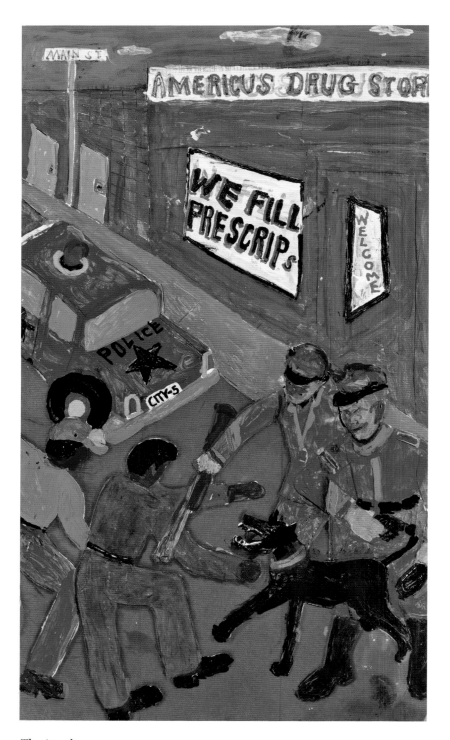

The Attack

were hitting people. Then a gunshot went off and everybody started running and scattering. It was mayhem. I started running too. I knew a little bit about Americus, so I knew where to run. I didn't wait for anybody to run with. I ran down an alley that was just big enough to drive a car down. It was a small alley off Cotton Avenue, just north of West Forsyth Street, right in the center of Americus. There were a few cars parked here and there. I ran down that alley, and when I stopped to catch a breath, I looked back and saw these two White men coming with shotguns. They didn't have those shotguns just to shoot squirrels, I'm telling you. They weren't playing. It happened there was a car sitting there, and I saw the keys sitting in it. Folks left the keys in the car back in the day. I jumped in and took off.

I took that car and drove it to Cuthbert. While I'm driving, I'm thinking to myself, *What am I going to do?* I didn't know whether to ditch the car in Cuthbert or to keep driving it, or where to go or who to tell. I was worried about staying alive. That's what I was thinking about most. I took those folks' car and I thought I was going to get killed when the police caught me. One thing you just don't do in Georgia is steal. You can kill somebody and you won't get as much time in jail as you would if you took something from White folks. White folks in Georgia don't like for you to take things from them.

You know how you might think one thing and you do another? I was thinking about getting rid of the car, but then the more I rode around in it, I'm saying to myself, *Let me keep it for a while.* I asked Duck whether he'd like to take a ride in the car. I was riding around in it just for the hell of it. It was something to do. The next thing I knew, the police were riding behind me. If I got it right, my friend Jimmy Greene was in the car with me. I said, "Jimmy, you want to get out? Because I'm going to keep going. I'm taking them for a chase." Even though I knew I was going to jail, I didn't want to give up. I wanted the police to have to earn their money. After all the abuse I'd seen them put Black folks through my whole life, I didn't want to make it easy for them. That's another reason why I think they hated me so. I gave them problems. They're used to telling

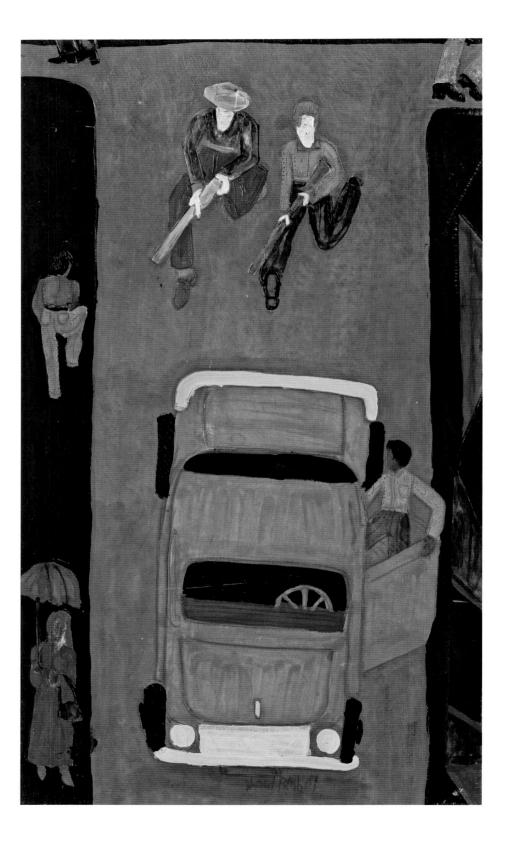

a Black man to stop or come back, and he'll do that. They actually thought I would stop. I didn't.

Jimmy got out, and I gave the police a chase until I ran the car in a ditch. Then I ran like hell. I was running and running and running until I got tired and climbed up a tree. A little while later, here they come with the most sorry-ass country hound I'd ever seen. I was up the tree and the dog was sniffing around underneath it. Nobody saw me and they left.

They probably went back there and talked to Jimmy. He might have told them it was me driving the car. People will talk when they think they're going to get in trouble. Some time after that, I was sleeping in an old raggedy car in Cuthbert. The police came and shined a flashlight through the window. They said, *"Oooooh Shiiiiit.* Look what we got! We got Winfred." They were really happy to get me.

The police roughed me up and locked me in the calaboose. A couple days later, the sheriff showed up and took me to the county jail. The cook in the jail, Minnie Cooper, told me that Buddy Perkins had been up there looking for me, like he had done before. But they wouldn't let me out. I never saw Perkins's face that day. I was in too deep. I don't know whether they told Perkins I was there or not. But there was nothing he could do; they weren't going to let him have me.

Weeks went by and I sat in jail. Poonk's sister, Yolanda Carter, yelled up to the window of my cell from the street. She wanted to know whether I was going to get out. She had to scream to talk to me. That girl got a lot of nerve. The police tried to run her away and she come right back.

I thought about my family, about Mama and all the things she tried to teach me about surviving in a White world, and I knew that old lady was worried about me. I was a young Black man with no structure in his life headed down a path with no good end. I could see that. I remembered men in prison stripes working by the side of the road in Cuthbert. I expected to end up there too, I just didn't know how long it would be before they sent me to prison.

OPPOSITE: *The Getaway*

I stayed there locked up in a single cell for over a year—they didn't tell me about no charges and there was no bond. No visitors. One day I took a roll of toilet paper. I stuck it in the john and flushed. It flooded the place. Deputy Lee come back there screaming and using the "nigger" word all over me. He gonna do this and he gonna do that. Then he went back and he got the keys. He opened the cell and said, "I'm gonna kick your ass." When he opened the cell, the first thing I thought about was what Mama used to tell me about White folks. "If White folks hit you, don't hit them back and you'll live."

The first time he kicked me, I fell down on the toilet and was just sitting there on it like you use it. Lee come up to me and kicked me again right in the face. That drew blood. Blood was everywhere, and it hurt so bad I didn't think I could continue that kind of beating. I didn't think I could take a beating like that without fighting back. So I changed my mind. I said to myself, *I've got to fight him.* And when he tried to kick me again, I grabbed his leg and I threw him to the floor. Once he was on the floor, he went for his gun. We wrestled for the gun and I managed to take it away from him.

Why did Deputy Lee have the nerve to wear his gun into the cell when he was confronting a prisoner—me? Why did he wear his gun in the cell? Do you know why? Because he's not expecting any confrontation. He can wear his gun and he's thinking, *I can just beat up on this nigger all day long, and there ain't nothing he can do about it.* That's what he's thinking, because if he's thinking he's going to have a confrontation, he would've locked his gun up. But he's not expecting it, so he's going to wear his gun when he's going in there to kick my butt. And if I give him any problem, he's got a right to shoot me. I figure that's the way he's thinking.

I didn't know what to do after I took Lee's gun. He was begging me not to shoot him, and I knew I was in big-time trouble. He said, "Gimme my gun," but I knew I couldn't give it to him. I said, "Ah, sir,

OPPOSITE: *The Deputy*

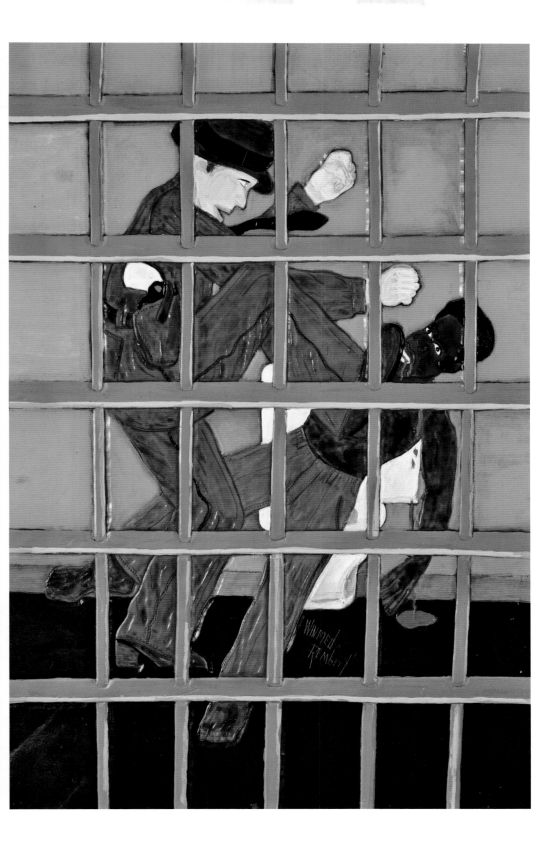

I can't give you the gun. Sir, I'm gonna have to lock you up." I took the keys and locked him in the cell and then, before I left, I turned to him and said, "How does that feel?" He was so mad. You should have seen the color of his face. It was red and his eyeballs got big. I was on my way out of there and he's thinking, *A nigger done locked me up. This can't be happening.*

There were two or three guys there in the other cells. I unlocked the doors and let them out. Now the jail and the deputy sheriff's house were built together. You could come out of the back door of the house and you were in the jail, just like that. Your feet didn't have to hit the ground. So after I locked the deputy up and let these other guys out, I'm headed for the door and his wife shows up. I guess she was looking for him. There was like a one-two step-down for her. She might have been on the second step, and I was down below, about to pass her. She was in my way. She didn't say a word, and I knew one thing—I couldn't touch her. This White women thing was going through my head when I saw her—the thing about how you had to walk on a different side of the street when you meet a White woman. She was blocking my path, but I knew I couldn't push her out of the way. I was in enough trouble already.

She stepped to the side and I made a dash for the door. There was the deputy sheriff's car. I got in the car and started it up. By this time, I hear sirens. That meant the deputy's wife had called the state policemen right around the corner.

I knew my life was in jeopardy. I figured I was going to get killed. It just didn't seem like after I locked this man in his own jail I could live after that. Black men in Cuthbert had died for way less. I knew I had done a terrible thing—when it comes to White folks' rules. How could I live after that? I locked this mean White man in his own cell and he is pissed with me. I'm thinking, *He's coming after me if he gets a chance.* I know it. In my mind, as I'm on the run, I'm thinking about him and what he's going to do to me if he catches me. I thought maybe he would just shoot me down. On the other hand, I thought that my private parts might end up in a jar next to the ones

the plantation owner showed me. I didn't know if Deputy Lee, old man Lee, kept any private parts, but that was the kind of thing that was going through my head.

All the state police cars are coming in now, and I passed right through them and kept driving. After I got past them, I ditched the car and took off on foot. I couldn't go to Perkins or Jeff for help because I didn't want to put them in jeopardy. So I made my way clear across town to someone I didn't know well. I didn't have anybody else I could go to. I don't know his last name, but his first name was Roy. I met him in Homer Clyde's poolroom, where some of the civil rights meetings took place, and I understood that he was in the background of the movement. I knocked on Roy's door. In my mind was the question, *Are they going to help me or are they going to turn me away?*

Listen, if you're not Black, I don't believe you can understand. I really don't believe you can understand what a Black man can go through. You see other Black men getting whipped with baseball bats and gun handles. You've seen Black men get beat up because they won't laugh in the laughing barrel. If Lee had never come back there to beat my butt, or if I had never put that roll of toilet tissue in the john, the escape might never have happened and I would have still been sitting there in jail. But he came in and he created a problem. The problem was that I couldn't take his whipping. That was a big-time problem. That last kick in the face gave me a different outlook from what Mama had taught me. The last time he kicked me I said to myself, *This can't be right.* I didn't think about my life being on the line. I just wanted to kick him back. I wanted to do back to him what he was doing to me. I didn't give a damn that he was the deputy sheriff, though I knew that I had to lock him up and get out of there. I knew that. I also knew this: They were going to catch me. I knew that. If I had run to Perkins or to Jeff, or Homer Clyde, somebody like that, they probably could have saved me, shipped me off

somewhere. They had the power to do that and the ways and means. But I had decided not to, so I was out there on my own.

Roy's wife answered the door. Her name was Cora. She wanted to know why I didn't have a coat on, because it was wintertime and I was freezing. I told her I just broke from jail. She didn't believe me, but I showed her the deputy's gun and that convinced her that I was telling the truth. She said to me, "Roy's not here. He went down to get some beer from the store. When he gets back he's gonna go to Tallahassee, Florida, to see his mother. Maybe he'll take you with him. Come on in and sit down." She made a cup of coffee and brought it to the living room for me. Then she disappeared. I'm trying to figure out where she is. I called out to her and she didn't answer. I went to the kitchen and she wasn't there. Then I pulled the curtain and looked outside.

Roy was a horse trainer, and I found out later that he trained horses for Faircloth, the sheriff. Maybe that's why his wife called the police. Maybe she was scared to do anything for me, or have anything to do with me, because her husband had worked for the sheriff and she didn't want no stigma.

The sheriff and the state troopers kicked the door clean off the hinges and came in with their guns out. "All right," they said, "where's that gun?" I threw the gun down on the floor and next thing I knew I was on the floor. They started kicking me, and one of them hit me with a shotgun upside the head. They were using the shotgun like a stick. They were kicking me and hitting me with that gun. You know what they call peripheral vision? Well, I saw this gun handle coming, though I didn't realize it was a handle until after it struck me. I saw something coming from the side toward my face and I threw my hand up just in time to catch the impact. The handle broke into pieces and went into my hand. It was over a month before I realized they were in there. My hand was hurting me so bad and I saw a little piece sticking out. I stuck a safety pin into the end of that piece. I pulled it and it kept coming, about two inches. There were three of them pieces.

Roy and Cora moved away after that. I heard that some people in Cuthbert weren't too happy with them and they left. When I go to

Cuthbert now, sometimes I ride down to that house where the sheriff and the state troopers got me. Sometimes I park and sit in front of it and I think about living. I lived. I went in that house and I lived through that, tough as it was. I took my family down to that house. We sat there in front of it. I talked to them about my memories and I cried.

There was a big tree sitting in the yard next to that house. It was a big oak tree with limbs every which way. When the sheriff dragged me outside, I looked at the tree and I thought my life was going to end right there, under that tree. I didn't see any ropes, but I knew they had ropes. They beat me up something terrible under that tree. I got a scar on my forehead from that beating. Finally, Faircloth, the sheriff, said, "OK, handcuff this nigger up and y'all bring him back to the jail." They handcuffed me behind my back and turned me over to these two state policemen who threw me into the back of the car, calling me nigger and all that. Then the passenger trooper turned to me and said, "Nigger, don't you know better than to hit a White man?" He reached over and hit me in the face with the back of his hand. My blood got on his shirt, so he says, "Oh shit, I got nigger blood on my shirt." He took off his badge and then his shirt and he threw his shirt out the window. He didn't want no "nigger blood" on his shirt. I wish I could go into every school and talk to some of these kids to tell them what the N-word means, in life, to people. It's a *mean* word, and neither the Black kids nor the White kids know it.

The radio was ringing and ringing. It was the state trooper at the barracks. "Y'all got that nigger?"

"The sheriff said bring him to the jail."

"You'll bring him back over to the state troopers' barracks or you got no job."

I got another beating at the state troopers' barracks. What happened then is kind of funny. This dispatcher, he's going to get a last lick on me before they take me back to the car. He draws back to punch me and I spit in his face, blood and all, and, boy, did he go

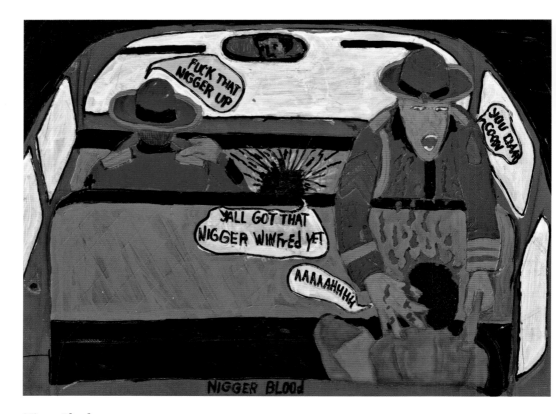

Nigger Blood

crazy. He act like I spit acid on him. "Oh, that nigger spit on me! I got this nigger's blood all in my face," and he ran to the bathroom as fast as he could to wash his face off. That was hilarious to see him do that. It was like something in a movie. The whole situation felt unreal. It is just crazy how White folks think. Two state troopers got me out of there before he came out of the bathroom. He ran out behind us, though, and pushed me into the rose bushes that were full of stickers.

They took me over to the Cuthbert jail, and I was sitting in the car. I don't know what time it was. It was still dark, but it must have

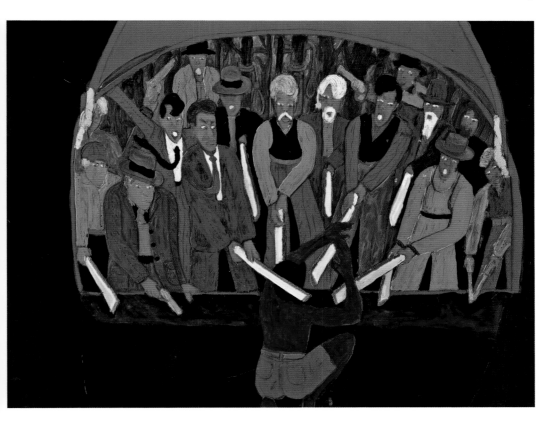

Inside the Trunk

been pretty close to morning. I'm sitting there waiting to see what they're going to do, and they ain't doing nothing. Then, all of a sudden, these White folks approach the jail. It seemed like twenty or twenty-five of them. And when they got there, they came over to the car and took me out of it. They pulled off all of my clothes except for my pants, put me in the trunk of another car, and closed it.

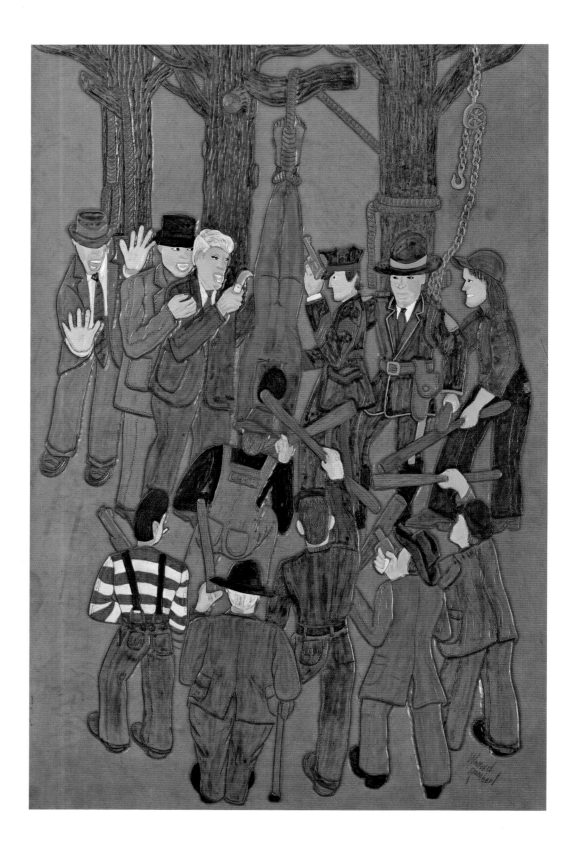

A MAN DON'T KNOW WHAT
HE CAN GO THROUGH

A blast of cold air blew in when the trunk slammed shut, and I felt like I was on my way to hell. They took me on a ride that lasted for about a half an hour, during which time I'm fixing to die. And when they opened the trunk, there they go juuging me again—beating me—but there were so many of them, nobody could hardly get a good lick on me.

I had no idea where I was, but it was a beautiful place with nice cut grass and trees all nicely trimmed. When I visited Cuthbert with Patsy and Phil and Sharon McBlain in 2002, we took a ride outside of town to see if I could find where I was taken. I timed myself for that ride, thinking about what turns we made and how long it was between each turn. I ended up at a place with a sign that said KEEP OUT. I believe that was the place. There was a road going in there, and we were afraid to go down it, so we turned the car around and got the hell out of there. The man who owned that land was a man I remember as being a very prejudiced guy. I think I saw him that night. There were a lot of angry White faces from Cuthbert that night and the day before.

They took me out of the car and pulled off my pants. I'm on the ground and they're beating me bad. I looked over their shoulders and I saw some nooses, could have been three or four, hanging in a row. They took a rope and put it around my ankles. I thought about the trophies in the jar.

They hung me up by my feet in a tree—up in a tree—and here come Deputy Lee with a hawkbill knife in his hand. He came over and he grabbed my parts, and he stuck me with the knife. He didn't slice me, but he stuck me. And you talking about pain, and you

talking about the blood—blood running down my butt, down the back of my neck onto the ground. I was bleeding like a hog. I was bleeding like an animal or something out there to be killed. And the pain, I'm telling you, I never had so much pain in all my life.

A man don't know what he can go through with until it starts happening. Just think about that. You don't know what you can endure until it starts happening to you. You wouldn't know it right out, but you could endure a lot of things. You might think, *I couldn't have done that*, but you could have. You just didn't know it. I would not have thought I could have survived that. But I was young, and I did.

You could probably hear me for miles, screaming, but I didn't cry for mercy. They were going to kill me anyway, and I didn't want to give them the pleasure of hearing me beg. You know, so many things go through your mind when they threaten to kill you, when they're doing all those things to you. Your mind is just racing. I kept thinking about what Mama used to say, about racism, and how to deal with White people, about how you supposedly have to satisfy them when you deal with them, whether you are working for them or not. Mama's idea was to stay alive, and she was passionate about that. She felt that she had to do the Uncle Tom thing to stay alive. Her idea was to please White people.

Pleasing White people is a hard thing to do, because if you do try to please them, you never know if you did a good job of it. I don't care how you please them, I think they walk away thinking you are nobody. And that's the way they treat you. They think nothing of you. Maybe no other White people treated Black people like that, outside of Cuthbert, Georgia. But I would say, if I had to say, that they did Blacks just the same way throughout Georgia, Mississippi, Louisiana, and Alabama.

Lester Maddox was governor of the state of Georgia from 1967 to 1971. He was a Black-man hater. Before he was governor, he had a restaurant in Atlanta called the Pickrick. After the Civil Rights Act of 1964, he refused to integrate his restaurant. Three Black students

came to his restaurant and he chased them away with a pistol. He put a box of wooden axe handles next to the door. He called them "Pickrick drumsticks" and sold them to his customers for two dollars apiece. There Maddox was, on television, with an axe handle in his hand. He might as well have said, "Here's what you do to a nigger. Go and buy an axe handle. Hit a nigger in the head with it." He made a lot of money. You hear me? He couldn't sell enough of them. Axe handles became the premier weapon after Maddox started promoting his Pickrick drumsticks. White folks raided the hardware stores. The factories ran out of stock. I wonder how many people in Cuthbert, Georgia, bought an axe handle. The White folks would take it and do things to it—maybe scrape it a little bit, reshape it, so they could really get a good grip on it. You can do a lot of damage with an axe handle. How many people got hit in the head because of what Lester Maddox stood for?

They had axe handles when they were lynching me—when they broke into Roy and Cora's house and got me, and when they were punching me and juuging me in that car. That's what they had in their hands. There were twenty or twenty-five people, so that's a lot of axe handles. Only thing I was trying to do was to protect my head. I was letting them hit me in other places, but I was trying to protect my head. I didn't want to get hit in the head with one of those axe handles or one of those guns. They turn the gun around so they are not holding it in the shooting position. They turn it around and hit you with it. So I held my hand up to block the swinging. And I'm going to tell you, the more of them trying to hit you, the better it is for you, because they don't get a real good swing at you when all of them try to swing at one time. They end up hitting each other.

I wonder what the premier weapon was to control Black people back in the thirties and early forties. What were they whupping up Black folks with then? When I was a little boy, they carried sticks and whips. It seemed like White folks loved to carry things that they could hit you with. "Oh, I might have to hit a nigger today, so I'm going to cut me a stick—make me a weapon—I may have to hit

a nigger in the head." I think they made things just to hit us with, because they treated us just like they would treat a pig, a cow, or a hog. They thought we were animals just like that, so they had to control us in the same manner as they did the other animals on the farm. They didn't think we had intelligence. And I imagine a lot of us seemed like we didn't, because we had a different outlook, different ways, and it seemed like we were dumb just because of that. They treated us in that manner—*Dumb nigger, he don't know nothing*—and they made us look dumb. They treated us like that when I was coming up.

There was no law to stop them from mistreating us. A White man can come into the shoeshine parlor and beat up a Black man. You couldn't go to the police. They weren't going to prosecute a White man for what he did to a Black. Like Poonk says, "I've seen White people jumping on Black people, and nothing done about it."

That guy in the shoeshine parlor, I could see him when the mob was trying to kill me. I thought about him in a big-time way. He wasn't being lynched. He was just being whipped. The White man didn't want to kill him. He wanted to teach him a lesson, like Mama said, about satisfying White people most, so that you won't be in a situation where they could kill you. But I had messed that up. If I had been humble, if I had just let Deputy Lee beat my butt, walk on back out, and turn the key to keep me locked in there, I don't think all that would have happened to me. When I escaped from jail and locked the deputy sheriff in the cell, that sealed my fate. "Oh, he locked up the deputy sheriff." I can just picture them in my mind, you know, what they are saying: "That nigger locked up the deputy sheriff. We got to catch him." I don't know whether they cared much about catching the other guys I let out of jail. They wanted me.

The *Cuthbert Times* published a headline on March 2, 1967, that said, "Three Prisoners Now Back in Jail."

*Three young Negro prisoners, held in the Randolph County jail
on auto theft and burglary charges, overpowered Deputy Sheriff
R. M. Lee as he was transferring them to another cell last Friday
night and all three made their getaway....*

*The comparatively young bad actors are John R. Jackson,
17, a 16-year old boy, and Wilfred [sic] Rembert, 20 [sic]. They
are to be tried at the May term of Randolph Superior Court.*

The newspaper didn't tell the truth. But the paper couldn't print
the truth. How in the world is that going to read to White folks when
they see, "One nigger beat up the deputy sheriff and locked him in
his cell"? They aren't going to print that! No way in the world. And
I'm young too, just twenty-one years old. That's not going to read
good.

By this time, Lee was ready to slice on me while I'm hanging from
the tree. But then this man grabbed his hand and said, "Don't do
that. We got better things we can do with this nigger." Lee didn't
like that. He was carrying on, talking about what he wanted to do.
"I want to teach this nigger a lesson." He's carrying on like that, and
the other man said, "No, we got better ways we can do this." Now
this man, I don't know who he was. I was hanging upside down
and all I saw was his wingtip shoes. The only thing I know is this:
He had power. He said don't do it and they didn't do it, even though
they wanted to. They were carrying on something terrible. He said,
"Carry him on back to the jail. He gonna die anyway." And they cut
me down.

There's a picture I painted called *Almost Me*. It's a picture of a guy.
Dead. Fully lynched. He didn't survive. He's hanging there all alone.
He can only speak from his grave, and there ain't much talking you
can do from the grave.

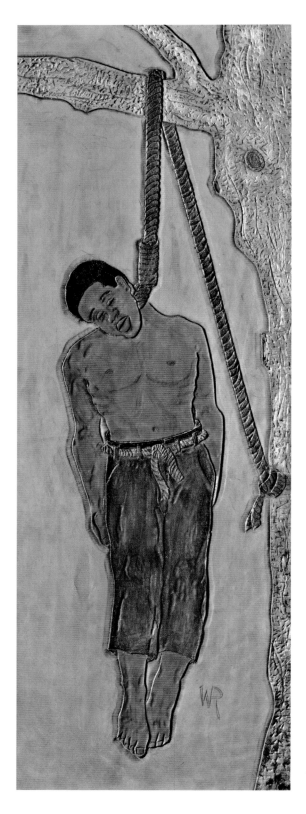

Almost Me

When I started off painting that picture, I got sick. I couldn't finish it. I would have crazy dreams about it at night. I'd wake up kicking, and sometimes I was kicking so hard I would fall out of the bed onto the floor. I ain't never finished thinking about that picture. I would love for it to be a finished project—all over with. But it's not. Every time I see it, I'm thinking, and I think about a whole lot of stuff when I look at it, including what Mama said about how to keep that from happening to me. *Almost me.* I don't think I'm ever going to get over what happened that night. And some of the memories had to come to me in flashes. When you are back there, taking all them licks, it's hard to remember everything right off the bat. It took me time to put it together.

Thank God I'm alive, and while I'm still alive I can talk about it. I can talk about surviving. I am history. I am a witness. I can tell about being almost lynched. And when I die, I didn't die by the rope. I just died from being an old man. I lived my life out. My children, when I'm gone, can read about it, and that picture will be there to speak for me. If you stand and look at it, the picture will talk to you. My great-great-grandchildren can walk up to that picture a hundred years from now and say, "That was my great-great-grandfather. He did this picture and the story is about him." If I didn't survive that lynching, I wouldn't be here. There'd be no picture, no book—and no one to tell or read the things I've lived through and seen.

When they put me on back in the trunk of that car, after cutting me down off the tree, I still thought I wasn't going to live. I had a pretty bad wound and I was in a lot of pain. I didn't have on any clothes, and there were my clothes lying there. I grabbed my T-shirt, rolled it up, stuck it between my legs and squeezed real tight. That was the only thing that saved my life—squeezing that open wound real tight. They took me for a ride back to the jail and threw me in a cell. I didn't see no doctor or nothing, and I was squeezing that wound real tight for days. Finally, one day, weeks later, they did bring a doctor in there.

And now, listen to this, I knew the doctor. His name was Dr. Martin. He used to come and sit on the porch with Mama. He loved her food. He used to come there and eat her biscuits. But when he got to the jail cell, he acted like he didn't know me. Now, see, I was fighting a losing battle, so I didn't try to pursue that any further. Also, the wounds had started to close, so he didn't bother to sew me up.

I still suffer today from that knife wound. My scrotum hangs lower because of it. I have problems sitting down. I have to move around in the chair to get in the right position. That's the problem I have right now. Anytime I sit down.

It seems like Whites want the balls more than they want anything. The first thing they grab and they cut is your balls. They don't care about nothing else. They want your balls. I don't know of any other people, other than Black people, whose balls they wanted, and it was a long time before we could even think about fighting back.

I think people in Alabama and Mississippi were making more moves than we were, in Cuthbert, to try to make things equal. I think Georgia just was the hardest state in the union to get anything done that would profit Black folks. There is no place like Georgia. Martin Luther King couldn't get those White folks to stop turning the water hose on us, stop beating us with those axe handles—axe handles, guns, water hoses, and dogs. Those German shepherds know how to attack a person. They were trained to do that. They knew how to jump up on you, knock you down, and bite you. When you are sitting in one of those positions on the sidewalk—like we were taught to do, when we would do a sit-in—a dog can hurt you. And when you're running, a dog can hurt you—he'll chase you like you're a rabbit or something. A water hose is powerful too. When you get knocked down by a water hose, it will knock you ten or fifteen feet, and it hurts. The dog comes behind you, when you get knocked down by the water hose, and jumps right on top of you. I was lucky not to get knocked down by a fire hose or attacked by a dog.

*

A lot of Black people left Cuthbert. Charlie Brookins graduated on a Friday night and on Monday morning he was on a Trailways bus out of town. He just couldn't stay. My sister Loraine left too. She graduated from high school in May 1957 and left in June. Not long ago we talked about Cuthbert and why she left. "There were a lot of things the elders didn't tell us, a lot of things," she said. "It might have been out of fear that they didn't tell us things. Mama didn't allow me to go into the White people's homes to babysit or to do cleaning. She never told me why she didn't want me to go into the homes to work, but as she got older, I began to see things as they really were. The White men were getting girls pregnant, and there was nothing that we Black women could do about it. But I didn't understand that until way later. All I knew then was that she wouldn't leave me with nobody. She always took me where she went. It was years before I went back to Cuthbert. I didn't like it there. I didn't want to live there anymore."

How are you going to change anything with the way White folks are together? They control the papers and the courthouse, and they make the laws. If they want to break the law, they break it. How are you going to do anything? That's the way I was thinking when I listened to Jeff and Buddy Perkins and those guys in the poolroom, talking. I thought to myself, at eighteen years old, *This is not going to happen. We're not going to get no equality.*

But I did witness, in the Martin Luther King era, Blacks act. I think people made up their minds that they would die. *I'm gonna die to make this change.* I think a lot of Black people thought that—*I'm gonna die*—because in the Martin Luther King era, that's what they did. They died for change. Black people marched and put their lives on the line. When you look back and you see twenty people went on the bus, and only eighteen of them came back, you begin to think differently. There go two people who gave up their life for the cause. Then somehow or another you want to be a part of fighting for the change. Some people may feel guilty that they hadn't put forth any effort, so they jump on the bus and go.

In Cuthbert, I looked at how many people got on the bus. More and more people got on the bus each time. They knew that once they jumped on that bus, they put their life on the line. That's what we do when we march and do sit-ins. People put their lives on the line. And I think some of them were scared. I was one of those scared people. I knew, when I jumped on that bus, I was putting my life on the line. I knew that. But the way I was growing up, there was no hope for me. I felt no hope. I was raised up in the cotton field with no future. I couldn't see anything ahead. Every day there was nothing to do. Go to the Curvey every day? Hang around the poolroom all day, every day? My life was going nowhere. So it was easy for me to get on that bus. Why not go on the bus?

REIDSVILLE STATE PRISON

I had been in jail for a total of almost two years before they took me to court for sentencing. The cook, Minnie Cooper, would sneak me food and ice water, because the water I was getting was hot and not fit to drink. She would tell me things. She told me that Mama thought I might be up there in the jail. Minnie told me that Mama came by and they ran her away. They wouldn't let her see me. Maybe three or four weeks after I was almost lynched, Faircloth and Lee come in. They handcuffed me and shackled me. Then they took me outside and marched me down Hamilton Avenue, right on by Bubba Duke's place, past the Dirty Spoon Cafe, past Black Masterson's place and all the other juke joints, past Brur Barnes's barbershop, right on by the school and past all the people on the street.

They picked Hamilton Avenue. They wanted to show all the people who cared something about me that a nigger's life ain't worth a dime. That was tough. But you know what? I felt a sense of pride too. I had on them shackles, but I knew that I had been fighting for my people. It did go through my mind, though: *What were all those Black folks thinking when they were looking at me?* I didn't know whether they thought I got thrown in jail for a just cause or whether they thought, *Winfred is a bad guy and he got what he deserved.* I didn't know which to believe. Charlie Brookins says that at the time nobody really talked about what happened to me. For a long time he and others didn't know where I was. As Charlie tells it, "That little town was so hush-hush you wouldn't believe it. The people who lived in that town that had jobs—whether it was at the sawmill or the peanut gin—they were all working for Whites, and if you were talking about something Whites didn't like, you could lose your job and your family is going to suffer."

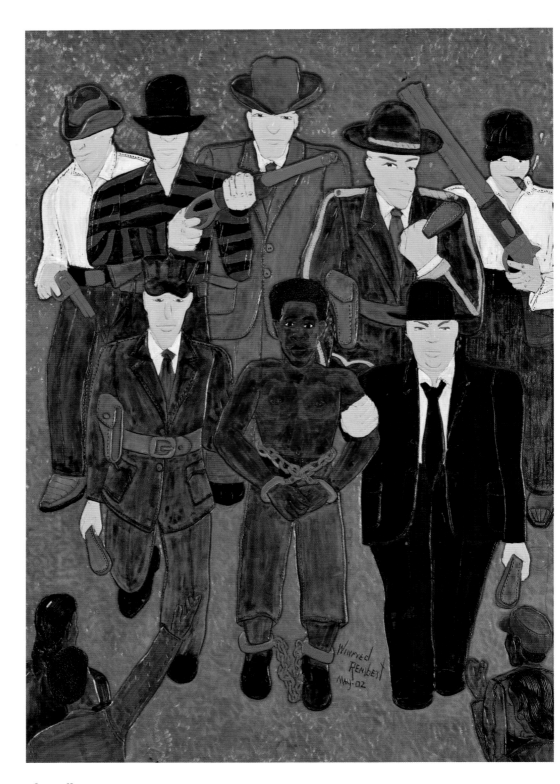

The Walk

Grayceda Prather knew nothing about what had happened to me or where I'd gone, but she'd heard about things that happened in our town. "For instance, when young guys would die in jail and it was reported that they hung themselves. Things like that I found hard to believe, but you can only speculate because you didn't see it. Quite a few sad situations have gone down in Cuthbert that cost people their lives. I heard of people having to leave Cuthbert at night and never returning, and nobody knows anything about it. They just leave here like they've never lived here. They don't come this way anymore. That's frightening, and it's why, when people are talking, they have to be very careful. And you still got to be careful, because you really don't know who the heck is who."

I found out from Naomi Jenkins that, years later—she thought it could have been in the late seventies—some people talked about what happened to me. "We got this rumor that Winfred was one of the ones they castrated right before he left Cuthbert. That was the story that we got. I was angry and heartbroken. Those were my feelings. I didn't hear about what happened early on because the people were afraid to mention it. There was always, with the Black male especially, the threat that something could happen. So to actually know somebody who that had happened to, that put a lot of fear in the men around here. They thought, if that could happen to him, it could happen to me."

When they finally took me to court, there was no one in the courtroom for me. I had no lawyer. There was no trial. As I recollect, the judge didn't ask me was I guilty or any of that. He just looked at me and said, "Nigger, I'm gonna give you some time."

Your Honor, you just called me a nigger.

"I'm going to give you one year for escape. I'm going to give you one year for pointing a pistol. And I'm going to give you twenty for robbery."

Robbery. Twenty years. "I know I escaped from jail, and I know I pointed the pistol. I know I took the car. But I ain't robbed nobody. Who did I rob?"

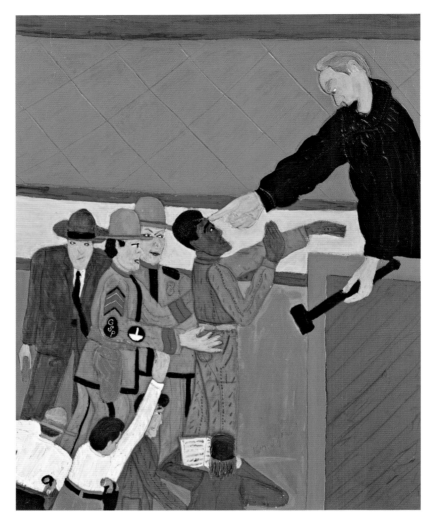

Georgia Justice

"You robbed the man of his gun."

"He pulled a gun on me to kill me."

"Well, you should have let him kill you."

A judge talks like that and—*whoa*—you ain't got no wind after that. Going before the judge is the last hope you got. And then, before you can even open your mouth, the judge calls you a nigger. That's the way it went.

Judge Geer shipped me off to the Georgia State Prison in Reidsville. A judge in Americus sentenced me to five years for taking the car, so there I was with twenty-seven years. Reidsville was a big place with hundreds of prisoners. It's the prison where Lena Baker was electrocuted in 1945, the year I was born. Lena Baker was a Black woman from Cuthbert. She was the first woman ever to be executed in Georgia. This White guy was trying to buy her away from her mama, and her mama told him no and not to fool with her. He kept fooling with her until he got on her good side and got her working for him as a maid. Then he wouldn't let her go home, and the next thing you know, he was demanding sex from her. Then one day she decided not to stay that night, and he insisted that she stay, and she killed him. That's what I learned from hearing people talk about it many years later and from YouTube. I heard about it, a little bit, in Cuthbert, but people were scared to talk about stuff like that. They didn't really talk about it. They're still scared to talk about things like that.

I was a bitter person when I first went to prison. I did a lot of fighting. I was a bitter guy, probably doing people wrong who didn't deserve to be treated like that, but that twenty-seven years was working with me. I was fighting for two reasons: One reason was that I know I was mistreated and didn't deserve those twenty-seven years. My other reason was that guys were hot for sex—these old guys with life sentences, sentences of twenty and forty years—and they were after young boys. They would take prison pants and sew them up tight, and you'd see young boys wearing those pants. I was in the visiting room one time and there was a young guy there who was wearing mascara, lipstick, and those tight pants. His mother was visiting him. She looked at him and said, "What happened to my child?" and she started to cry.

I was a young boy, about 5'9" and under 150 pounds. I had put some old crazy stuff in my hair to have it curl and hang down. I was trying to copy off of James Brown, but the prisoners took it a different way. When I first came into the prison and walked down the hall,

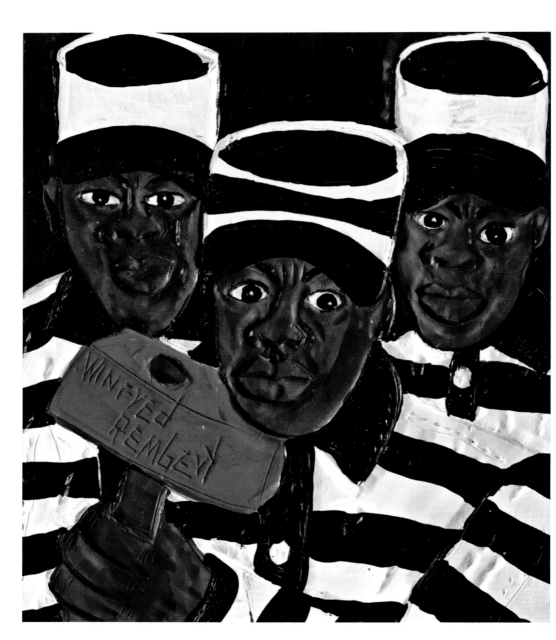

Angry Inmates

the guys called out, "Fresh meat!" So that was my other fight. I had to defend myself.

I had three, four, five fights down there in Reidsville, trying to establish some kind of reputation for myself as being a fighter, because no one bothers you if you fight them back. All you really have to do is have one good fight and you more or less won't have any trouble. There's a way you carry yourself after that. You look like you got pride and you're fixing to knock somebody in the head. There was this guy who was telling me I was going to be his girl. I took some lighter fluid and I waited until he went to sleep. Then I put that lighter fluid on his shirt and lit it. He was burning, though lighter fluid don't burn you that tough—not like gas. When he woke up, I grabbed him by the collar and I said, "Listen, I'm not going to be your girl, nigger. I'm going to kill you if you try to do anything to me." After that he didn't bother me and nobody else did either.

In Reidsville, they had a place where they buried prisoners called Piss Ant Hill. A piss ant is a type of ant, and Piss Ant Hill is a place that's infested with them. When piss ants dig, the dirt comes up and it looks like a desert. There was big mound of red dirt that was infested with ants as far as you could see. Everywhere you'd go there were ants. Piss Ant Hill is where they'd bury you if you had no family. They go in there with a machine, dig a hole, put the prisoner in there, and cover him back up. Then the piss ants would eat him up. It was a terrible place. No one wanted to end up there. All the inmates were hoping that their family would come and pick them up, but in a prison like Reidsville, there were some inmates who didn't have family. Nobody visited them. Nobody wrote to them.

You know what it means when you don't get a letter? You're sitting there, the mailman is calling out names, and he don't call yours. That means your wife didn't write you. Your brother didn't write you. No one in your family wrote you. They forgot about you. That's a bad feeling, and you're already locked up. You're sitting there and you want the mailman to call your name so bad—*so bad*—and it just don't happen.

Reidsville was a miserable place and I was mad with the world. I was mad because I was locked up. I was mad because I had to pick

cotton and mad because I couldn't read and write. It's hard when you can't read and write. I escaped the cotton fields, but I didn't know nothing about life. I was so far behind. All I knew about was picking cotton. So I did contrary things. Not following rules gives you a way to express your anger. I wasn't enjoying my twenties like you are supposed to—you know, those years as a young person when the whole world is open to you? The world wasn't open to me.

About a year after I got to Reidsville, I was sent to Lee State Prison in Leesburg. The warden's name was Boney. He was a short, fat guy with a red sunburnt face. He had this little dog he would talk to all the time—a pug. He talked to that little pug like he was a human being. One day the warden had me in his car. He had me in the back seat and the little dog was up front. The dog was barking and the warden said, "I know what you want. You want me to turn on the windshield wipers." He turned them on and the dog's head was going back and forth with the windshield wipers.

I met a couple of schoolteachers from Sumter County who were locked up for crimes related to civil rights demonstrations. I was in the library, messing around, and I told them I couldn't read. They said I might be a good candidate for them to teach me something because I could carry a conversation. I had "gab," that's what they called it. They approached me with the syllable method. You separate the syllables and put them back together. I realized reading wasn't hard. I also discovered that reading makes you smarter. It opens your mind.

I think your mind is just waiting to learn. Your mind wants you to pick up a book and read it. Once I learned how, I began to read all the time. There was nothing else to do and I was happy to do it. I wanted to read more. I didn't have any idea that it would be like that. I knew I wanted to learn, but I didn't know my mind would open up to wanting to read more and more.

After I learned how to read and write, I got a little business going in the evening, writing letters for prisoners who couldn't

write. Some of those guys had wives who never came to see them. I felt for them guys. They would be sad when they didn't get a visit. I really felt for them. I'd be out there with my visitors on Sunday and I'd see guys sitting there just as lonely as they could be. So I tried to help them by writing letters for them. I would write to their wives like I was them and they would get a visit the next Sunday. I could write a letter just that tough. I made it all up, and I was convincing. I had a reputation for that. I found it strange that I could write a letter to someone I didn't even know and they would read that letter and come and visit their husband the next week. Some would come from as far away as Atlanta, which is a long way from Leesburg. I thought that was fantastic. Sometimes guys would be standing in line waiting for me to write a letter for them. I would charge them, though. I wouldn't do it for free, except when guys didn't have the money. Then sometimes I'd do it for nothing because I felt good about seeing those guys out there in the yard, smiling and hugging their wives.

We worked by the side of the road, in shackles, cleaning out culverts and cutting grass. Those shackles were heavy and they hurt your leg, but I was proud of being a tough inmate. I dragged that ball around like it was nothing, and I didn't take nothing from nobody. I got into lots of fights and kept getting sent to the hole—solitary confinement. One day, probably a year or more after I got to Lee, the warden came to the hole and said, "Come in my office, I want to talk to you." I went with him to his office and sat down.

"The way you're going, you ain't never going to get out of prison. I'm going to do you a favor. I'm going to ship you to a place where you can easily do your time."

"I'm not used to no White folks doing me no favor."

"Well, I'm going to do you a favor. You take it like you want to. I'm going to send you to a good place."

Ten days after that, he called me and told me to pack my things. I was getting transferred. This tall White man was standing out front waiting on me. I looked at his name tag. It said, "Youngblood."

"You ready?"

"Yes, sir, I'm ready."

I'm waiting on him to put me in the back seat, and he says, "Naw, you ride up here with me." I noticed he didn't have a weapon. He opened the front door. I got in and we're riding on and he's just talking. He says, "Oh, man, you got a long time."

"Yeah, I got in some civil rights trouble."

"Well, you can do your time with me and you can make it easy. Depend on how you want to do it. You can make it easy or bad."

"I don't know how I can make it any easier, 'cause I got twenty-seven."

"Let's see what you can do with that."

Then he starts looking through my stuff and he says, "What is this? You got these money orders here. They never gave them to you?"

"No. I never got no money orders."

We went to the bank and he said, "Cash these money orders for this gentleman." He didn't call me a nigger. Then he gave me the money, about $250. I was thinking, *Hmmm, something ain't right with this.*

We drove on down one of those long country roads—real long, I mean *real* long—and we got to a bridge. Youngblood turned to me and said, "Can you use a hammer?"

"Yeah, I use a hammer."

"Do you see those boards sticking up over there? Nail 'em back down."

I grab a hammer, and when I begin to nail the boards down, he jumps in his car and takes off. So I stop hammering long enough to see what he was doing. He went clean out of sight, over the hill—old dusty road, not no pavement road, car just kicking up dust. A voice in my head said to me, *Maybe some White folks are hiding up in these woods or something, because I can't see that he'd be trusting me.*

I had that money in my pocket. Something told me to run and escape, and something told me not to. I nailed the two boards and I sat down. It was forty-five minutes to an hour before he came back.

"You got it done?"

"Yep."

We got in the car and I'm still trying to understand what's going on. We went on to this place that looked like an army barracks. Youngblood turned to me.

"You got a girlfriend?"

"No."

"Well, you'll probably get a girl hanging around here with these fellas. They will introduce you to some girls, because if you don't have a girlfriend, I'm scared you might try to escape."

"If I was going to escape, I would have did it back there at the bridge."

"You got a point there."

We got out of the car. There was a mobile home in front of us. It was a big double-wide trailer home. Two girls were running out of the door laughing and grinning, with guys chasing them. I heard music. It was James Brown singing "I Feel Good." I looked around and thought, *What's going on? This can't be true. This cannot be true.*

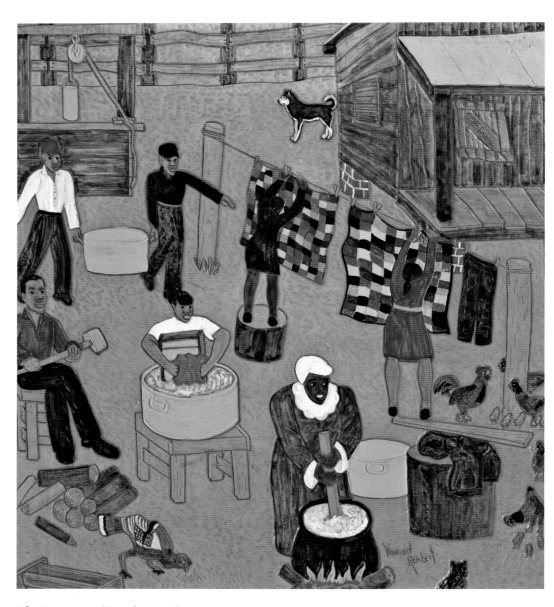

The Gammages (Patsy's House)

FINDING PATSY

We had arrived at a small state penitentiary work camp. It was the Turner County Public Work Camp in Ashburn, Georgia. There were twenty-five to thirty guys at the camp. They were all wearing black-and-white-striped uniforms, except a few who had been there a long time. If you had been around there a long time, and you worked hard, they would give you pants with a single stripe straight down the side and you could wear any shirt you wanted.

Some guys were sitting around talking with their girlfriends, who had come to visit them. Others were playing basketball. There was no guard outside, and inside there were no cells, which was an improvement over where I just come from. Instead they had one big sleeping area for everybody. I thought maybe this was a good place after all. Youngblood took me to my space and I packed my clothes in a little chest upside the bed. He introduced me to the cook, whose name was Berry, and to another man, who was a guard. The guard was an old guy. They called him "Crip" because he had a clubfoot. Crip cut a hole the size of money out of the pages of a Bible. He would keep his money in that Bible and sometimes we would take it. He would hire guys to pick and clean his ears, and he would go to sleep while we were doing it. And after he fell asleep we would open up the Bible and take money out of it.

My first detail was with a guard who was real prejudiced. He would have Black guys take a rag and wash his face and all other kind of crazy stuff. He acted like he was in charge of a back-in-the-day plantation. He said to me, "Every inmate that's working for me, I give them a name. I'm going to call you Baniel." Now, you know, Baniel is a slave name. So that's where his mindset was.

Youngblood and me got into it one day. I don't know what I had done, but he came to the bars that separated the inmates from him and grabbed the bars. He said, *"Come here, Winfred!"* I was on my way to where he was standing and he said, "I'm going to whup me a nigger's ass." He was talking about me, and when I heard that I made a run to the bars like I was going to break them. He turned around and ran. Everybody laughed. But when Youngblood was getting along well with his wife, he would treat us real nice. He wouldn't give us any problems. He would let us play baseball and basketball with the other camps, and we also played baseball against the high school. Youngblood would let us do all that. I got to give it to him. Youngblood was all right. He treated us well until they shut the place down.

During the day we would go out on a work crew. There was an inmate at the camp named Sonny Cole. Sonny was a smart kid. He had a degree for surveying, and I started working together with him. I would hold the rod for him. We'd do the work and Youngblood would get the money. Later Sonny taught me how to be a surveyor. He waited until he got ready to go home. Then he said to me, "I couldn't teach you until I got ready to go home, because I got to be the only person who know how to do this in the camp. Now I'm going to teach you, but don't teach nobody until you're ready to go home, because Youngblood will do favors for you if you are the only somebody who knows how to build these roads."

What Sonny said was true. In small camps like that one, the warden did what he wanted to do. Women would come to visit the inmates and there were some little houses where folks could go for privacy. You got a little house with a bed, couch, and all that. It was a way the warden had to keep you satisfied so that you would do what he wanted. He's thinking, *If he do what I say, I'll give him a chance to sleep with his wife or his girlfriend, if that is possible for him,* and then the guys do what he say. I would too. I would do favors for Youngblood because he would do them for me. If you worked hard for Youngblood, he would look out for you.

Youngblood came to me one day and said, "I'm gonna take you and get you a license. But I have to call you a 'nigger' in front of the people who will give you the license. Would that be OK?" I told him to go ahead and call me a nigger. We went up to the state police to get the license. I was filling out the papers and Youngblood says, "I got a nigger here and I got to get this nigger a license." It was important for him to put it that way. He couldn't get up there and say, "I got a friend here working at the camp who needs a license." He got to go up there with a negative attitude, just like they got, so they would be happy.

I got my surveyor's license and also a chauffeur's license that allowed me to drive any type of vehicle in the state of Georgia. Then Youngblood hired me out to the free world. We'd go out there with no guard, and I'm bossing all these White folks around even though I'm the inmate. The White folks would make calculations to come up with how much dirt we got to put here, and how much dirt we got to take away, all that kind of thing. Every hundred feet there's a formula for the stick they got nailed in the ground. I'd look at the stick and I'd take my rod and adjust to that, whatever they left for me to do. And there were times I would say to them, "That's not correct."

"You're going to argue with our numbers?"

"Yes, I'm arguing with your numbers. They're not right. If I fix it by that formula right there, water is going to stand in this road and it's not going to drain."

They would check it and I'd be right.

Early one morning, about seven o'clock, I was building a road. It was in the spring of 1970. We had built enough of the road so that it was drivable, though we hadn't paved it yet. Down the road I was building came a truck with two girls in it. I was standing there at the stop sign and the truck stopped. I didn't know it at the time, but there was Patsy, the girl who would become my wife, and her sister. On the back of the truck were some tomato plants. Patsy and her sister were going to set out tomatoes. I thought to myself, *How could I get to talk to this girl?*

A while later a storm blew away a nearby bridge. The flood-waters floated it away. One morning Youngblood said, "Winfred, could you build this bridge back, you and your crew?" So my crew of six guys went out to the bridge site where the water had washed the bridge away. I had no idea at the time that Patsy's family lived back there past the bridge. The guys started hauling dirt to build the banks back up. I loved to drive the machines, so I got up on one of the machines too and drove a little way up the road, about a half mile or so, to grab some dirt. There was a special place to get it. You couldn't get the dirt from just anywhere.

When I was on my way back to dump the dirt I passed a house. There was the girl I had seen riding in the pickup truck with the tomato plants on the back. It was Patsy, sitting on the porch. I was working with this kid who had half a hand gone. Youngblood put him with me so I could treat him nice and give him easy things to do. But let me tell you, he could handle a shovel just like a two-handed person. He could scoop that dirt with the shovel just like he had *three* hands, though he would use his damaged hand as an excuse not to do things if he didn't want to do them. So, after I dumped my dirt, I said to this kid, "Come on, let's take a walk."

Patsy was outside the house washing clothes on an old-time rubboard. I walked up and said, "Excuse me." She looked at me, ran inside, and told her daddy prisoners were in the yard. Her daddy came out with a shotgun. I said to him, "Sir, we're building the bridge there for you to get in and out, and we just want a drink of water. Nice cold water. That's all we want." Patsy's mother heard us from inside and was nice enough to get us some ice water. Patsy's daddy stood by to make sure everything was all right. Patsy came to the door with her mother, and her mother said to us, "You boys working every day down there?"

"Yes, ma'am. We're working every day."

"Well, you guys can come up here at twelve o'clock and I'll give y'all something to eat."

So we walked up there the next day at noon and every day after that at lunchtime. Patsy was looking at me and I was looking at her.

One day when I was up there, Patsy was cooking some bacon and burned it up because she was talking to me. Just burned up everything. Her father said, "Patsy, look at what you're doing!"

I asked Patsy whether I could write to her and she said no. "My daddy and mama wouldn't like that. You're a cute guy, though."

I thought to myself, *I got to find out which way her school bus goes.* I found out how the school bus drove to her school and I took my machine and put a big pile of dirt in the road so that the bus couldn't get by. The bus was stuck there, and I walked around it until I saw Patsy. She wouldn't say a word. Finally, the driver said, "Look, Patsy, why don't you give this guy some line so that he'll quit stopping the bus." So she turned to me and said, "OK, I'll write you."

Patsy kept her word and we started writing each other back and forth. She came to visit me, but her parents didn't know I was writing her or that she was sneaking out to see me. I was making a lot of money for Youngblood, and one day he called me in the office. He wanted to do something for me. He opened up a drawer in the desk and picked up a big key. He said, "This is your key. After everybody is asleep, you open the door, go in the laundry, and put on some clothes. You can go out and see your girlfriend. Come back before they get up, lock yourself back in." That's what I did. I went out to see Patsy. I would go out, come back, and lock myself back in. I didn't escape. Ain't that a movie?

Patsy was a fine girl. She was so fine. She had a walk that was out of this world. She had a walk that should have been in Hollywood. When she was coming to see me, I could look down the road and see it was her. Nobody in the world looked like that. Her parents didn't know she was coming to see me until her boyfriend followed her to the camp. After that she had to stop coming, but her daddy couldn't stop me from writing.

One day he read one of my letters. He read my words and he said to Patsy, "Patsy, does this guy mean any of this stuff he got in this letter? If he does, then he's the guy for you." Next time I look

P.O. Box 519
Ashburn Ga.
July 19 70

Dear Sweetheart Patsy
 I got a whole lot of love for you so I
desided I would write you a letter every day this
week, I hope you don't mind (smile) I noticed you
Sunday, you wasn't uptight as you had been before,
because you discussed lots of things you have
been holding back. I am glad you can talk to me
now, I want the world to know that I love you
and we are lovers, I going to hold on to you for
ever and ever. I pray for us every night that we
can soon be together for good. I often think what
its going to be like when we are married and in
a house of our own and liveing on our own rules.
won't that be wonderful? Heavenly father who's up
above please protect the one that I love Guide and keep
her and let her know that I'll alway love her so
no matter where my love may be my heart is locked
and she holds the key. that was a lovers prayer, I
love to say it, I say it at least twenty or more times
a day, I'm looking for you to answer every one of these
letters I write you this week, don't say that you don't
have the time, you know I have a great deal of respect
for you, I'll never do you wrong. I wake up at
night thinking about you, I love you so much, I
have never loved this way before, my whole life
depends on you, you can make me be something or
nothing, I didn't ask to fall in love with you I
just couldn't help myself. I not ashame to say I

My letter to Patsy, 1970

I love you, I saw Margret Nelson today (Monday) she
was looking for ~~Jane~~ Jerome McCoy, he's a friend of
mine who I gave the address to that you gave me,
if you can let her come to your house and bring her out
here to see him, I can hardly wait until Sunday so
I can be with you, you bring me so much joy,
a preacher whose name is Reverend Jones he wants
us to come to his church and sing, if we get a
chance to go I want you and your family to be
there, we are haveing a program out here the 5th
Sunday, then will be ~~and~~ other groups here from
Ashburn and Tifton, I will send your family a card
or a invetation later next month, I don't want you
to miss this program, I want you to write Loraine
and give her these, thats alright I change my mind, I
will send them myself, think about me when you ~~goes~~ to
bed tonight, take this letter to bed with you. I'll be
~~thing~~ thinking of you tonight as always, I love you
Sweetie don't ever forget that, give love to Sisters and
nephew and special love to your Mom and Dad, I
love,

Winf

around, here is Patsy with her daddy and her mama. Her daddy says, "I brought my daughter to see you. She wants to see you so bad, it's causing a problem at home. But I don't want you to disrespect my daughter. Would you not take my daughter in one of those little houses?"

"No, sir, I will not do it." Me and Patsy were married before we slept together.

Patsy was coming to see me and I enjoyed my time with her so much. We would go in the church and kiss because it was unlocked and there was no one in there. One day we were going hot and heavy and her mama came back to get her. We had been sweating so much Patsy's hair wouldn't curl. It was just hanging down straight and her mother said, "Patsy, what happened to your hair?"

"Mama, it's hot in there."

Now what happened to Youngblood's camp was this. One time, after I had been at the camp for about two years, Sonny Cole and I went by this woman's house. Sonny and her had a thing going. He parked the truck and went in to see her. But as soon as he got in the house, the husband drove up. The guy was going up the steps and Sonny came running out of the door and ran over the top of him. I'm sitting there in the truck watching every move. Then I started the truck up and began creeping off. I said, "Jump, Sonny! Jump!" and he jumped on the back of the truck. By this time the guy had his gun and began to follow us. I drove way out in the country. I was driving fast on those country back roads and this guy couldn't catch us.

The man turned around, went home, and killed his wife. And that's what got the camp closed. The people in the neighborhood said that Youngblood was giving us too much freedom.

THE CHAIN GANG

I got transferred to a place in Morgan, Georgia. It was one of the worst places I've ever been. There ain't a minute I can think of when the warden was good. Not one minute. He didn't give a damn what I knew or what I could contribute to his camp. He didn't care that I had become a model prisoner. He didn't care about the fact that I was trustworthy and could work without a guard over me. I told the warden that I could build roads and operate all kinds of equipment. The warden didn't care *nothing* about that. He put me out there on *hard labor*.

Morgan was all about work and busting you down. Not just physically, but in a mental way too. Everybody was locked down tight. They didn't have no movement. There was no playing around, no freedom. The only thing they would let you do was to go in the yard on Sundays. There was a big yard with a tall fence. On Sundays we would play basketball and throw the football around and the inmates would talk to each other. Other than that, we were tied down. No freedom. And the warden is sitting there outside the fence, with his guards, just looking at you like he owned you or something. That's the way it felt to me.

You had to go out in these caged trucks—back of the truck built like a cage. You would go out with ten or twelve guys. You climb in the truck, sit down, and they would shackle you to the truck. All these prejudiced guards would talk a bunch of crap to you. They were ignorant too. I remember one day we were out doing a bridge job. At lunch break I was sitting there talking to the guard. He had a can and he opened it with a knife. I saw him open that can and start eating out of it. It was a can of dog food that looked like corned beef

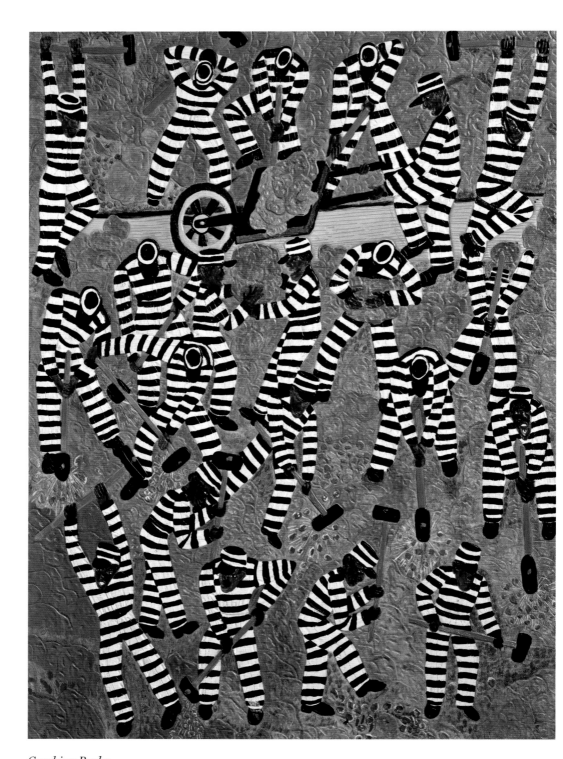

Cracking Rocks

hash. I said to him, "Hey, boss, what are you eating that dog food for?" He said, "Oh, that's my wife. I told her about mixing the dog cans up with the food!" I think he couldn't read.

The food for the inmates was terrible. They served a dish they call "shit on a shingle." It's ground beef scraps with white gravy and they give it to you on a board. Every prison you go to had that. We ate a lot of beans too. One day there was a rat in the beans. He was in the pot, cooked with the beans, white beans. I said, "Boss, there's a rat in these beans." And he said, "At least you got meat!"

And that's the way it was. It was just that gross. I didn't eat those beans after I saw that rat, but I was eating them before that. You had to expect bad food. It wasn't clean. The food was crap, but you had to eat something to live.

I worked hard that first year, digging ditches and breaking rocks. That was a time when me and Patsy were just writing each other, because I couldn't see her. It was tough. Being at a place like Youngblood's and then getting shipped to a place like Morgan— sometimes you don't think you can make it. It seemed like they wanted to make the work hard. They wanted to make things as hard as possible for you.

They had a big vat at the camp, built out of wood and tin, a few feet deep. It was filled up with creosote. They would put poles and cut trees in there to keep them from getting rotten. One day a guard walked up to this kid and pushed him in the creosote bin. I'm telling you, that kid was burning. His skin was falling off. He was real scarred after that. He lived, but he was messed up. He looked like he got burnt in a fire.

I felt so bad for that guy. He already had only one eye. After that, whenever he thought something else was going to happen to him—oh my God, he would just tap dance all around the place, literally. His nickname was Frog. Frog was a guy that was afraid of White people. Have you ever seen a Black person tap dance in front of White people just to show humbleness? Frog could even dance on his hands. He could stand on his hands and dance. That was his way

of showing humbleness, and the guards loved it. The mental cruelty may have been worse than the physical cruelty. Other inmates would see that type of thing and it made them humble too. The guards could say or do anything to them.

It was at Morgan that I was first introduced to the sweatbox. I had never seen a sweatbox before. When they put you in sweatbox, you can't stand up and you can't sit down. You're in a crouch. You can't see out. It's dark except for daylight coming in through the cracks, and it's real hot in there—sweating hot. They keep you in there anywhere from three days to seven. You use the bathroom on yourself. When they're ready to let you out, they'd pull you out, strip you naked, and put you in a little space with a fence where they'd turn a water hose on you, like a fire hose, to clean you.

They didn't have to have a reason to put you in the sweatbox. I mean, they would find some reason—like if you were in the ditch and you weren't digging right, you weren't using the shovel like they thought you should, or you talked back—but their reason wasn't worth anything. They just wanted to be cruel to you. I had been through so much in my life before I even went to the chain gang. Let me tell you, I could take a lot of cruelty and survive. I figured that if I had survived that lynching, I could survive anything they threw at me. But when I stood there in the sweatbox, I was afraid I was going to lose my mind. In the sweatbox your mind is talking to you constantly. I'm thinking, *Am I going to really lose it? Am I broken?* I remember being scared the guards might come and throw some gas in there and kill me. I had never seen that happen, but there were always unexpected things happening, and I knew I was a guy that the administration didn't care too much about. They didn't like my thoughts.

The sweatbox was there for a reason, and I think that reason was to break you. They didn't want you to talk back. They didn't want you to say anything to other inmates that might cause them to be disobedient. So they would crack you upside the head and throw you in the sweatbox. That's part of the cruelty you go through for being Black. Up until the later days, I thought the chain gang was

designed just for Black people. Later I saw some White guys go through there too, but the White guys on the chain gang couldn't take the cruelty like the Black guys could. They would try to run away and they'd get shot. Black guys wouldn't take a chance on that. Because the White prisoners were a threat to run, the guards would shackle them to each other. The White boys really turned the prison camp into a chain gang.

For some reason, I felt I could withstand. I had been in the sweatbox dozens of times and I began to think to myself, *There's a lot of power in the sweatbox. Somehow the power has to be taken away from the sweatbox. How can the power be taken from the sweatbox?* There was a little door in the front of the sweatbox. Twice a day they would open that door and push in a cup of water and two slices of bread. I decided I wasn't going to eat that bread or drink the water. I was thinking that if I didn't drink that water or eat that bread, I wouldn't satisfy their ego, you know, them thinking, *I got this nigger in the sweatbox and I'm treating him like an animal. I'm treating him worse than my dog.*

You know, when they set that water up there and that bread, that bread looks like a piece of cake. It looked good. I wanted to eat it so bad. I wanted to drink that water so bad. But I would mess my plan up if I did. So I didn't eat or drink and I took the power out of the sweatbox. That's what I felt like I had done. I wanted other inmates to see that too. I felt like if other inmates saw me take the power that they would do it too. But when the guards mentioned the sweatbox to them, they would get so humble. They would do a tap dance not to go. They would do all kind of old crazy things trying to satisfy the guards. I didn't. I did what I wanted to do and I accomplished my feat.

Now on the way to the sweatbox with you, they would hit you with their gloves and things in front of everybody. I didn't want the other inmates to see them doing that to me, so if I did something that made me think I would be sent there—if I had disobeyed when I was working or I didn't do something to the guards' liking, and I

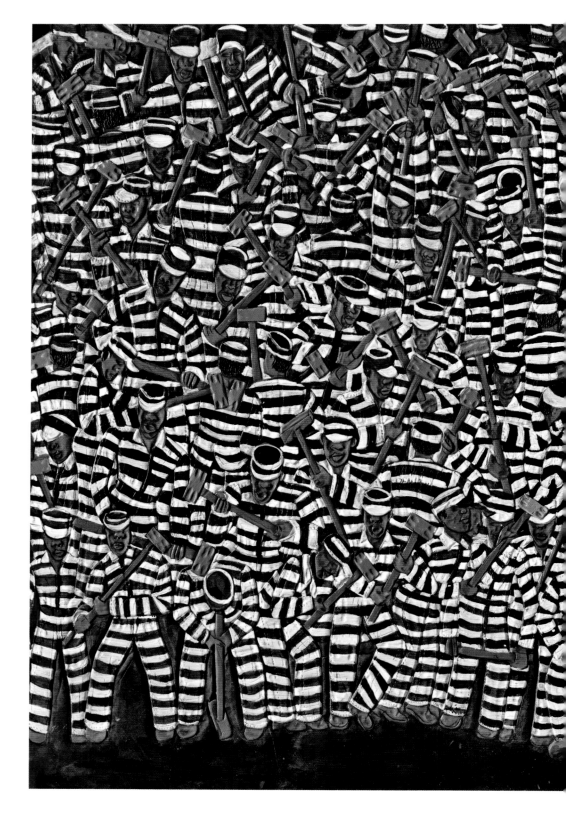

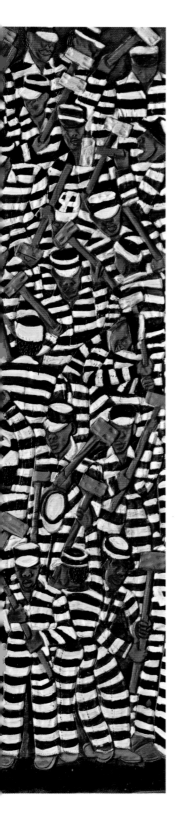

All Me

knew they were going to lock me up—I would go and stand beside the sweatbox and wait for them to put me in. I wouldn't wait for the guards to come and get me. I wouldn't let them march me past the other inmates. After I did that three or four times, the warden came out and said to me, "Nigger, get away from the sweatbox. You can't predict what I'm gonna do." To the other guards he said, "That nigger's crazy." And guess what? I never went to the sweatbox another day.

I realized I couldn't be what the officials were expecting of me. You got to put that in your head so they can't break you. They want to break you. If you're not broken, they say you're crazy. That's what they decided I was. They called me a crazy nigger.

The chain gang is one of the most ruthless places in the world. The state owns prisoners, so there are rules and regulations, but the county owns the chain gang, and there are no rules and regulations. The guards don't care what you do, so there's more pressure on you to be bad. Inmates put pressure on you to fight. They might approach you with one of their shanks—homemade knives that they would hide in their bunk—or they'll block you when it's time to go to the mess hall, or maybe they'll turn over your plate. When they do that, you got to jump on them right then and there. If you don't fight, you're going to get that all the time. You got to fight. And I mean you've got to really fight. You may have to draw blood. I never had a weapon. I'd use my hands and my feet. The knuckles on my right hand are rough, even today, because that was my punching hand. I also did a lot of kicking and stomping with my chain gang boots. If I get you down on the ground—you stomped.

It seemed to me the goal of the chain gang was to make you bad, to make you do bad things. That's the Winfred I didn't want to be. I showed meanness as a survival tool. I would sometimes do crazy things to people. I had to go through a lot to show myself as somebody who couldn't be bullied. I would say things like, "I might lose my life, but I'm not going to be bullied," and I would mean it. I had to

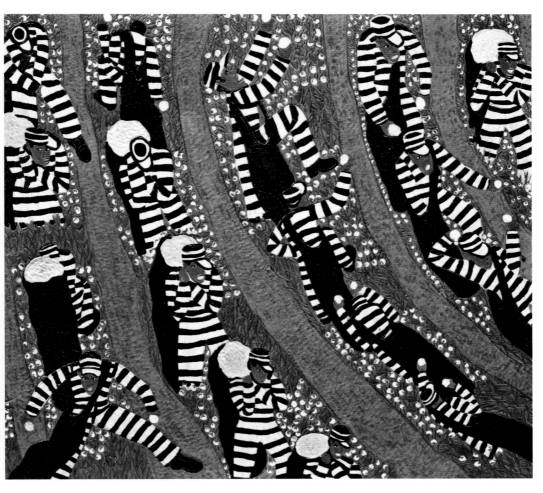

Chain Gang Picking Cotton

take on all these personalities. I only wanted to be one of them, but the one I wanted to be, I couldn't be.

There were probably more good guys on the chain gang than bad. Even the ones that tried to bully me were trying to hide the good side of themselves. There's a lot of demands on you as a prisoner on the chain gang. "Hey, nigger, get over here with a shovel. Dig that pipe out." You have to do it or you'll go to the sweatbox, and you have to answer in the manner the guards want to hear, rather than how you actually feel. You have to play a role that isn't really you. It's like slavery. You have to meet all those demands and keep a sense of yourself as well. You don't want to be identified with any of the roles you have to play, so you are all of them. It's like all of you and everybody else around you are all tied up into one.

All Me—that's how I painted it. Each person in the picture has a role to play. I didn't want to play any of the parts, but I had to be somebody. I couldn't walk around and be nobody, so I became all of them. It's like I was more than one person inside myself. In fact, I think if I hadn't decided to play the *all me* role on the chain gang, I wouldn't have made it. Taking that stance—*all me*—saved me. Everybody thought I was crazy. The guards and the inmates too: *That nigger crazy!* One thing is for sure, when inmates think you're crazy, you can survive. They won't mess with you. And when officials think you're crazy, you'll never go to the sweatbox.

OUT OF THE DITCH

At some point, after a year or so at Morgan, the warden brought me out when he was building roads. They already had a road crew with machine operators, but they didn't have a guy who could read the transits. The transit is a machine that you set up and it tells you how much dirt you got to pile up or how much dirt you got to take out. So, finally, the warden put me in charge of building a couple of roads. They needed me but, at the same time, I was a crazy nigger and they didn't want to see me doing anything I wanted to do. So before long I was shipped out of there.

I was transferred to a place called Bainbridge. This Bainbridge needed some workers for digging ditches, and I was one of the guys they decided to ship. We worked hard in Bainbridge. You'd get up at about 6:00 a.m. and the detail would go out around 7:30. We would come in at 4:00, you'd take your shower and wait until you're called for supper. We worked so hard that sometimes I lay down on my bed to wait my turn in the shower and the next thing I knew they were locking us up for the night. I didn't get a chance to take a shower or eat. That's how hard it was.

I had worked hard before. In Reidsville we dug up tree roots. They'd cut down trees around the county and leave a few feet sticking up out the ground. You had to dig down in the ground until that tree would tilt over. Sometimes you'd be so deep in the ground you'd be clean out of sight. You'd be that deep in the ground. The work at Morgan was tough too, but Bainbridge was harder. At Bainbridge we had to work overtime and under all conditions. There was almost no time to write letters or anything like that.

I've painted a lot of pictures of the chain gang. I believed that many people in the free world thought bad of the chain gang. They

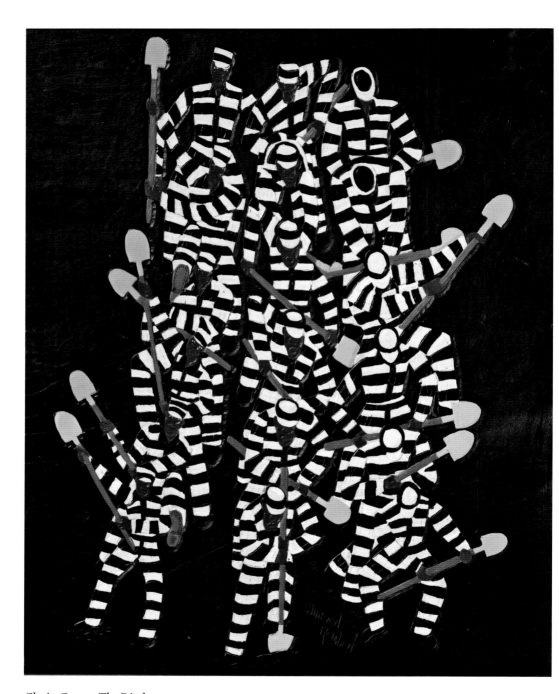

Chain Gang—The Ditch

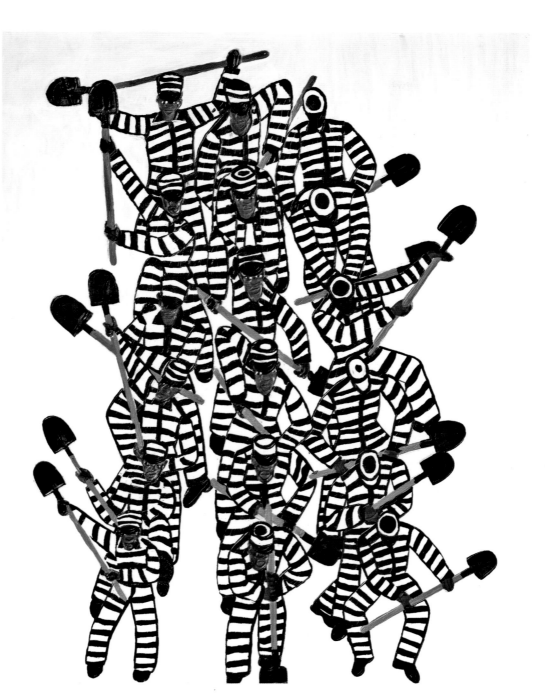

In the Ditch

looked at the workers on the chain gang, working on the highways and in the ditches, and I believe they thought that all the guys were killers. That's what Patsy's mother thought about me—at first, before she knew me. She was scared I would hurt her daughter. She didn't want Patsy and me to have a relationship. With the paintings, I was trying to show that it wasn't that way. There were a lot of guys I thought didn't deserve to be there. Most of the guys there on the chain gang were there for nonsupport of their children. They would get you quick for nonsupport in Georgia. You have a baby and you got to pay, or else you'd go to the chain gang. Those nonsupport guys were mixed in with other prisoners who had a long time. I had that twenty-seven years, and there were a few more of us that also had a long time, but most of the guys there had a short time, for non-support. The nonsupport guys would do six months or a year and then they'd be let go to see whether they'd take care of their children. If they didn't, they'd be back on the chain gang.

With my paintings, I tried to make a bad situation look good. You can't make the chain gang look good in any way besides by put-ting it in art. Those black and white stripes look good on canvas. People can't really tell what they are until they get up close. They don't recognize those stripes as people until they take a real good look. That was my goal—to put it down so you couldn't under-stand it until you take a real up-close look. That tells you something about prison life. When you look at it from the outside you can't see what's going on, but when you're up close you realize what you're up against.

We were in the ditch. It was the first time I was ever in a ditch that deep. You're down in the ditch and you got a shovel and you're digging. The object was to throw that dirt up on top, out of the ditch, where there are already tall piles of dirt, ten or twelve feet high. That's what they're expecting of you, and if you can't get your dirt up there, they got a problem with you. They crack you upside the head. You don't even know they're coming and they crack you upside the head with those nightsticks if you don't get that dirt up there. And if

you happen to dig into a hornet's nest, or come across a rattlesnake or a water moccasin, you'd have to deal with it. You couldn't run or you would get shot. I saw a lot of bee stings, but I was lucky enough never to hit a hornet's nest. We also had to deal with red ants. You might dig into a pile of them, and they were *terrible*. They'd go up your pant leg, but they wouldn't bite you one by one. They'd pile up on your leg. Then they would wait and bite you all at the same time. I guess one of them sent a signal.

Sometimes the water in the ditch was up past your ankles and you'd still have to dig. You were not supposed to have to work under thirty-two degrees. I think that was a law in Georgia about the chain gang, but it was a law that was just a law. They didn't care about laws when you were working on the chain gang. In the winter, you'd stand up on that ice and you'd break through and go right down into that cold water. I saw people's toes get crazy messed up with frost-bite. And when you were shoveling, that cold dirty water got all over your clothes. In the summer it was hot. Can you imagine how hot a Georgia summer is anyway, *without* you being in a twelve-foot ditch? And you are not just in a ditch; you are shoveling. Can you imagine how hot that is? It's *hot*. You don't get any air. Somebody would fart in that ditch and you could smell it for the next forty-five minutes.

If someone had to go to the bathroom, they'd say the word: "Getting over here, boss." That meant you had to take a crap. The guard would say, "Come on up. Get over there." You come up out of the ditch, go twenty or thirty feet away, and do what you had to do. Then, if the guard was a mean guard, he'd say, "Bring some back on the shovel." That was to prove you had to go. That's the ditch. Ain't that crazy?

Now at Bainbridge there were at least five or six details. There was a guard named Gilliam. He was a good man. I worked hard on every detail I was on trying to show that I was complying, and Mr. Gilliam saw that. I had asked him whether he could get me on his detail. Finally, he did and he made me what they call a "jackboy." The

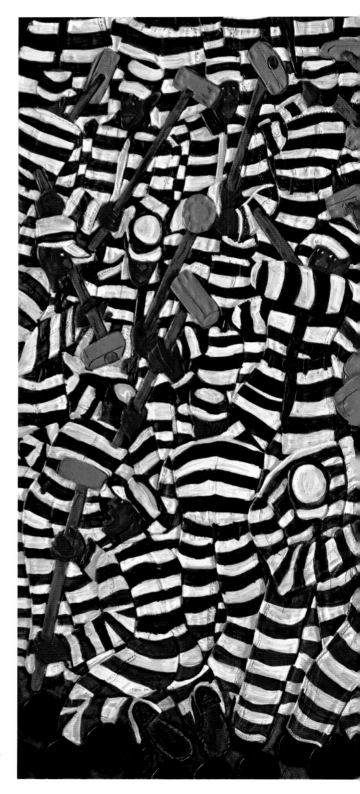

All Me II

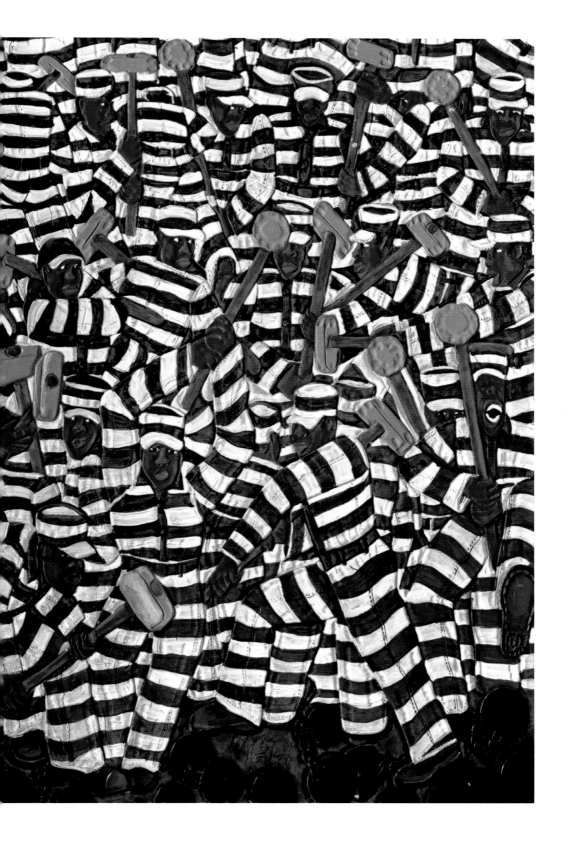

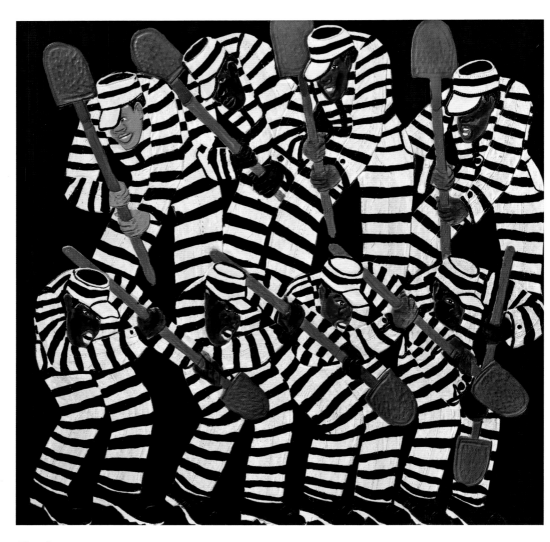

Shovels

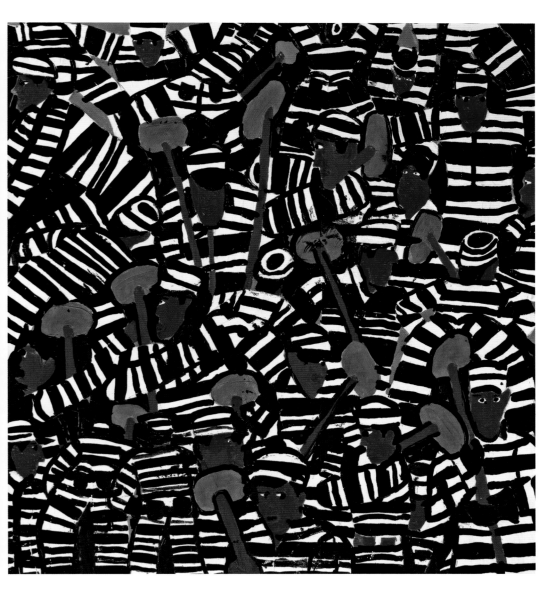

Stripes

jackboy sharpens all the tools. If your shovel's broken, he would get you another shovel or fix the one that's broken. He would get the food from the truck at noontime, give everybody a plate or food bowl, and bring the food around. That's what the jackboy does. The guard wasn't afraid that the jackboy was going to jump him and take his weapon. The jackboy was trusted. He could walk up to the guards and have conversations. A lot of times the inmates would be working way up the road and I'd be back there talking with free people who lived near where we were working. Mr. Gilliam didn't care about that.

Things were better for me when I was working as a jackboy. I started writing letters again. I wrote letters to congressmen. I had been writing letters for a long time—four or five years, starting when I was at Leesburg. I explained what had happened to me and why I was there. I explained that I had worked on the movement and escaped from jail. I wrote to people I thought would hear my case and do something about it. I thought Black congressmen who were working in the civil rights movement might do something for me. The prison library had this article on Ronald Dellums, who was a representative from California. So I wrote him a letter. We couldn't mail letters like that from the prison, though. They wouldn't get sent. So we would take our letters and drop them by the side of the road and hope somebody would pick them up and mail them. We had no choice. Hope was the only thing we had.

Some months later I was coming up for parole. I went before the parole board and they asked me a lot of questions. They asked me whether I would have a job if they let me go and all that kind of thing. My sister Loraine was in Rochester, New York. I asked her if she'd get me a job when I got out. She wrote to the parole board and told them she had a job for me. And there I was, waiting and hoping.

One day I came in from a hard day's work, feeling sad and blue. I was getting ready to take a shower and the assistant warden was passing out the mail. He said, "I got a letter for you from the parole board, Rembert. You're going home in ten days." I looked at the letter and, sure enough, it said they were releasing me in ten days. I had made

parole and I was going home. I couldn't believe it. I had been locked up for nine years—two years in the Cuthbert jail and seven years in the Georgia system after my almost-lynching and mock trial. I didn't know how to act. It was tough because, in prison, when you get ready to go home, there are a bunch of other prisoners who don't like that because they're not going anywhere. There are guys who ain't going nowhere, ever. They're going to die in there. I had seen somebody get stabbed who was going home. I don't know if anybody had anything planned to do to me, but I had those thoughts in my mind. I had to watch my back, and I tried to hurry those ten days up.

On the fifth day, I'm halfway there, ready to go, and here come these guys and they want to go on strike. All the time I'd been in prison, all those years and all those camps I'd been in, ain't nobody ever gone on no strike, and here are these guys who want to go on strike. They thought the work was too hard—you know, the work in the rain, water up over your shoes, all that kind of thing. So they were going on strike. I said, "Guys, please, why can't y'all wait? I'm going home in another five days. If you go on strike now, I'm not going to be released!" But they didn't want to hear that, and they would hurt you if you didn't participate with the strike. They had shanks, and some of the guys that had a long time didn't mind hurting you. They might cut your throat.

On the sixth day, they didn't strike. We went to work, and again on the seventh day. On the eighth day, they struck. When it came time for us to go to work, the guys said, "We're not going to work today." Now when the prisoners wanted conditions changed, they wanted conditions *changed*. But Bainbridge ain't changing no conditions.

The place was integrated—half White and half Black. There were about eighty of us together in one big bunk room, some up and some down. I'm sitting on my bunk. Here come the guards. "We're going to open the doors and all y'all that want to work, come on out. All y'all that stay in there, we'll deal with that." I wanted to go out that door so bad, but I was scared for my life.

Nobody went out. The warden went and got the state police. You could see them through the glass, and here they come. "OK, we're going to say it again. All y'all that want to come out, you come out." Nobody went out.

What happened next was that the police took these gas bombs and threw them—four, five, six bombs, rolling in. Somebody said, "Get on the floor. It won't come down on you." That's a lie. It don't make no difference to be on the floor. That gas was tearing us up. I was there coughing and gasping on the floor. You couldn't breathe. The guards yelled, "Can you come out now?!"

I'm always surprised by things and I shouldn't be. I had no idea how they were going to handle that situation, but I surely didn't think they were going to throw no tear gas on us. I thought they should have said, "Rembert, you come on out here. You're going home anyway." If the warden had called my name, I would have gone out there and asked him to lock me in another cell, somewhere by myself. But he didn't.

The ringleader of the strike, a White guy, was the first one to hit the door. When he come out, I went out. Eighty percent of them guys came out. We went up against the fence to catch some air. The other ones didn't make it. They had to be carried to the hospital. I never appreciated air so much in all my life. It was a blessing. That air was the best thing I ever experienced. God's fresh air. I wasn't thinking about who was left in there. All I could think was, *Thank God I'm breathing.*

That tear gas made all those tough guys weak like little babies. After that we went to work. The warden didn't hold it against me that I initially stayed in the cell, even though he could have. So after seven long years of hard labor, I was released. The warden wanted me to stay there, in Bainbridge, and work for the camp. He wanted me to run the machines and build some roads for him. I said no to that. They gave me thirty dollars and a suit that was too little. The legs were too short and I couldn't hardly button the waist, but I squeezed those pants on and got the hell out of there.

Mama, Boy, and Boy's wife, Candy Lee, came to the prison to get me. I said I wanted to go to Patsy's house. Mama didn't want to do that. She was scared. She wanted to get me out of there and right on up to Rochester, but I had promised Patsy, and Boy was big on promises. He was a promise guy. If you promised something, he wanted to make sure it got done. So he intervened and said he would take me there.

When I got to Patsy's house, she was in the back room. She came out, looked at me, and couldn't believe it. She was crying and we hugged. "Patsy, I came to get you. Are you really going to go with me?" She said yes.

"How do your parents feel?"

"They don't know you and they don't want me to go unless we're married."

"Well, let's get married."

We tried to get married that same day, right then and there. Back then you had to have a blood test to get married. So we took off for town to get the blood test, but everything was closed. I said, "Patsy, just give me a little time and I'll come back and get you. I got a job. Let me get us a place to stay and then I'll come back and we'll get married." It was July 1974. I left in the car with Boy, and Patsy was just going crazy. I was free from prison and she was scared I wasn't going to come back. But I went on, took that job, and saved my money. I worked for a woman named Emily, who was a friend of the family. She had a business cleaning office buildings.

By December I had an apartment for us, and Patsy is still thinking I'm not coming back. So I sent her a thousand dollars and said, "Patsy, buy yourself a dress. I'm coming to get you." Loraine's husband, Joe, was going to Florida and I asked him to drop me at Patsy's house. We pulled up and they were boogying back in there like it was a juke joint. That's the way it was, because Patsy's mama sold home-brew—homemade whiskey. They had a house full of people all the

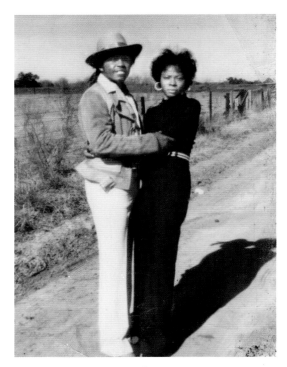

Patsy and me, 1974

time, drinking. I walked in and Patsy was sitting in the middle of the bed, adding up what people owed her mother on credit. I said, "How much do I owe, Patsy?" She looked up at me and threw the pad and pencil up in the air. Then she kissed me. Now, I don't think Patsy ever did that in front of her mother before. Patsy had a lot of respect for her mother, so I knew that if she was kissing me in front of her mother, it was a serious thing.

I got me a tuxedo and on Saturday Patsy and I got married in the church. Her daddy gave her away. When we came out of the church—they're throwing the rice and everything—one of Patsy's boyfriends reached to grab her hand as we walked by. Patsy's brother said, "Uh-uh. It's over. It's her day now. Get out of here."

Patsy's brother Edward wanted to know where we were going for the honeymoon. I had no idea, so he drove us to his house in Columbus, Georgia, and that's where we spent our honeymoon. That

was the first time me and Patsy ever had sex. Her mother drove up to Columbus that next morning and she said, "Well, Patsy, you can't lie to me no more. I know what you did last night." And we all laughed and got a kick out of that. Patsy's mother wanted us to come back to her house and they drove us there. It was just *good*. And in two or three days we were leaving to go back to Rochester. I had us plane tickets and we flew. It was the first time Patsy had been on an airplane. When the plane landed, it couldn't stop with all the snow and ice. It slid all the way to the end of the runway and Patsy was going nuts. We got off the plane and the snow was piled up high. She'd never seen all that snow.

I took her to our apartment. There was no furniture. I had a little fold-up bed. Patsy slept on that little bed and I slept on the floor. All we had was a stove and a refrigerator and that little bed and a little TV. But before long I bought a bedroom set, and then a living room set, little by little, and finally we had a house full of furniture.

I loved Patsy. I don't know how that worked out like that. I don't know how I was able to show my love for her and be convincing. How was I able to be convincing? I'm locked up behind bars and she's free. She's *free*. I convinced her to wait for me, just through letters. I haven't read through all of those letters again, but Patsy still has them today. I wanted her to think that I went to school and graduated, so I'm pretty sure I must have lied about that. I tried to convince her any way I could to wait for me, and it worked. She waited like she said she would. I know there were guys who offered Patsy everything in the world. After Patsy spent the money I sent, they offered to send the thousand dollars back out of their own pockets if she would tell me she didn't want to see me again. But Patsy waited for me and she didn't have no problem leaving with me. That's the part that gets me. You're going to leave your mother, your family, to go with someone you don't even really know? Much of what you know about that person is through the mail. There must have been some good stuff in those letters. I just couldn't believe good things finally happened to me.

because I don't answer — I'll be there before you get the chance (smile)

Hi Darling,

How is my future wife? time is drawing near, by the time you get this letter I will have about five days left, the 25th is the day I will be a free man, yes darling I'm comeing home, your waiting and suffering is over, I am very ancious to see you and to touch you, and to look once more into those beautiful eyes I know its going to be good holding and kissing you once more, I have been threw hell thinking about you, knowing you need me and hopeing I could hold on to you until I come home, you are a very

My letter to Patsy, 1974

strong young lady and your love
for me has got to be strong
for you to waite three years,
its not every day that a guy
can find somebody that feels that
way and care that much for him,
I'm thrilled to death that I got
you, I apreciate you and your
ways and most of all I'm glad
that you didn't turn me away
the day I met you, that day
will always remain in my mind
it was the start of something beautiful
that has yet not start to looze its beauty.
its still the same way it was on
your back porch and in Church and
every other time we had the chance
to express our love, be sweet
and be looking for me between
the 25th and the 30th, I get out
the 25th but I might can't get there
the same day,
Love & kisses
Winfred

BECOMING A LEATHER MAN

When I go to buy leather, I examine each hide. Some I turn away and some I don't. I look for a nice, smooth piece of leather with few blemishes or holes in it and I make sure it's not too dark. Leather comes in different shades—some dark, some light, some in between. I try to get the lightest piece I can so that when I use the dye, it really shows up.

Hides don't come usable like they are. When you're ready to work on them, you have to square them up using a square ruler. The first thing you do to your canvas is square it up. I cut a hide into the shape that it allows. Different hides have different shapes. I cut the biggest square I can and use what's left over to make smaller pieces.

Once I've squared up my canvas, I lay it to the side and go to my drawings. I look to see which drawing will fit the piece I cut. Then I take my spray bottle and spray the leather. The leather pulls the water inside and leaves a semiwet surface. I put the drawing on top of the damp piece of leather and tape it down. Then I take a pencil and I trace the drawing. I remove the drawing and the image is pressed into the leather.

When you trace a drawing onto leather and you lift the paper and look underneath, you want that traced image to be exactly what's on the drawing. You want to do the best possible trace that you can do, and you worry about whether it's going to come out right. You worry, and then you feel good when it comes out the way you want it to. Sometimes the tracing doesn't come out right, but after years of working with leather, I know how to correct it. I remove lines that are not right by flattening them using a tool that's shaped like a spoon. Or I might create something that's not in the

drawing in order to compensate for my mistake. I'll add something to fit those lines.

My tools

When I start beveling, I start at the bottom and work my way up. I turn my bevel backward, forward, and to the side, to make the leather rise up and go down. I use my pear shader to make eyes look like eyes and lips look like lips. The pear shader makes perfect sockets for your eyes to fit in. You work with half of the pear shader for a smaller eye or the whole pear shader for a full eye. I discovered that by studying my tools. I stitch seams onto shirt collars and thread belts through loops using the sharp point of a cutter. I can even sew up a pair of torn pants with that knife. I take a spoon to make prison cell bars pop out and fingers wrap around them. You spray the leather and make it nice and wet. Then you press that spoon into an edge real hard, back and forth, back and forth, back and forth, until the bar and fingers look round. You'd be surprised at what you've created—a round bar on a flat piece of leather. I'm happy when I discover how to do things. It makes me feel good.

*

In Bainbridge, I'd been locked up next to a guy named T.J. He was a little barrel-like guy and he was mean. He was doing a long time. I think he had been there fourteen or fifteen years when I got there, and he was still there when I left. You know there were some guys in the Georgia system with long sentences who had it easier than guys with shorter time. Like when you kill somebody, in the Georgia system, it's easier to do your time. They got it backward. It should be harder, but when you kill somebody they give you an easy job and let you do easy things. I think maybe it's because when you have a long time they look down on you with compassion.

T.J. was the first guy I'd ever seen do any leatherwork. I would peep through the bars at him. I called him T.J. the Tooler. The warden let him do his leatherwork. T.J. made shoulder bags, billfolds, and wallets. I noticed that he put the same thing on everything he made—a rose. He had a stencil with different sizes and he would trace that rose on everything he made. It was the company rose, the signature piece of leathercraft company Tandy Leather. I've always been interested in doing things with my hands. As a boy, I enjoyed making toys. So when I saw T.J. doing things with his hands, it drew my attention. I had the idea that I could make things and send them to Patsy and Loraine, and they could sell them. I also wanted to make beautiful things I could bring home, if I ever got out.

I had a conversation with T.J. one day and I told him I could draw. So he talked the warden into letting me come over to his cell. I started drawing all kind of stuff and tracing it on his wallets and things. I asked T.J. to teach me how to sew, because he had a pretty stitch that he was putting in his wallets. I began to sew up things for him and to paint. He also taught me how to tool—to cut and bevel the leather. Then I started making some stuff for myself. T.J. didn't like that. That was the end of our friendly relationship.

I tried to get the address of the place where T.J. got his tools, but he wouldn't give it to me. So I talked the warden into letting me use the shop where you cut iron. The guards didn't let inmates in that

place because they might sneak something out of there and try to hurt somebody. But the warden had pity and he let me go there so I could make my own tools. I would work with them in T.J.'s cell, and after I was done I'd drop them off in the warden's room where they would be counted. T.J. didn't have to lock up his tools. He kept them in his cell. He kept all of his leather and tools there, and he kept everything neat. He didn't have to go out to work either. His clothes were nicely pressed every day, clean as a whistle. I never knew how. They had a laundry there in the camp, but nobody was pressing clothes. T.J. probably had his own iron. He had creases and everything.

T.J. wouldn't let me use his tools, but we would still sit around there in his cell and talk while we worked. I was killing time. You get tired of lying in your bunk, not sleeping, thinking about the people you miss. So I worked with my hands and it took my mind off a lot of things. T.J had a big, nice place to sit around and work. It wasn't really a cell that he was in. It was more like a big room, though it had bars. He wasn't happy about me being there, but he had to put up with it because the warden had given me permission to be there.

The next thing you know, I was a leather man too. My billfolds and pocketbooks all had different drawings on them. I would draw whatever I could think of—a band, or a person blowing a horn, or two people dancing, or a person holding a microphone and singing. I was good at it. I could fit a lot of detail on a billfold. I made a few things and sold them to people who came into the prison on Sundays to visit. The billfolds looked nice and I had a couple of shoulder bags hanging up there. Everybody liked what I was doing and, boy, T.J. was not happy about that. He would give me the eye every time he passed by—that old crazy look—and he tried to get the warden to stop me from selling stuff. I was selling purses for fifteen or twenty-five dollars. I'm so surprised at myself, thinking about it now. Here I am today, selling my paintings for a lot more than that. I got to thank T.J. for getting me started.

*

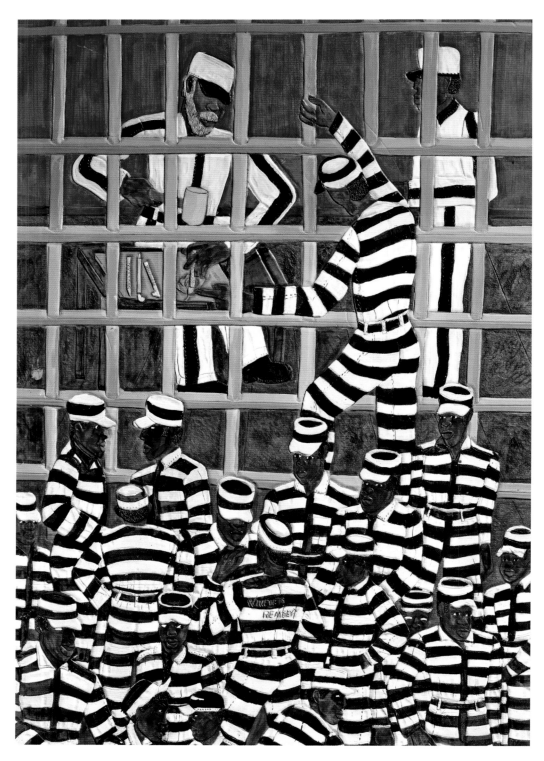

T.J. the Tooler

Times were so different when I got released than when I went in. I had been keeping up with things by reading in prison. People threw magazines by the side of the road. We would find them when we were out cutting grass and we'd pass them around. But it was something different to actually see how things had changed. Most of the civil rights work was over. The marching and protesting was done, except here and there. I thought things might have changed for the better and that maybe Black people had proven that they deserved to be treated equal, but I saw that things hadn't changed. There were a lot of things I wasn't happy about, but what could I do? I was an ex-inmate. No one wanted to hear from me. I was on parole and I didn't want to go back to jail. I wanted to work, marry Patsy, and have a family.

I was happy to be in Rochester and to try to get a new life. I was working for Emily's cleaning business, and Emily had a liquor store too where I also worked. She was married to a guy named Eddie, but Emily was the money person. She handled all the money, and she had money. She bought this huge house in a magnificent neighborhood just outside of Rochester—in Henrietta, New York. Emily drove her car in the garage and the kitchen was right there. You walk up some steps and you are in her kitchen. I've never seen anything like that, even in rich people's homes. You drive in the garage and you are literally in the house.

Emily and my sister Loraine were close. Emily would come to Loraine's house every day. She had a big part with my parole, and after that she wanted to control my life, to boss me and tell me what to do. She said, "You just got out of prison, you got no business getting married. You need to be single for a while so you can find a woman who you really want. Let that girl stay in Georgia. There's a million pretty girls in Rochester." It was true that the church I was attending had a lot of pretty young women. I mean, so many. I was one of the lead singers in the choir, so it was easy for me to meet them. But I didn't listen to Emily because I was in love with Patsy.

Patsy and I had a lot of fun in Rochester. We went out on Lake Ontario, renting boats, fishing, and just having a good time. I knew

she was lonely for her parents, so I tried to give her a good time. I also put nice things in our house. I went out and bought the car she wanted—a Pontiac Grand Prix. She wanted it and I went out and got it, though a car wasn't easy to get back in them days. I did some leatherwork in the evening for a little side money, like I had done in prison. I found a place that sold leather and tools, and I did fairly well. I sold some shoulder bags on the weekends for $150 to $200 each. I also worked a second job at Morris Distributors, which was owned by a guy named Hank. I had a shipping-and-receiving job. My job at Morris Distributors didn't last long though. Hank hung himself. They found him in the garage at eight or nine o'clock in the morning.

Patsy miscarried her first pregnancy. She was so upset I decided to take her back to Georgia. She didn't ask me to take her back home, but I did. It turned out I didn't lose much by leaving the job I had with Emily. I would have lost it anyway. Emily's husband, Eddie, had an outside affair and Emily came home and caught Eddie with his girlfriend. Emily just blew up and killed both of them. She went to prison, and after five or six years, she died. She was fortysomething or fifty years old.

So Patsy and I were living in Georgia again and I got a job with—guess who?—Youngblood. He was grinning all over the place when he saw me. He didn't have the camp anymore. He had a construction company with all the equipment. I went out there doing the same thing I was doing in prison and he paid me fairly well.

Our first child, Winfred Jr., was born in Georgia in 1976. Patsy was pregnant, and when it came time for Junior to be delivered, they delivered the baby but they wouldn't let Patsy bring him home from the hospital. You couldn't bring your baby home until you paid the full amount of the delivery: $750. So Patsy found me on the job. She said, "Winfred, they won't let Junior come home." I told Blood—I called Youngblood, "Blood"—and Blood took Patsy up to the hospital. I don't know whether he paid them or not, but he got Junior. That's the way White folks are down there. They are *with* each other;

they on the side of each other. They *look out* for each other. They had the nigger thing going, to make each other feel good. It was like what Youngblood did when I was on the chain gang and he had to call me nigger so I could get my driver's license. He probably did the same thing when he went in to get the baby: "This nigger work for me" and so on. I don't know why it satisfy White folks' minds so much when they hear that word. They are so happy to hear it, they will just go along with anything.

Me and Patsy's mother weren't getting along very good, and I wasn't happy living in her house. You know how it is when you're living with your in-laws. It never works. The house was too small for all of us, and I knew if I lived there I never would accomplish anything. Patsy's mother wanted this and she wanted that. The situation called for me to help out, and I wanted to help, but I couldn't save nothing. I wanted to go where I could get a better job and my kids would be able to get a good education. Mama's son J.T. ("Boy") was living in Bridgeport, Connecticut. He told me he could get me a job as a long-shoreman. I wanted it, but Patsy's mama didn't want to let Patsy go, and Patsy was used to doing what her mother said.

Patsy's mother's name was Mary Belle, but people called her "Mae Belle." One day I said to Mae Belle, "Patsy's married now. She's twenty-three years old. She's a woman and she's got to have a life. I'm not going to treat her bad. I want us to be a family." To Patsy I said, "Patsy, I'm going up to Connecticut. You can go with me if you want to, or you can stay here if you want to. It's up to you. If you want a family, you can come with me. If you don't want a family, you can stay here." I put my things in the car, the few clothes that I had. Before long, Patsy was loading up her stuff and back north we went.

After Patsy and I left Georgia, I worked hard to make Patsy's mother my friend. I bought her a plane ticket so she could visit us, once we got settled. She had never been on a plane before and she was scared. They gave her the plastic wings—the ones you pin onto

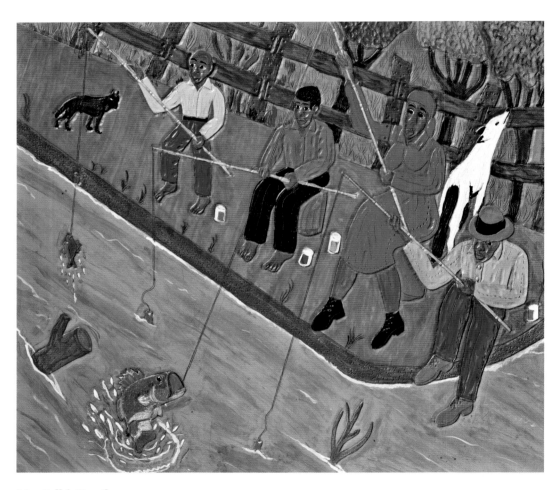

Mae Belle's Family

your shirt—and treated her well. I took time off from my job and we went fishing. Mae Belle loved going fishing. I won her over and I did Patsy's daddy the same way. I went out and bought some nice clothes for him, things I couldn't afford, but I did it anyway because I wanted Patsy's family to feel appreciated by me. Patsy's family didn't have a whole lot. I was trying to be generous with them to show them I wanted to be family with them and not just their daughter. Patsy's mama didn't put no roadblocks in front of me after that.

Patsy's mama's nickname was "Sugarcane." She used to say, "My name is Sugarcane. Ask me again and I'll tell you the same." She was a well-built, stocky woman who still had her figure in her older age. If you look at Patsy now, you're looking at Sugarcane. Patsy looks just like her mother did. As a matter of fact, Patsy thinks like her mama too, and they were both snuff dippers. Sugarcane had a nice, big garden and she was the best cook in the world. She cooked all those old Southern dishes, like the ones they might have cooked in slavery time in the big house. You would think that Sugarcane cooked for some rich White people. Her creamed chicken was falling off the bone. The gravy was almost white, and you could see the melted butter in it. She served it with rice and biscuits. Everything was seasoned just right. Her moonshine was good too. She made two kinds. "Buck" was made from cornmeal. You let it sit for about two weeks before you taste it. By then it's almost whiskey. Her homebrew, or "raisin jack," had raisins, peaches, apples, and molasses in it. You heat it up and let it sit for five or six days. Patsy's mama also made plum wine, during plum season, and blackberry wine. The insurance man would come by and eat her cooking, and the sheriff would come out there, eat her food, and drink her homebrew, even though it was illegal.

Sugarcane worked hard for her children. I saw that woman go with no shoes on her feet, and I'm talking about in the wintertime, to make sure Patsy and them had shoes. I saw her take her coat and make it into two coats so Patsy's sisters—Evelyn Sue and Mary Ann—could have coats. That's the kind of person she was. She had that swag too, and she knew how to walk. Not every woman can

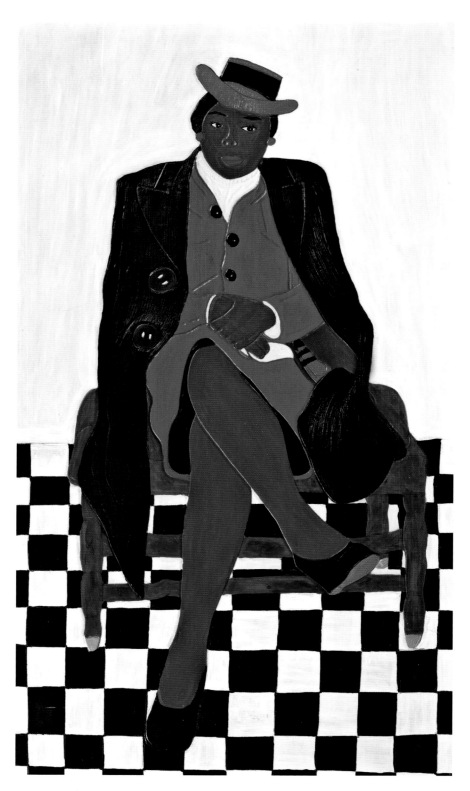

Sugarcane (Patsy's Mother)

walk in heels. Sugarcane was a fine woman and before she married Patsy's daddy, men were after her. I know about that because after Patsy's daddy died, some of those guys came back and tried to talk to Sugarcane.

I painted Sugarcane to give her some recognition, and if you look at the picture I painted of her, you'd think she was the finest thing in this world. It was easy for me to imagine what she looked like before she got married. If she carried herself like Patsy said she did, and if it's true that Patsy carries herself like her mama did, then I had a vision of Sugarcane when she was younger. I painted her with posture and an elegant look. I paid special attention to my tooling job, to every cut I made of her, when I cut her into the leather. I had to be very careful. I didn't want to make the wrong cut, or else it wouldn't look like her. She's got to be elegant and beautiful. If you go around with the name Sugarcane, something's got to be special about you. You got to be showing it. I painted her like she's got it all. She's got a Sugarcane coat, dress, hat, and shoes. She's got that African face and features. There's sensuality there. Her skin tone is dark. She's got a look without a smile, and her hair goes back in waves. The picture looks just like her. Sometimes when I look at it I see the younger Sugarcane, and sometimes I see the older her. *Sugarcane. Ask me again, I'll tell you the same.* She didn't stay here long enough.

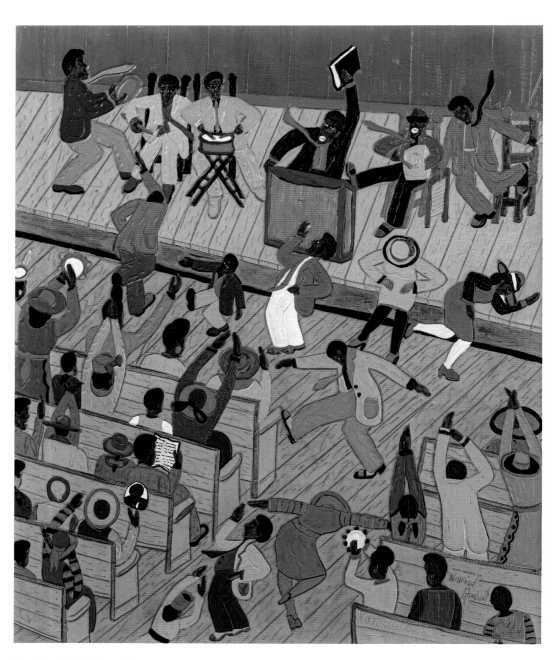

Rocking in the Church

BRIDGEPORT DOCKS AND PROJECTS

J.T. ("Boy") had a son named Jessie, who had been in Bridgeport, Connecticut, for a long time. When I lived with Mama back in Cuthbert, Jessie would send us a big box for Christmas every year. We would get this big old box full of fruit and toys and clothes for my sister Loraine. Loraine was J.T.'s daughter, Jessie's half sister. Ever since I was a baby, she lived with Mama and me. J.T.'s wife, Candy Lee, couldn't stand Loraine, who was not her daughter, and she was always doing some crazy stuff to her, like cutting a hole in her dress or messing her shoes up. Candy Lee and J.T. would come over every Friday and do a fish fry. Candy Lee poured hot sauce on my fish when I was three or four years old. That was funny to her.

In the forties and fifties, J.T. and Candy Lee put up a big curtain in their juke joint in Cuthbert and lived behind it. J.T. sold his moonshine whiskey from behind the counter in little shot bottles for a dollar a shot. When the law started catching up with him, and he couldn't make moonshine in Cuthbert anymore, Jessie convinced him to move to Bridgeport. J.T. had saved all that money from back in his moonshine days. He had a duffel bag full of silver dollars, worth a lot of money, that he brought with him when he moved to Connecticut. He saved it all the way up to the 1980s. It took me and Junior and Patsy—all three of us—to roll that money on a wheelbarrow type thing we had rented from U-Haul. J.T. wanted us to count the money. It took us a whole day and we still didn't count it all.

In Bridgeport, Boy owned a house across town. On the first floor of the house was a church. Me and Patsy moved in on the second floor and there was nobody on the third floor. The church on the first floor was a Sanctified Church. The church had live instruments:

guitars, piano, drums—that boy would go *crazy* on those drums—
and singers. It was like a juke joint with blues music, blues music
that had church words. They believe you have to dance and sing to
God. If you didn't get up and dance, somebody would come up to
you and say, "What's wrong with you? Don't you believe in God? Get
up and dance!" Every Sunday they were carrying on for at least two
hours. Finally I said, "Patsy, we might as well go to this church. We're
listening anyhow, so we might as well go down there with them."

I can dance, but what they were doing was a different dance—
the Holy Ghost. Some of those people were so good at it they looked
like they had skates on. I never could perfect it. It reminded me of a
dance back in the sixties called "the pony." People would go around
and around holding each other's hands, like a square dance, and
turning each other loose. You could walk up to anybody and dance.
Sometimes I got so tired, I would have to sit down.

After about a year I became a deacon in that church. I saw that
I could make the church grow. I would bring people in off the street.
I'd say things like, "Listen, I got a group I put together in the church
and we'll be singing. Come and hear us sing. You'll like it. Do you like
Sam Cooke? I'm going to be singing Sam Cooke gospel. You don't
have to stay for the service. You can leave if you want." And that's
how I'd get them. They would come—one or two people we didn't
know, sitting in the back, listening—and they would like it and join.

There were five of us, all men, singing together. We went all over
Connecticut singing. Patsy didn't like it because the women went
crazy.

Holy Glory.
Hallelujah.
Since I lay my burden down.

Patsy and I had our place upstairs fixed up nice and Boy was all
over us for more rent. I had no job, so we decided to move from there
into the projects—public housing. It was a rough place where people
would get killed. They had shootings there almost every day. I didn't

like the projects, but I was liking the fact that I was on my own. The rent was cheap. I was so glad to be in a place where the rent was paid that the danger didn't bother me too much.

Things got better for a while. I worked on the docks, loading and unloading cargo from other countries, South Africa and Germany mainly, and I was making a lot of money—$1,200 to $1,500 per week. That money was so great. I'd bring my check home and Patsy couldn't believe it. One day a ship came from South Africa. There was a big tree on that ship. One tree. It was huge. The word was that they were going to let cars drive through it. There were a lot of young African boys working on that ship. Now I know how to talk to people. I'm good at starting a conversation. So I met this young African guy named Simba and I started a conversation with him. "Listen," I said, "come to my house at noontime. My wife is preparing me a meal and you can eat with us."

He came to our place. He sat at the table, just looking at the food—collard greens, pork chops, stuff like that—and he didn't touch a thing. He said he couldn't eat pork. Then when we went back to work, he said to me, "You eat garbage. Food no good. And you messed up the bloodline." What he meant was that we came here, through slavery, and the White people messed with our women and we got children that were not pure African. He was going on and on about that, but I took the abuse from him because I had invited him to dinner. "You messed up the bloodline." He loved to say that, and he also said, "Stay here. Don't come back to Africa." Only he pronounced it A-*FRI*-ca—not the Southern way. He said, "Don't come back to A-*FRI*-ca."

One day when I was working at the docks, I picked up a big chain and tried to thread it through some coils that weighed thousands of pounds. You thread the chain through and pick it up on the far side. That messed up my groin. I had a hernia. I was walking around every day with a walking stick and I couldn't work. The union people at the docks sent me to their doctor—an Italian doctor. They wouldn't let you in the union if you weren't Italian. They would cut you off before you did enough hours to be eligible. Then when

I was hurt, they sent me to their doctor. The doctor said there was nothing wrong with me, even though I couldn't even stand up in his office. That groin was tearing me up. I got surgery at another hospital and I didn't go back to the docks. I couldn't lift those chains anymore. After that I wasn't working.

I was naïve. I was using that down-South mentality. I didn't realize I could get help if I needed it. By this time—1983—we had three babies: Junior, Lillian, and Edgar. I needed help with my family, to put food on the table, but I didn't know anything about welfare or food stamps and all that kind of thing. To get by I was taking things. I would go into a store and take a couple of pieces of meat and bring them back home. I got caught taking some meat and I went to court. The judge asked me what I was going to do with the meat. I told him I was going to feed my family; they were hungry. It broke my heart to say that. It still hurts. My family was in trouble.

The judge had mercy. He said that because I wasn't trying to sell the meat, he wasn't going to convict me. Since I was trying to feed my family he would let me go. I couldn't believe it. I still was looking at it like I was in Georgia. I knew if I had done that in Georgia, I would have been locked up deep.

So we were suffering because in my mind I was still down South where they weren't trying to help Black families. In Bridgeport, my cousin Christine, from Cuthbert, who lived in the building next to us, said to me one day, "What are y'all doing suffering in this way? Why don't you go down and try to get some help?" Sure enough, she guided us the right way. So that's how we started getting help from the WIC people. WIC is a government program for women, infants, and children. They give you milk and stuff for your baby, baby milk in a can that you mix up with water. There were some White churches too, in Trumbull, Connecticut, with food pantries. Christine took us there and the people liked Patsy. She could go in there and get whatever she wanted.

I wasn't working, so every day I was walking around the house and hanging in the driveway watching people drive by. That's when I saw this young boy driving by. His girlfriend lived next door to Christine. He would come by in his nice car and he was wearing clean clothes. I figured he was selling drugs. I stopped him one day and asked him if I could work for him. At first he said no because, he said, I was a family man. But maybe a month after that, I saw him again and told him I had been looking for jobs and was still not working. He was in business with his three brothers. He said I could work for him. The drug of preference at that time was heroin. Crack wasn't out yet. He sold heroin by the ounce. You had to buy an ounce or above. He was not a small-time street dealer.

He sent me to New Haven to pick up money from his sales. I was naïve about drugs. I could have gone to jail so easily, but I kept doing it, just taking a chance, because the money was good. A girl was selling the drugs in New Haven and she would give me the money. I stayed all day, and every time she would make a sale she would give me the money. Then I would go back to Bridgeport and give the money to the man I was working for.

Let me tell you something: That man trusted me. I was his lieutenant. I held all of his money—thousands of dollars. He'd go places, out West and elsewhere, out of the country, while I held his money. If his children or his mother or father wanted any money, they had to come through me, and a couple of them didn't like that, but that's the way it was. Sometimes when they needed money, they would be at my house early in the morning, before I got out of bed. He was free with his money too, because he had so much. His father said to him, "If you guys happen to get busted, Winfred is going to be the one that sends you to jail." But I never did turn state's evidence against them.

One day we were riding around in a new Cadillac. The man I worked for was a married man with a slew of girlfriends—just an enormous amount of women. We were on our way to Norwalk to see one of the

girls. He was driving and he happened to look to his left. He said, "There go that nigger that owe me money, and he been dodging me." He took the car and smashed the other car off the highway down into the median. That's the way him and his brothers were. It's how their father taught them, and they did everything in that manner. If they liked you, they were on your side. If they didn't like you, you had a problem.

Their New York partners had a club in the Bronx. Patsy and I went there. We didn't know there was going to be a show, but it turned out the Temptations were performing. There were movie stars there and everything. Oh, and the way everybody was dressed! The jewelry that the girlfriends wear, the drug dealers lend to them. They have to give it back at the end of the night. I thought that was kind of crazy. And every woman in there was looking for a drug dealer. They were really flirting and putting it on, and those girls were not giving Patsy any respect. She couldn't deal with that. Patsy didn't want to act a fool there, because she knew it was a big establishment, but it was hard for her. If those girls had been anywhere else, they would have found out how she felt. And she was watching me hard, because the women were dressed to kill. They had on short dresses with the splits on the side. The way Patsy remembers it, they would come up to where you're sitting and stick their butts up there on the table. They were in there to catch, and even Patsy had to admit they looked good.

When you're a drug dealer, you don't have to be chasing women. They chase you and they make it hard for you to resist. Patsy did her best to run them off. I hung out at a little club in Bridgeport where there was activity all day long. The guys would sell mixed drinks and it was a nice place. One day Patsy come around the club to ask me for money. She wanted to take the kids to the movies. I kept two or three thousand dollars in my pocket all the time. I peeled out some money and gave it to Patsy. Then Patsy looked at me and she said, "What is that on your face?" She took her finger, run it along my cheek, and then looked at it. She said, "That looks like lipstick!" She wiped

her finger on a baby diaper so she could see the exact color and she walked past me into the club. She walked around looking at the diaper and the women, and when she got to this one girl, she stopped.

"You messing with my husband?!"

"No."

"Yes you are. You can't sit here with me here. You got to go!"

The girl crossed her legs and lit her cigarette. She said it was a public bar and she was free to sit there. Patsy walked back outside, picked up a brick, came back, and hit her dead in the face with it. The girl slid down off her chair. Blood was running down her face and Patsy said, "You ain't pretty now." I grabbed Patsy and got her out of there.

I never used drugs myself. I saw the effects of what it was doing to other folks and I didn't want to travel that road. I've had drugs piled up high in front of me, in a hotel room, six women and me.

"C'mon, Winfred!"

"You go ahead, I'm OK."

I didn't feel like I was hurting anybody at the time, but I was. There was a girl one time who bought some drugs from me. She was a good-looking White girl. I asked her what she was going to do with the drugs. She said her boyfriend was sitting in the car out in the parking lot. He was a regular user and she was just starting. I told her that if she got started, she wasn't going to have them good looks much longer. About a year later she came looking for me. Her arms and pretty legs were all messed up from the needles. She told me I was right and that she appreciated my warning. Then she tried to build a relationship with me. That's the life of a drug dealer.

There was a boy that was giving me some problems about selling drugs in the village—Father Panik Village—the public housing project in Bridgeport where I lived. He didn't want me to do any business in what he called "his area." I didn't pay him no mind, but one day, he had two or three guys with guns standing around while

he was talking to me. I felt a little intimidated by that. This guy in New York that I was dealing with had told me to give him a call if I had any problems, so I decided to call him. I thought he would come up and talk to the guy and tell him to leave me alone. The next day he shows up. There were eight guys in two black jeeps, four guys in each car. They got out with these duffel bags. They came in the club, took out their guns, and started strapping them on like they were Navy SEALs or something. I said, "What are you guys doing?!"

"You said you got a problem, didn't you? We're going to take care of it."

"Damn, I ain't talking about *shooting* nobody."

"A problem is a problem. This is the game you're playing. We're going to the village to solve the problem."

I never called them anymore, for anything.

One night I was the last one to close up the club. I had about $50,000 worth of drugs. The police were hanging around and I said to myself, *I can't leave here with these drugs. The police may stop me. I got to find somewhere to hide them.* So I closed up the club and sat in my car in the parking lot for a little while. I made up my mind to hide the drugs in a bulldozer. I put the drugs underneath the hood, on top of the motor. The next morning the drugs were gone. Now you can't tell somebody you owe in New York City that somebody stole your drugs, or you might have to pay with your life. So me and the boys sat around thinking and we came up with a name. There was this low-level user, let's call him "Leroy," who could have been watching me. He was always around. I said, "Let's go check Leroy out."

We kicked Leroy's door in. He was in bed. One of the boys started whipping on Leroy.

"Where those drugs at?"

Leroy wasn't talking. He just took a butt beating. There were four or five of us. I was just standing there and something told me

to pull out my gun. I had a .44 Magnum—nice, big pistol—and some bullets that I bought in Georgia. They won't sell them in Connecticut. You can't buy but six—one round—at a time. So I pulled out my gun. That was just the most foolish move I ever made in my life. I pulled out that gun and told everybody to step back. Leroy was on the floor. I jumped down on top of him and put my gun to his head.

"Leroy, you tell me where those drugs at, boy, or I'm fixing to kill you."

If Leroy hadn't talked, I'd be doing time for life. I'd put myself in a position where I had to shoot him. I got all these other drug dealers standing around me and I made myself a foolish move. I got to shoot Leroy if he don't tell me where those drugs at, because I said I would, and they're all standing there waiting on me to do it. If I had killed Leroy, I would have been a hero in the drug game. All of the drug dealers would have been praising me. But I would have been a nobody in the world. A killer. Dead right. I would have been nothing.

Leroy told me where to find the drugs. He had put them on a string and tied them outside his window. They were hanging there. I said, "Well, Leroy, you saved your life." And that's what saved me.

A GOOD, BAD MAN

That drug life was a tough life. The way I see it now, I'd rather be broke. You're always looking over your shoulder. When you come home you're looking for the police. Every time you drive in the driveway you're looking back to see whether anybody is following you. One day I was coming home from New York City after picking up some drugs. I came down Martin Luther King Drive in Bridgeport, driving a new Volkswagen van. I looked in the rearview mirror and two undercover cops turned around fast when they saw my van and followed me. I recognized the cops—two White cops. People in the projects called them Starsky and Hutch. I drove all the way to my building, and when I got out, they came up behind me and I gave them hell. I said, "What are you doing following me? You should be chasing some drug dealers! I'm a workingman."

I had on working clothes—overalls, with a hammer hanging in my side pocket. I never dressed like a drug dealer. I dressed like I was working on a job or something. I kept a Taser in my glove compartment. I picked it up to draw their attention, which I did. I figured I'd rather have them get me for a Taser than for two or three pounds of drugs. They took the Taser from me and went on about their business. They never searched the car. And I'm telling you, if they'd caught me, I'd be in jail now. If they had searched the car, I would have been gone!

One day those two cops were raiding the projects. While they were inside, somebody went into their car and took a radio. When they got back downtown they realized the police radio was missing. So Starsky and Hutch came back out to the projects. They got out on Martin Luther King Drive and Hutch said, "Everybody gather

around. We've got something to say." Everybody gathered around to hear what they had to say. Starsky said, "If you give me that radio back, I promise you, you can sell drugs for the next two days and we won't even come out here." So somebody gave him the radio back and everybody had free rein to sell drugs for two days. People were selling drugs all over the place like they had a license to sell. Those were happy drug-dealing days.

Starsky and Hutch—they ended up going to jail for wrong-doings. They took money from their raids and didn't turn it all in. They bought brand-new motorcycles and they had their garages full of new toys—and I don't mean Christmas toys. All that stuff got taken from them and they went to jail.

I got caught too. I had a three-year run without the cops bothering me. It was 1985. I knew in the back of my mind that the cops had to be looking at me. I was making a lot of money. A lot of dealers depended on me to mix the drugs. You couldn't find nobody to mix it like me. I always got it right. I could cut drugs so well they called me "the Doctor."

There are different kinds of heroin. You can't cut it all the same way. Sometimes the strength is not good enough to cut it much. You got to do it one-to-one. When I was first messing with it, the heroin was pure. The more powerful it is, the more rubbery it looks. It doesn't look exactly like powder. It has a rubbery, glue look to it. You could put twenty-three spoonfuls of filler to one spoonful of heroin. Later, it was hard to get the heroin uncut. If you get it and it looks like baking soda, they really stepped on it. They put a whole lot of cut on it. You can't take it through the sifter too much when you're mixing it either, or it won't have any strength and you got to sell it within two or three days. You can't hold it.

I thought I could make some money and then get out. But I couldn't stop. The money was good, and drug money for some reason cannot be saved.

The police went to Cuthbert and got two of my friends, brought them back, and made informants out of them. I was in the drugstore one day and here are these two guys.

"Hey, what's up? We haven't seen you in a long time! We live in Boston and we're just coming through. We heard you have a spot down here."

"Yeah, I run a club around the corner."

So these two guys come to the club and all of a sudden they want to buy drugs. But I smelled a rat and didn't sell them any. Another guy tried to build a relationship with me by selling insurance. He was trying to find out how much money I had. I smelled a rat on him too. He took us to his house. He said he was a family man and he lived there with his wife and kids. Patsy looked around and whispered to me, "Don't no woman live here." She thought it was too neat. She said the hairbrush wasn't right. "I know how we do things when we comb our hair. We don't always put stuff right back. We don't leave our kitchen quite like that kitchen is. We might keep a neat kitchen, but we're going to leave something amiss. Maybe we didn't swing the dishrag out. No woman is sleeping in that bed. Let's get out of here." And I was glad she said it.

One night somebody shot into our apartment. Patsy had just finished washing dishes and she put the dishrag on the spout. The paper towel rack was on the wall, even with her head. Just as she walked away, a bullet came through the window and hit the paper towels.

I took Patsy and the children out of the house that very night. I told them to grab what they could—clothes, some toys—and I took them to a hotel. The next morning the police came to our apartment and kicked the door down. Nobody was in the place. We stayed in a hotel along I-95, outside of Bridgeport, for two days. Then we moved, at night, to a house in Trumbull, Connecticut. I had already put money down on the house to rent it and I had the key. It was a single-family house in a White neighborhood. A lawyer owned it. Later I told him I wanted to buy the house and he said, "It's a

lily-White neighborhood and they'll have my ass if I sell you that house." I went to my car, got a briefcase, came back, and opened it up. It was full of one-hundred-dollar bills, all stacked up. I said, "Will this change your mind?" He nodded. "You damn right that'll change my mind."

It was a beautiful house. You walk in the front door and you're in a little room where you hang your coat. You could go downstairs to a beautiful place or you could go upstairs to a beautiful place. I said to myself, *Well, since I got this house and I'm dealing drugs, I'm going all the way.* I hired two black belt karate boys and told them to escort Patsy everywhere she went. So Patsy had two bodyguards. I found two chefs to prepare our meals. I told them to ask Mrs. Rembert what she wants for her meals every day and that if I wanted something I'd tell them. I had a room downstairs where every day I would take a big garbage bag full of five- and one-dollar bills. I didn't have time to count them. I would take them in that room and dump them. Then I let the kids go there to play. They went in there and started throwing money around.

One fine day I was riding with a friend of mine in New York, on Route 1 in the Bronx. There was a Mercedes-Benz dealer there. My friend said, "Let's go and buy us a car." So I stopped at the Mercedes place to see what they had. I'm walking around on the lot looking and there was a nice car. The price was $18,000. I got the money and counted it out. Then I'm sitting there in a chair while the salesman is drawing up the papers and I look up on the wall. There was a picture of a *beautiful* car. I said, "Hey, wait. Where's *that* car?"

"That car is in Germany. There ain't but three made like it in the world."

It cost a lot of money, a *lot* of money, but I wanted that car. I said, "Let's kill this deal. I tell you what, you keep that $18,000 and I'll come back tomorrow and bring the rest of your money." The next day I gave him the money, and three or four months later he called me on the phone. "Mr. Rembert, I got your car. You go out to the airport. I'm sending a helicopter to pick you up."

The car was a white Mercedes-Benz 500 SEC. It was immaculate. The Mercedes emblem on the front of it was gold. Around the headlights was gold. Part of the steering wheel was gold. The whole car was trimmed in gold. But I'm telling you—I couldn't drive it! Every block I turned the police lights were behind me. "Sir, you didn't commit a crime. We just want to know where you got this car." Police every which way—I got stopped five or six times going to Georgia. I got scared to drive it. I even hired a White guy to chauffer me. They called him "Lurch." He was tall and he looked just like Lurch from *The Addams Family*. Lurch was my man. He was intimidating. I had him up front and I sat in the back with the tinted windows.

One morning I woke up to some noise. The Trumbull house had a driveway, and if someone came down the driveway I knew they had to be coming to see me, because I'm the only house on it. I looked out the window and there were tractors, backhoes, and black trucks. I see all these guys get of out the trucks. They had DEA and FBI all over them. They came to my house with a warrant for my arrest and a search warrant for my home.

The police have no mercy when they have a search warrant. They searched the house and pulled the walls open. They dug up the yard looking for drugs. They didn't find any. I had a big safe. They ran up on the safe and said, "Bingo!" They thought I had money and drugs in the safe. It took them about an hour to get it open, but there was nothing there. They were very disappointed.

The feds charged me with three counts of intention to sell. They never found any drugs, but they had people testify that I sold them drugs. They had a girl who said she went to New York with me to buy drugs. I had no idea who she was. I jumped up out of my chair right then and there. It wasn't even my turn to talk. I said, "I've never seen that woman before in my life!" The judge said, "Sit down, Mr. Rembert."

The judge watches how you carry yourself in the courtroom, so I tried to show a side of me that wasn't a drug dealer. I tried to

show that I was a family man and a good person. I did that by doing what they asked me to do. I didn't talk back to the prosecutors. I was respectful. I just sat there, and if the prosecutor asked me something, I answered and then left it alone. The other guys who were being tried with me were talking back to the prosecutor. They called her a fat something-or-other when they saw her out in the hallway. Those guys didn't realize that the judge and the prosecutor are on the same side—federal judge and federal prosecutor. One guy came to court with blood running down his face. He was in a fight just before he came to the courtroom.

I knew I was going to jail. I knew that. The only question was how long. The judge separated me from the other guys. He said I should be fishing somewhere with my family. And some of the lawyers seemed to agree. In the courtroom, Patsy pleaded my case. The judge told them to take her away or he might end up giving me no time at all. He said to me, in the courtroom, "Mr. Rembert, I don't know what you are doing with these other guys. You're different. You need to be with your family. You're not late. You come to court on time. Sometimes these other fellows don't even get here. I'm going to send them to jail." He gave me four years and the other guys were blown away, because they were getting ten and fifteen.

The government took my Mercedes, my house, and everything they thought was bought with drug money, and I went to prison. When Patsy came to visit me in prison with the kids, that just killed me. It was tough, and Patsy couldn't take it well. A few months later, she went to see the judge. She told him I was a real good husband and she needed me home. When Patsy sets her mind to something, she is convincing. And the judge was a good man—a good, bad man. I mean, he appears to be a tough guy—*If you sell drugs, you're going to jail*— but down under he has compassion. His name was T.F. Gilroy Daly. He was a United States District judge for the District of Connecticut. He called me on the phone and said, "Rembert, if I let you out, will you promise that you will never sell drugs again? Will you go home, raise your boys, and not let them sell drugs?"

"Yes, Your Honor. I promise."

That was something. I just couldn't believe it.

Judge Daly let me out and I never sold drugs again. It was tempting, though, because I was broke and used to having money. For ten years, guys from New York City would come to my house in New Haven asking me to sell or to mix drugs again. Even today, all I got to do is say, "OK," but I will not do it. That promise means so much to me. It's what allowed me to come back to my family.

Some time ago the judge died. I would love to make a picture of him to send to his wife. I want her to know how grateful I am that her husband gave me a break. I want to do a picture of him wearing his black robe. Judge Daly was a tall, skinny guy with gray hair and a thin, Northern White face. He didn't move around much in his chair. I would put him up on his bench, where he sat still, looking around the courtroom with eyes that stare right through you. He projected a figure of strength and power. I would like to paint the tough guy look, from below, where I was standing. I think he would have been happy to have the tough guy version of himself. But I noticed that when court was over, and he's getting up off the bench and walking away with his head down, he is hiding the good side of him. I think that judge didn't want to be bad. I think he didn't want to sentence people. I believe that deep down in his heart, he didn't want to be a judge, though I wouldn't know how to express that in the painting. I kind of liked him, even before he gave me a break.

Do you know about the mayor of Bridgeport? His name is Joe Ganim. He went to jail for a long time on corruption charges. When he got out he ran for mayor again and he got it. You know why? Because he did a lot of things for Black folks. He's a Black man's mayor. So, Ganim is mayor and in 2018 he even made a run for governor. You see now, what I'm fixing to tell you has no bearing on me, but here we are, over thirty years after I did my time, and nowadays a man can go to jail as a mayor, get out, run for mayor again, and win

the election. I'm trying to say, I don't see how you can do that. I don't see how people are so forgiving. I wonder, am I forgiven the same way? If people look at me, at my case, are they forgiving me? Or do they say I'm a bad guy? Would they say, "Rembert is a bad guy. He did this and he did that?" Or would they forgive?

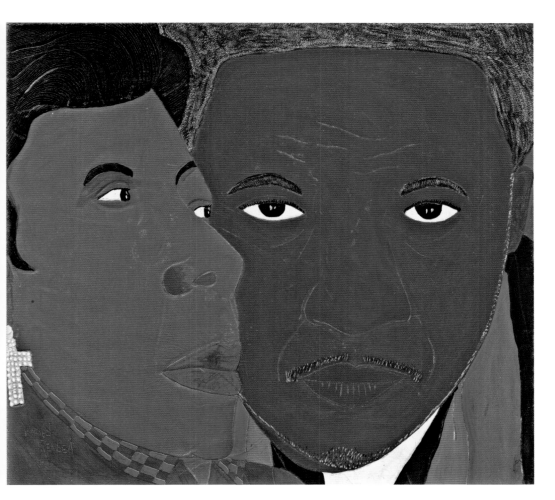

Patsy and Me

PATSY'S STORY

I can't remember how long Winfred had been locked up, but it was long enough for me to know that everything was resting on what I could do, and it got to be more than I could bear. I had thirty-five dollars left for the month after I paid my bills. I was having a hard time managing. I was standing in a store in New Haven and I forgot who I was. My daughters, Lillian and Nancy, were with me. I was getting Nancy an Easter dress because I wanted to take a picture to send to Winfred so he could see his children dressed nice and it would cheer him. I was going to put the dress on layaway, and when the lady asked me, "Miss, what's your name?" I looked at her. I remember that—I just stood there and looked at her and I couldn't remember who I was. It was too much. Lillian took a pencil, wrote my name down, and paid the woman the money. She took me out of the store, got me on the bus, and brought me home. She wasn't but ten years old and she saw that something was wrong with her mom. She got me all the way back in the house and I didn't even know who she was.

What brought me back to reality was my son Patrick's cry. When I came through the door, he started crying for my attention. I came back to who I was and I realized I had been losing my grip. I told the children I was going to a doctor. I walked over to the clinic on Columbus Avenue and said I needed to see a psychiatrist. A doctor came out and took me to the back. He asked me what was the matter, and I told him I wanted to scream. He said, "Scream just as loud as you want." I did. All that built-up frustration left me for a moment and I could breathe again and come back to myself. When I got through screaming and getting that frustration out of me, they sent

a lady over to my house to watch the children and they gave me a space to just do nothing.

I was having bouts with myself. I could close my eyes and be back when I was a child. Being with my daddy was a safe place for me to be, so my mind would take me there. I could easily slip there. The doctors were worried I would lose touch with reality and not come back. They sent a psychiatric worker over to the house and worked out a program for me. They put my two youngest children, Patrick and Nancy, in an early stimulation program. We didn't have Robby yet. My son John went to kindergarten and Mitchell went to Head Start. They were picked up at the house and brought home later. For a couple of weeks, the mental health worker was there when the kids came home, to help me maintain and get stuff right. The three older kids—Winfred Jr., Lillian, and Edgar—were pretty much stable in what they were doing.

During all this time I hid the fact that Winfred was in prison from the younger kids. John had already tried to run away from home. He was devastated when his daddy wasn't there. He took his clothes, put them in a pillowcase, got on his bicycle, and left the house.

My biggest task was to keep John in the dark about his daddy being in jail. I would bake a cake every day, cut a slice of it, and leave it on the table for Winfred to eat when he came home late at night. Once John went to bed, Junior would come down and eat the cake. So that's how I hid it from John.

I had moved from Trumbull, which is near Bridgeport, to New Haven so that the children wouldn't run into someone who knew what had happened with their dad. Once a week I took the children to visit Winfred in Otisville, New York, where he was locked up. I told them that he was working and he couldn't come home right then, but the older ones figured out he was in jail.

I could barely get myself to accept the fact that Winfred wasn't coming home. It was hard. He got four years for each conspiracy charge, and I counted them up as twelve years. The sentences were

running concurrently, but I didn't understand that. I went away with the thought that he was going to be gone for twelve years. I had never *ever* been on my own. Winfred took care of everything. He bought all our clothes. He bought all the groceries. He could fit us—get all our sizes—without us being with him. So I never had to buy groceries or clothes or pay bills. All that was mounting on me. I had a nervous breakdown, that's what it was, and I had to get my bearings straight.

I was getting charity, state assistance, and some help from my sister, but I wasn't getting enough, and I had no smarts about the street. So I wrote a letter to the judge and I went to see him. I told him, "You know, this man has had a hard life. He's worked real hard and he's got a lot of children. I'm there with all these kids and I don't have enough to provide for them. You are holding Winfred away from his family and he's a good man."

It was devastating to try to sit there and explain to the judge all the things that Winfred had done to try to get a job and keep it before he started selling drugs—heavy equipment work in Georgia, the cleaning business in Rochester, the docks in Bridgeport, construction jobs, repairing cars, and more. I wanted him to know what kind of father Winfred was and that he had tried to do whatever he could to take care of his family. As a father, Winfred took time. When he was working at the docks, he came home after work and put a train set together. It went up on the wall and came down on the floor. There was a racing track with cars that went up and over the train tracks. He had men up on the ceiling that would come down on a parachute. He drew pictures on the walls. He had a light that he set in the middle of the floor, and when the children got in bed, he turned the light on and everything looked like it was moving around on the walls.

Later, after I looked over the matter, I was glad Winfred got caught. It kept us together. Before that, I was losing him. I couldn't keep up with those women on the street. I couldn't be a glamorous woman and raise the kids. Winfred told me to go to the hairdresser and to

get my nails done, but those were things that would take me away from the children, and I didn't want to be away from them. I saw our relationship diminishing. When he went to jail, though, it was me he had to depend on. That gave him time to see what he was losing. You got a family. Do you want it or not? When he came home from prison he was back to the person I married. I often tell people this and they don't believe it. It brought us back together. In the first years of our marriage, he would come home and he would be so loving and sweet. Right before he went to prison, I didn't recognize him when he would come home.

One time when Winfred came home, he had a cigarette behind his ear and he was chewing on a matchstick. But Winfred didn't smoke. What was happening was that he was fitting in with the people he was dealing with. He would take on their personas and do what they did. He would be talking like they talk and everything. I observed that and I asked myself, *Who is this I'm with?* It was like he had different personalities that would show up from time to time. It brings to my mind the *All Me* painting, the one that shows all the people he had to be to survive on the chain gang. The man I wanted to see was the one that married me when I was a girl in Georgia, and I didn't see that person all the time. What Winfred was like depended on the situation he was in and who he was with. Sometimes he would be that other person and he would fit right in.

Winfred never had a problem communicating or making friends. He knew so many people, I used to get upset. He couldn't get four or five feet down the aisle when we were shopping without someone stopping him and talking to him, and I didn't know any of those people. I was jealous. Winfred could sing beautifully. When he was a deacon at that Sanctified Church, people would come at him like he was a star. You would think he was Michael Jackson. He'd be up there on the pulpit and he had men crying when he was singing. Women would run up there from the audience to hug him and stuff like that. I almost hit a lady. They would hug him and hold onto him and I couldn't deal with that.

One day I was sitting in the church as Winfred was performing and I saw how people were around him. I also saw women running from me. They would run because they knew I was coming to get them. I looked and looked at Winfred and I saw how happy he was to be appreciated by other people. I got to thinking that God was going to punish me for being too jealous. Winfred was a minister of music and I was holding him back. I was making people jittery. They were scared to come up to him because of the way I would act. I was hemming him in. So I took a step back. I stopped going to a lot of his singing because I could not control the jealousy I had. It was a beautiful thing to see how people were about him, but it was more than I could deal with. My love for Winfred was unrealistic, and I had to learn to love him with common sense. That's what I call it—loving him with sense. It was hard. I had never had that kind of attraction to anybody. I wanted him all to myself. I didn't want to share him.

When we were living in Trumbull, a lady came to our house. Winfred was lying in bed. He pulled back the curtain and saw her car sitting in the driveway. I was asleep and he sneaked downstairs. It was snowing. Later he told me that he went outside in his little house shoes and said, "What are you doing here? You can't come here and wait on me in the driveway! Don't you know this is my *family*? You have no business being here. You can't come to my house." She said, "I'm not going anywhere." He picked up some snow and threw it at her to get her to go and she backed over our neighbor's mailbox.

The next morning she come back and told me, "You just got to kill me because I can't leave him alone." She was in the little hallway in the front of our house. I was as angry as a human being can get. I wanted to kill her for coming to my house, but then I thought, how could I humiliate her? I made the woman strip out of all her clothes. She had nothing on but her bra and panties. I called the children. I shouldn't have done that, but I did. I said, "Come here, kids. Let me show you what your daddy's fooling with." Then I hit her in the head with one of my heels and I made her walk back to town. I got in her car and my sister-in-law took my car. I drove her car back to town,

pulled out the wires, and broke all the lights. She sent word to me that Winfred was going to get it fixed, so I went back, poured gas all around in the car, put a match to it, and said, "Fix that."

I knew Winfred was dealing drugs and I wanted him to stop, but he wouldn't. He would come home, give me money, and then he'd say, "I got to go to work," and he'd go. I asked him to stay home with us all day for one day out of the month. One day. He said he was going to do it. He didn't do it. He couldn't stay home *one day* with us. Before he got into the drug game he was with us. We went places. We did things together. Now he left it up to me to take the children to the movies and stuff like that. He wouldn't be in the mix. He would just bring the money. He said, "You ain't got nothing to worry about. You got everything you want. You got cooks. You got this, you got that." I said, "I ain't got you. I didn't marry this house. I married you. I don't care nothing about no material things."

I thought to myself, *I got to get away.* So one night I went by the bar. Winfred wasn't there. I asked where he was and they wouldn't tell me. I asked his friend for money. He had $280 in his pocket and he gave it to me. I took the money and went back home. I put the $280 in a little briefcase and piled in more money that was lying around on the floor. Winfred had bought me a brand-new minivan. I put pillows and blankets in it and everything you could think of for the babies—bottle warmers and all that stuff. I waited until I knew Winfred wasn't coming by. Then I put my children in the car and I said, "I'm going home." I drove all night. When I saw a sign that said "Welcome to Georgia," I got out and kissed the ground. I stayed there for three months and I was there when Winfred got arrested.

When I first met Winfred, as a young girl, he walked into my yard and I ran from him. I ran in my house and told my daddy there was a prisoner in the yard. But I thought he was so beautiful. I really thought he was beautiful. I wanted to talk to him, but I couldn't. My raising said, *Don't talk to the boys. Let the boys chase after you, don't*

chase after them. I had to stay on that line, so I stayed away. But I wanted so badly to talk to him.

After I saw Winfred, no one else could compare. The chain gang baseball team would play against the high school. I was standing off where I could see him. I would wait and look and stretch. I wanted to see him come up to bat. I wasn't looking at whether he hit the ball. I just wanted to see *him*. And I fell in love with his letters. He was saying all the right things and hitting all the right notes. Winfred was giving me my fantasy. He was my Prince Charming. I have been that way about Winfred ever since I met him. It hasn't changed. I still view him the same way. I think it was divine intervention that we met. I had a lot of what they called back then "suitors" coming over to see me and I didn't care for any of them. My mother saw that I wasn't liking the boys that were coming to see me. She said to me one time, "If you ask the Lord to send someone to you, he'll do that." So one night I was sitting on the porch, looking up at the moon, and I asked the Lord to send me someone I could love. I didn't love anyone but Mama and Daddy, and my sisters and brothers, and I needed to love somebody. Then I saw Winfred. I was about sixteen when I said that prayer, and I saw Winfred when I was seventeen.

Once I met Winfred and straightened things out with my parents, I told everybody that he was going to be my husband. I put a picture of Winfred wearing his chain gang uniform on my coffee table and I said, "That's my husband." My intention was no secret, but nobody believed I would do it. "Girl, you crazy. You can't marry that man. You don't even know who he is or what he done."

One day I went to see Winfred. We were in the church, there on the chain gang. I had never been kissed on my lips. We were there in the church and Winfred asked me to marry him. I said yes right away. Then he kind of grabbed me a little bit. He pulled me to him and kissed me. He French kissed me. I didn't know anything about that. That was the longest kiss in the world. I lost consciousness, I think. It was unfair. After that kiss it was like I had a fixation on him. I wanted to feel that way again. I wanted him to kiss

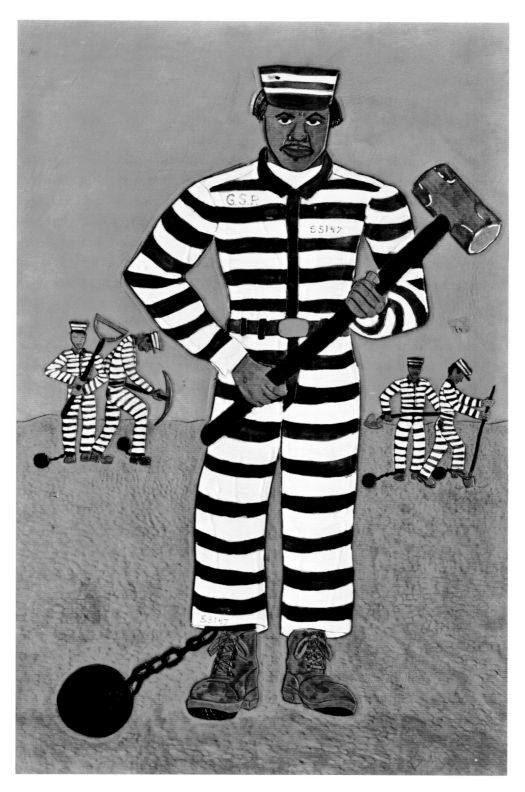

Self-Portrait

me again, but it didn't look like we would ever have a chance to be that close again.

Winfred kissed me in that church and that kiss has lasted me fifty years. I can walk through a room where Winfred is and still get that feeling—my initial feeling from him. If he touches my hand, or gets romantic with me, that kiss comes back into play. I often tease him that he shouldn't have done that to a poor little young country girl like that. It was something that captivated me and held me. He captivated me, and that kiss really sealed the deal. After he kissed me the way that he kissed me, it stuck in my mind and I could just close my eyes and feel the sensation and warmness from that kiss. It was a feeling I had never felt before. It caught me. I thought, *What else could we do?*

Winfred has always been my star. We have had cars—Lord have mercy—that were like Flintstones cars: You could see the ground. But I would be sitting in there with him and I would feel proud. I told him, "Honey, it's your car, you're in it, and I'm with you. I'll go anywhere with you."

I still believe that the Lord put us together. There was no other way for me to have met Winfred and had the opportunity to go and see him. The way I was being raised, he was out of the picture to start with. He wouldn't have been in my life—no way. He was a no-no. "He already in trouble. He already behind bars. What can he do for you?" But all of that was blinded from me. I wasn't think-ing about what he could do for me. I wanted to be with him. And it's been that way. Even when I caught myself leaving him, I never wanted to be without him. I always wanted to be with him.

In 1987, when Winfred was locked up in Otisville, he wrote me a letter telling me not to waste my life waiting for him again. He didn't want to be a burden on me. So I wrote him a letter to let him know the time didn't matter, I'd still be sitting there waiting on him. No matter what had happened, I still wanted to be his wife. I was highly emotional at the time I wrote that letter, which is the reason I wrote it twice. I was trying to make sure I got the content right.

God is standing by for he has both me
from a long way and even now he take the
time two keep me sept, your love is a love
one just cont walk a way from far I new
acily want two be with out you for you
I now I was hurt when that come when
I knew they were toking you away from
me for my nights are long and said but
time will stand still far us so when you
held me in your arms again it will
be new and all will beforgotin from here
on in I will be more understanding, of your
needs at well or my on, ask me what you
want far I'm here all you have two do
if ask me, your wish is my well
hold me and lock the world out far
I will stand

My letter to Winfred, 1987

After every prison visit, I never told Winfred goodbye. I'd always
say, "I'll see you." Then, when I was walking out the door, Winfred
couldn't hear me, but I would say, "Come with me." Just like that, I
would bring him home with me.

I HAD TO SCUFFLE

When the judge turned me loose, I had no idea what I was going to do for a living. No idea. No job prospects of any kind. Nowhere. I went to some kind of unemployment place where they give you a day-by-day job. You got to go there early, between five and six o'clock in the morning. A crowd of guys will be there. When they check you in, they give you a number so they know who was there first. Ain't no telling what you'll be doing that day. You find out when you get to your job.

I did a lot of cleaning. I mopped floors in hotels and restaurants. It was tough because I wasn't making any money, not compared to what I had been doing, and the money you get all goes to your bills. It's never enough. But I knew that I had to do what I could do because I'd made a promise. I couldn't get that promise out of my head.

At my sentencing, Judge Daly said to me, "You know how many people you were killing? If they're shooting the drugs you're selling, you're killing them." I really was killing people, if you looked at it right. People who are addicted to drugs are sick people. They are shaking and sometimes they look like they're about to die. I would give my clients their first shot of drugs in the day for free, when they were real sick. I knew they had to have that first hit in the morning, or else they'd be shaky and jittery all day long. They needed it so they could function. They called it "getting well," and then they could go on to their jobs or just go about their day. Sometimes they didn't have money to buy that first hit, but I knew they would come to me when they could buy it, so I didn't lose by giving them some. The way I saw it at the time, I was trying to feed my family. I wanted to give my kids and my wife things they never had. And then, once I got

into the drug game, I said to myself, *Well, if I'm going to be throwing bricks at the jailhouse, I might as well throw 'em real hard.*

That promise to the judge kept me going, and I made out fairly well with the temporary jobs. People liked me because of my work ethic. If I got to mop the floor, I'm going to mop it good. I do it quick and I'm right there ready to do something else. That's the way I did every job I went on. A couple of them day-by-day jobs turned into a week, two weeks, a month, but that was it. Then you were right back where you started. So I had to scuffle. I was just trying to be a good guy, and I had to deal with things I didn't want to deal with. I had to take a lot of crap from people, stuff that people do to you and you can't do nothing about it, like people holding your money and not giving it to you when they're supposed to. I need my money. I need it every Friday. But if you don't get paid at the end of the week, you have to wait and your family suffers.

I couldn't make enough money to pay the rent, even though Patsy was getting cash money and food stamps from the government. We were living on Ann Street in New Haven and we got evicted. The state put us in a hotel in New Haven, on the Hamden line, and gave us some vouchers that we could use at local restaurants. We went to a restaurant in Hamden and let them know we wanted to use the vouchers to get something to eat. They told us to stand to the side and they'd get to us in a minute. Other people came in, sat down, and were getting their orders. It had to be an hour and they still hadn't seated us. We didn't realize it, but there was an older White lady, a customer, who was watching us. Finally, that lady got up and yelled out, "Nobody's getting nothing else to eat until you wait on them. I been watching them. They been standing there patiently and they got kids to feed." Everyone stopped and looked, and she demanded to talk to the owner. And it wasn't just that restaurant that didn't want to serve us. We went through the same thing at other places too.

One time Patsy went to the bank and was in line to pick up her food stamp booklets. A White guy come in after her wearing a hard

hat. The teller told Patsy she was going to help him first because "he's a workingman." She asked Patsy to wait over to the side. Patsy got real upset. She got up in the teller's face and went off. "You ain't giving me nothing. My people earned this. If my daddy had been paid, I wouldn't be standing in this line, because I would have something. After all the work that my father and my mother did, and my husband worked too—this is *owed* to me. This ain't no free money. I'm just getting something back from what they should have got."

We needed more help. For a while I went down to the shipyard in New Haven. I knew from my ship experience in Bridgeport that the money would be good. I made sixteen dollars an hour, and after eight hours it went up to twentysomething. I also knew those Italian boys that run the shipyard ain't going to let you get but just so far. It was dangerous work too. You could get killed lifting up these twelve-ton rolls of wire. You had to throw a rope through those rolls and hang it up on a big hook. You needed to be precise when you hooked it up or those big rolls could fall back and kill somebody. I saw one guy get killed and another guy get his leg pulled clean off his body. The rope tightens when the crane operator lifts the wire up. The ropes are long and tangled and you have to make sure that your feet don't get caught. If you got your foot in there, the guy in the crane doesn't know it and he just keeps picking it up. And there you go, losing a leg.

I could make a thousand dollars a week. That was pretty good, but it was not every week. More often you were lucky to work three days. Still, the work was a crutch for me. If I could work there a day or two, that was something. Then my knees gave out on me. It was like someone was sticking pins and needles in them. I just couldn't make it. So I couldn't work there anymore.

We were getting help from some churches, and a couple of people gave us money. It was tough. People who have never lived in poverty probably have no idea what it's like. You get up in the morning

and you don't know where the next meal is coming from. If you care at all about your family, you got to go out and try to do something. You got to look for something to do. I picked up bottles and cans. I would ride around in my car and go through trash cans and dumpsters. Sometimes I could pick up thirty dollars a day. I don't think anyone should ever have to go through that, living where they don't have a meal, when they got children. I started thinking I shouldn't have ever had those children, especially when I had them all right behind one another like that. I thought I shouldn't have done that. It was so hard to feed them. It was hard to clothe them. You want them going to school clean and everything, with good clothes on.

Patsy and I went down to apply for government assistance for families—Aid to Families with Dependent Children (AFDC). We were told that, to get the money, we had to have a home without the father in it. They said I'd have to move out. But if you move out, they come and try to lock you up for nonsupport. I muttered under my breath, "I'll take care of my family. You guys keep y'all money." But we needed the money so bad, Patsy lied and signed a paper that said she didn't know where I was. She wrote a note, though, that said she was signing it in distress.

A social worker came around for a home visit. I had got Edgar a drum set and we had some nice dining room furniture that I bought when I was working at the shipyard. She looked at Patsy and said, "My God, how much did you pay for that? That's assets. You got to sell those things." We had an old piano we got from Salvation Army. She looked at it and said, "You got a piano? I ain't even got a piano!" And every few months they made Patsy go through the whole application process again, bringing new copies of all the birth certificates, over and over, down to that office and filling out the forms again. One lady even said, "Damn, how many times you got to bring those birth certificates down here? What are they doing, burning them up?"

Me and Patsy would do stuff to make our kids think they had more than they had. I'd go to McDonald's and buy a whole box of bags, nothing but bags, and bring them back home. We would

fix hamburgers and put them in the McDonald's bags. The children, at least the little ones, thought we were rich. They took their Happy Meal to school, thinking it was from McDonald's. Patsy and I sit down now and we talk about those days, about the things we would think of to try to get the children pleased. It was hard because there were eight of them. Judge Daly talked about that too. "You got all these kids. You got no business selling drugs. You supposed to be making sure those kids get an education."

I got very discouraged. What could I do? There was nothing I could do. I just had to deal with it. I made friends in church. I was a part of the choir and they wanted to keep me there, so they would do little things to help us out.

Patsy and I didn't allow our boys to hold drugs, or to sell drugs, or to stand on the corner, and the drug dealers didn't like us for the stand we took in the neighborhood. My son Winfred Jr. was sixteen years old, and his brother Edgar was fourteen. It was an ongoing thing. One Sunday, in 1992, some gangbangers jumped on Edgar. We had just come from church and I had sent Edgar to the store for some Kool-Aid. Edgar came home with bruises on him and his bike was bent up. I said, "Well, Patsy, that's it. I'm going down the street." I told her not to come down there. "Patsy, I don't care what happens, don't come down the street. You stay here." But she was hardheaded.

They circled me. I was in the center of them. They told me, "I'll beat you too, old man," and they started hitting me. One boy picked his bicycle up while my back was turned. When that boy hit me with the bicycle, that's what made Patsy come out. She thought I was going to fall, but I turned around and threw a punch. The boy wasn't expecting that left, and it knocked him down.

I went into a chain gang mode on them. Then I turned around and saw that Patsy was fighting too. This boy went to hit Patsy. Patsy blocked that lick, picked that boy up, and slammed him down on the ground. Everybody was watching and somebody said, "Look at that

lady! Look at that lady!" People were applauding. They weren't used to a woman like Patsy. See, Patsy is from the country and she can really fight. Her mama taught her, and her daddy too. She was little, so she had to know how to fight. She says, "You hit people across the neck and they can't keep their breath. Then you just fall back with them and they'll come right down with you. Their own weight brings them down."

We were laying them *out*. Then, in the midst of the fight, Junior came running down the street. Edgar was down on top of one of them, beating on him. Patsy was hitting one that was standing up over Edgar. Junior came up and saw that a boy who he went to school with had come out of a house with a gun in his hand. The boy pointed the gun at Edgar. Junior opened his arms wide, leaned back, and pushed Patsy and Edgar both out of the way. Then the boy shot Junior right in the gut. Junior said, "Mama, I'm shot. They shot me," and Patsy screamed.

Things got real chaotic after that. My daughter Lillian, who was fifteen years old, came down the street with a sawed-off shotgun and threw it to me. A big girl who lived next door to us helped Junior get to the hospital, which was right across from us. Then all of a sudden, there wasn't a drug dealer on the corner. They had gone in some nearby houses because the police were coming. I yelled, "All you motherfuckers come out here and fight. Come out! I'm ready to kick some ass today. Come out!" I was screaming all kind of stuff. They wouldn't come out. I was in the middle of the street with the gun in my hand. The police surrounded me and Lillian shouted, "Don't shoot my dad!"

Patsy remembers the police trying to get the shotgun from me and I wouldn't put it down. "Winfred was shouting that he would not be left defenseless among all those drug dealers. I'm surprised the police didn't shoot him down like a dog." I walked all the way back to the house and put the gun in the house. They never searched for it. They just took me down to the jail. Then they applauded me for standing up to the drug dealers and they turned me loose.

The doctors at the hospital took Junior in right away and did surgery. We didn't know how he was going to come out. The bullet was close to the spine. They were afraid that if they tried to move it, he would be paralyzed, so they didn't touch the bullet. They decided to wait and let the bullet move on its own. They sewed him back up. He stayed in the hospital for a month. After the first two weeks, the bullet came all the way up to the skin. All they had to do was cut the skin and pull it out.

Junior was interviewed on TV about how he could refuse to sell drugs even though he had nothing. He said it was because of me. The media went crazy when they heard that the father of the house was the reason Junior didn't sell drugs. They flocked to our house. We had *Good Morning America* out here. There was a big old sign and a bus, and the street was blocked off. They wanted to know what I was telling my kids so that they wouldn't be selling drugs. I talked about my prison experience and what I promised the judge.

After people saw us on TV, some folks dropped their kids off at our house. There weren't a lot of fathers at home with their families in our area. Patsy took the children in. She also took in runaway children, and she took kids that weren't learning anything in school. Our children brought strays home—their friends. They would bring them home and say, "Mama, they have nothing to eat at their home; they hungry. Mama, their clothes are dirty—you see how they going to school?" Patsy would bring them in the house and tell Lillian to give them a bath and some clothes. Then they would eat with us and Patsy let them stay. They had families, but they just didn't have anybody that was caring for them. Some of the parents were on drugs and didn't care where their children were.

One night we were coming home from church and we saw a young girl walking down the street. Patsy said, "Stop, Winfred." She got out of the car and talked to the girl for about five minutes. Then they walked back across the street and got into the car. The girl was

fourteen years old. She said her mother's boyfriend was always feel-
ing on her. She couldn't do her schoolwork. She said she couldn't live
there anymore and she had nowhere to go. She stayed with us a year
and a half before her mother came over to check on her. And guess
what? That girl graduated from high school with honors.

Patsy knows how to get a person going, and what makes it so
good is that she don't lie about what you can do. When she says you
can do something, you can do it. There were times in my life when it
seemed to me there was no future. I felt like there was just no good
ending whatsoever and nothing I could do about it. Things were just
not going to work. My kids looked at me to judge their future. They
watched me to see how I was doing things, and I was worried about
what they thought of me. I couldn't picture them thinking anything
good. I talked to Patsy about it and she got me to push my negative
thoughts aside. "Winfred, you can do things. Go ahead out there
and try. Do what you can do." She never put me down. Every day
she pushed me to be positive. She gave me hope. That's my spouse
talking to me. If your spouse says something bad to you, it can take
away your confidence. Patsy kept me high and ready to go. Somehow
or another, I'd come home with some groceries. That's the way it
went. I'd be dragging my feet and then all of a sudden I'd come up
out of it like a champ.

Self-portrait

LIFE ON LEATHER

We had several needy kids living with us that weren't ours. The girls were on the second floor and the boys on the first floor. We made it work and we taught them life skills. That goes so far with kids from broken homes. Unity is a big thing—family unity, which is why we had them all at the dinner table. We would tell our problems around the table while we ate. I told the kids stories about my life— not my whole story, but some parts that could help them. Now for years I had done drawings. I made little booklets for the children. I'd write stories about them and I would draw. I drew on Stop & Shop grocery bags because I didn't have paper.

Patsy started telling me that I should do pictures about the things I talked about around the dinner table, stories about the people I knew growing up. We were sitting and eating one night and Patsy jumps up from the table: "I know how we can put these stories together and they will last forever. Otherwise, when you're dead the stories will be dead with you." She thought my stories were important and that drawing them would be a way to preserve them. She also thought I should put those stories on *leather*—something that would really stand out.

I didn't agree with her at first. I thought the stories might be important, but my thinking was negative about the art world and about my talent. The negativity side had me, and I wasn't sure it was the thing to do. No one I was talking about was famous. They were just everyday people I knew growing up. So who in the heck wants to know about them? I also thought, *Here I am, fifty years old, and I haven't found any success in fifty years, so how is anything going to change now, by me doing a little artwork?* I didn't see the point. I

had a little bit of leather and my tools, but I didn't do much leather-work other than to make a few small things for the kids, nothing for the sale market. I did stuff for the kids that other kids didn't have—bracelets and necklaces with their names and astrology signs, the continent of Africa, and all that. They would go to school and brag, "My dad made this. You can't buy it in a store."

In 1996, Patsy and I met Sharon McBlain at a community meeting. Sharon was a volunteer supporting the leaders of a youth program in one of New Haven's housing projects. She and Patsy liked each other and enjoyed talking about helping kids. Sharon introduced us to a food pantry where we could get some food. One day, when things were really tight for us, she told her husband, Phil, we needed groceries. I met Phil for the first time when he showed up at our house on Beers Street. Phil didn't say much when I got in his minivan, but when I began telling him about myself, he started talking up. He liked me well enough to talk to me, and that impressed me. We became friends. I didn't know it then, but Phil would become an important figure in my life. I feel good about being around him. It's like going to see my brother or my father when I'm around Phil. It's really good for me and I know he's got my back.

Phil and Sharon McBlain have their own business. It's an anti-quarian bookshop in Hamden that has a big section of books about African Americans. I was in the bookstore one day and I asked Phil to show me some books about Black artists. Even though I hadn't gone with Patsy's idea, I figured I had a little art down inside of me and I wanted to see what Black artists had done. Phil put a bunch of books on the table in front of me. I looked through Charles White, Jacob Lawrence, and others, and I criticized them in my own mind. I didn't see anything I couldn't do, and the figures didn't seem real. Then I opened a book, *Negro Drawings*, by the Mexican artist Miguel Covarrubias. I thought to myself, *Oh, this guy is good.* He drew Black folks with big lips and big noses. His pictures had a lot of movement and they seemed to get something right about the

way Black people are—dancing, talking, and club scenes. I liked his work. So I asked Sharon to make me a copy of one of his pictures, of a man and a woman: He is dressed up in a suit with a bowler hat and she's wearing earrings and a pearl necklace. I looked around at some pieces of art that Phil had hung on the walls and I said to him, "I'll make you a picture you'd be real proud to hang on your wall." Phil replied, "That would be nice," but he didn't really pay me no mind.

Miguel Covarrubias, *On a Spree*, 1927

I was short on Christmas money that year, so I decided to use my leather skills to make a copy of the Covarrubias picture for Phil as a present. It was a small painting on carved leather. That picture got Phil's attention. "Oh, that's a pretty picture," he said. He had it framed and he hung it on the wall at the bookstore. He wanted other people to see it, which made me think there must be something to my artwork, because Phil don't hang just any old stuff on his walls.

Several weeks later, a book dealer from the West Coast visited the shop and wanted to buy it. Phil decided to sell it. He gave me the money. It wasn't much, maybe three hundred dollars, but it was a lot of money for me at the time. It was more than what I had, or anything I ever got for something I created. I couldn't believe it. Who would want to buy my work? It meant a lot to me that someone liked my work enough to pay money for it.

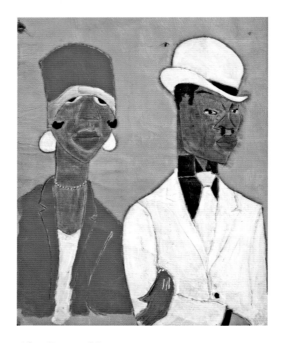

After Covarrubias

Phil told me I should make more, but I didn't have money for the leather. Phil was generous. He drove me up to the Tandy Leather Company in East Hartford and spent over five hundred dollars to get the tools, the leather, and the dyes I needed, and I started working. At first I was doing copies, but then I decided to try some work on my own thinking and from my own head.

I did a picture of myself. I was sitting on a park bench in downtown Cuthbert, Georgia, out there on the green, tying up my shoe. I remember my shoe had a hole in the bottom of it. I tore a piece

of cardboard into the shape of the inside of my shoe and stuck it in my shoe to keep my foot from hitting the ground. I couldn't step in water. I had to stay on dry land or else the water would wear it out. I thought that would be a nice picture. I did it in a Covarrubias-type fashion. The facial features and the feet are all big and fat. It turned out well.

My Shoe

The first pictures I did were small because I was conserving the small amount of leather I had. Now that I had more leather, Phil said, "Try making at least one picture a little bigger." I made a larger picture, maybe two feet by two and a half feet. It was *Jeff's Cafe*. I saw that I had something going when I did a larger picture. Phil invited some friends to his house. "Let's see what happens," he said.

We put the pictures out on the dining room table and Phil's friends Greg Seaman and Lois Smith went around looking at all the pictures. When they got to *Jeff's Cafe*, they stopped. Phil said, "That one's $750" and they said, "We want it." I thought—*Oh shit!*—and I

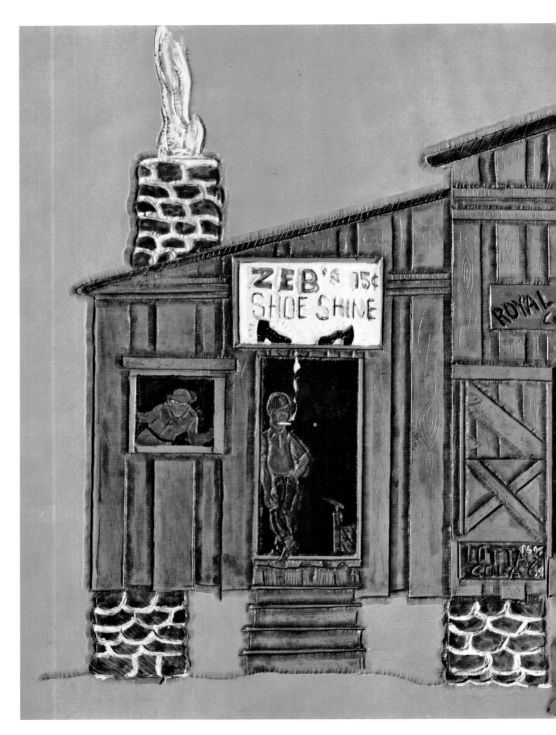

Jeff's Cafe

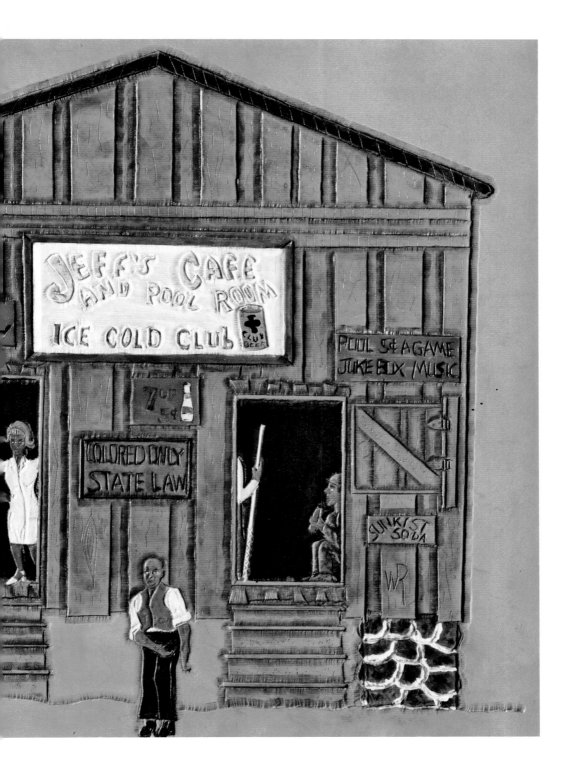

had to go in the next room for a minute. I was going nuts because I couldn't believe what I was hearing. I turned to Patsy: "My picture going for $750! What? My picture, Patsy, going for $750!" And Patsy said, "Guess what, Winfred. That's just the beginning. They going to go for twenty-five, thirty thousand. And one day they are going to go for more than that." I said, "You're crazy, Patsy." And she told me, "Winfred, you got to remember: There is nobody doing this. Nobody tells their life story on leather. *Nobody.*"

I started doing cotton fields and juke joints. I thought, *I can do pictures of places and people that are important to me, in my life, without telling it all. I can tell some of it.* I did Butch Jordan's café and what I called Colored Folk Corner. I did a couple of pictures of Black Masterson. I did Hamilton Avenue, Homer Clyde's, and my dance group.

There was a guy in New Haven named Johnes Ruta. He would go around, find beginning artists, and give them shows. He found me through a friend of Phil's. Johnes gave me a show in early 1998, at the York Square theater on Broadway in New Haven. It was a little show with about ten pictures. I brought some good-size portraits of Malcolm X and Martin Luther King, which I made because I thought people would be interested in buying pictures of famous people. I also included a few cotton fields and other pictures from my own life. I noticed that, even though it was Black History Month, no one was looking at any of the portraits. I said to Patsy, "No one is paying attention to Martin Luther King." There was a White man walking around, looking at the work. He heard me say that and he turned to me and said, "You know why that is so?"

"No, sir, tell me."

"We can get a picture of Martin Luther King or Malcolm X anywhere we want to buy it. But we can't get what you do out of your head. That's what we want."

I understood what he was talking about. I heard that man loud and clear. Patsy was mad too, because she'd been telling me the same thing and I told her nobody would be interested. She had convinced

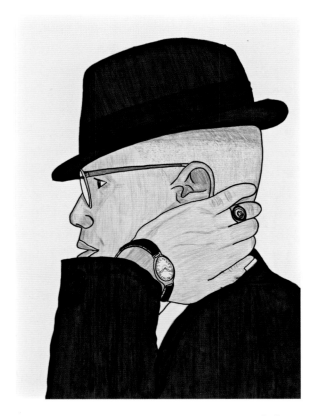

Malcolm X

me to make a few pictures about my life in Cuthbert, though, and Phil thought they had artistic merit. Now Phil don't say things to me just to make me feel good. He's not a falsifier. He'll tell me just like it is. If it's not good he'll tell me, "Winfred, that's not good." That means a lot to me because I'm used to getting lies from White folks. They'll say things just to pacify you. I've been lied to by White people all my life, but I haven't had Phil lie to me about anything.

I started to think, after knowing Phil and starting to sell pictures, that I might be an artist and, not only that, I began to think I was different from any other artist. Patsy was right. I was doing something that had never been done by an artist—to preserve his life on leather. On leather—not paper—*leather*, something that will not deteriorate.

I could have put it on paper. I could have easily put it on paper, and it would have been easier and less time consuming if I had put it on paper. But let's add a little something to it by putting it on leather. I thought to myself, Patsy's idea was a *great* one. Put it *on leather*. People make pocketbooks and belts and things out of leather, but they don't do pictures. Show me someone who is doing a picture, a *picture*, on leather, *about their life*. I was doing something no one else was doing and I was happy about that. I was real happy about that.

A few months after that first show, Phil, Sharon, Patsy, and me were sitting out at Phil and Sharon's house thinking about how to expand the leatherwork. We talked about things I could do that people might like and I started talking about my life. I let Phil, Sharon, and Patsy know that I had been in a lot of trouble at one time. I told them about how I ran away from home and slept in the cemetery. I talked about the people in Cuthbert who helped me. I talked about the little parts I played in the civil rights movement.

Then I told them about getting beat up in jail and about my lynching. I didn't really want to tell them those things, because I thought I wasn't going to be believed. I wanted them to know the truth, but who's going to believe me? I hadn't even told Patsy. How do you talk about something like that? How do you tell people? *Lookee here, guys, I got something I want to tell you. I was almost lynched.* Who would believe that?

I didn't want to tell them, but I went on and told them anyway. I guess I thought, since I was letting the cat out of the bag, I just might as well *really* let him out. I needed someone to tell it to. Before I started talking about it, I wasn't able to talk about it, but when I started talking about it, it just came out. *I'll tell you what happened to me, whether you believe it or not.* That's the way I was feeling.

Everybody in the whole room went silent. I was the only somebody in there talking. Phil and Sharon were sitting down. They listened to me the whole way through. I never got interrupted, not one time. Then, when I finished, it felt like they went silent for a long time. Yep. Oh my. I think Patsy was asking me questions, and she

said she wished her daddy had been there to protect me the way he had protected his kids. Phil and Sharon didn't say nothing that I remember. I don't know whether they believed me or not. I was afraid to ask.

I'd been carrying those things that happened to me around a long time. A long, long time, not being able to talk to anyone about it. There was only one person I had ever talked with about it and that was Mama, Lillian Rembert. I could talk with her about almost anything. Mama had been taking stuff all of her life and she was a smart old lady. When I came home from the chain gang, she knew I'd been through a lot. She asked me whether I had been abused. I said yes. It was tough telling her about it. I couldn't hardly do it. When I told her I almost got lynched, it was like I'm telling her out of a movie or something. *Mama, this really happened. This really happened to me.* Tears were falling down her face. I hated to see her hurt.

The more I thought about putting the things that had happened to me on leather, the more love I felt for Mama and for other people in Cuthbert, Georgia, who were good to me. Homer Clyde Smith had a poolroom and restaurant on Hamilton Avenue. He would cook for the workers in the field. The workers would come and eat, and after they went back to work, he would open up his restaurant for people who didn't have any money.

I thought about Jeff, Buddy Perkins, Miss Annie Bell, Bragg Brookins, Miss Prather, Grayceda, the guys in my dance group, and the other kids I hung around with. It was just beautiful to think about them, and I enjoyed doing the work. I said to myself, *Man, it looks like I can take Cuthbert, Georgia, and go a long way.* Johnny Frank James, Bubba Duke and Feet, Egg, Poppa Screwball, Nigger Ned, Tot Saul. And there's more. I ain't even broke the crust.

OVERLEAF: *Inside Homer Clyde's II*

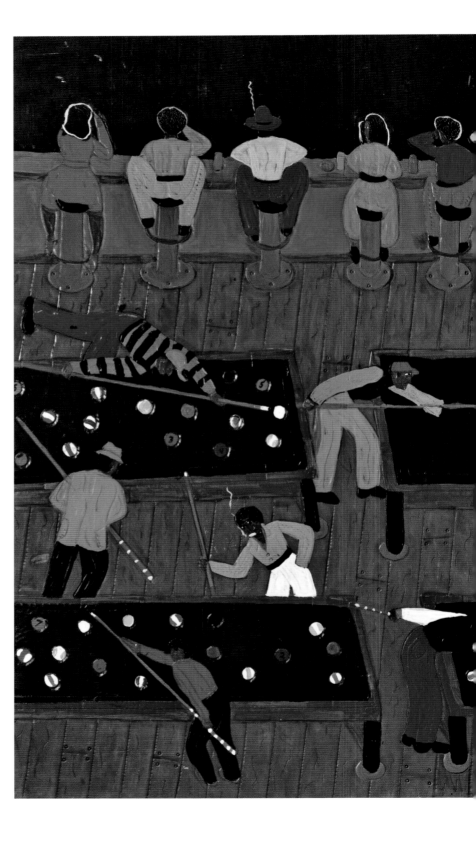

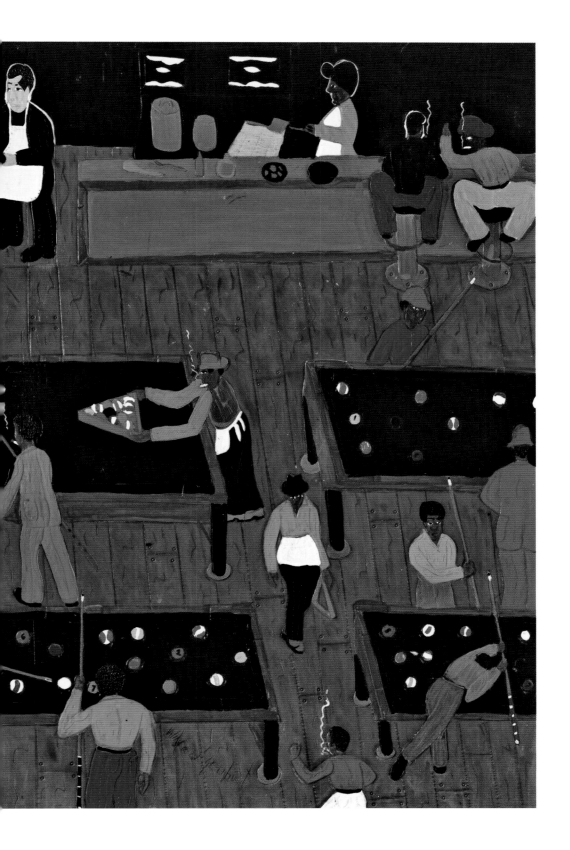

A THINKING MAN'S THING

In 1999, Bill Battle lived right down the street, and he would come by every day on his way home with his smart self. He was the director of the Newhallville Restoration Corporation in New Haven and president of the Enterprise Empowerment Zone Council. Later on, he was an economic development commissioner in Torrington, Connecticut. He's too much. He's just got so much *knowledge*. He's been to college in like four or five different countries and he speaks foreign languages. I've never been so proud as a Black man until I went to a party and took Bill with me.

We were the only Black folks there. These White men were drinking wine—something we don't do—and sitting around the table. Bill Battle got himself a glass of wine and all that, and he was listening to them. They were talking about international affairs. It was over my head. Bill Battle breaks into the conversation and says, "You got that wrong a little bit." He straightened them out. He got all these White folks straight about what went on in this or that country. I don't care what subject they brought up, he could elaborate on it. He was just amazing. I've never seen a person as smart as Bill Battle—Black or White.

Bill died in 2018, but before he died, he told me he's waiting for me to die. He got a picture of mine and he said it's going to be worth a whole lot when I'm gone. He said he's going to pay for his son's education with that picture. His son, Darnell, was admitted to Yale, and I called Bill up and said, "Bill, it's too late. I ain't dead yet."

One day, in 2000, Bill told me that these rich folks at Yale were going to donate some money for artists in the community. I had seen it in the paper too. They were going to be down there at

the Yale Graduate Club, drinking coffee and discussing about how much money they wanted to give. So I said to myself, *Hmmm. I'm going there.* But you had to have an invitation and I didn't have one. I had on my suit, though, and a picture rolled up under my arm. I got to the door of the Yale Graduate Club and the lady asked me for my invitation. I said, "Just a minute," and started looking through my briefcase, like I had an invitation. And while these other people were gathering around giving their invitations, I just slid right on in.

I got me a seat, and I listened to them talking about how much money they would donate to this art project and that art project, for artists' housing and studio space. At the very end, when they were fixing to close, the last guy was up and I timed it perfectly so that when he sat down, I jumped up and said, "Excuse me. I'm an artist. And I would like to know when these programs are coming about, because I'm a starving artist. This is my work. I do artwork on leather from my memory as a child growing up in Georgia." I unrolled my picture and held it up in front of the meeting, and they bum-rushed me. They rushed up there to look at that picture.

Jock Reynolds was in the crowd. I didn't know who he was, but he told me he was the curator at the Yale University Art Gallery. "I've never seen anything like this," he said. "Do you have more of this?"

"Yeah."

"When can I come see it?"

I called Phil McBlain and we went out to the bookstore. Jock took all the pictures down and put them on the floor. He's looking at them, and he's just looking, and then he gets up and he says to me, "How would you like to have a show at the Yale University Art Gallery?"

"But I'm not dead yet. Don't you have to be dead before you have a show?"

"I'll let you know what. In three months we can have this show up on the wall. Do you want to do a couple more pictures to add to this stuff?"

I did, so I went and did some more work, and in just a few months we had the show going. It opened on August 8, 2000. Yale publicized the show and most of the Connecticut papers ran big articles about it. One Sunday morning, in September, out comes the *New York Times*. I started getting all these phone calls from Long Island, New York City, New Jersey. They wanted to see my art. The gallery brought schoolkids in. I liked the attention, so I used to go up there and meet the kids. I would talk to them and explain things. Sometimes I would demonstrate how to carve the leather.

No leather is soft until you put water on it. It soaks the water right up because it's a dry thing. You can't work leather without water because when you take your knife to cut it, it won't cut unless the leather is soft. So first I spray the leather with water from a spray bottle. The water won't hurt it. You could throw a piece of leather in the bathtub and let it stay all night.

I use what you call a swivel knife to cut the leather. It spins. You can turn corners without having to pick up the tool. Then, after the leather is cut, I bevel it. Beveling is what gives the picture the 3-D look. It's like there's nothing before I start beveling. The picture looks like just a bunch of scratches. Sometimes you can't even tell what it is. Then, when you use the bevel tool on it—*wow*—it starts coming to life. I love that. I love seeing the leather come to life in front of me. I use the bevel mainly to lift, but I also use it some-times to indent, just to do something different. I take a sharp edge and mash it down. I crimp the leather to show movement, and those scratches turn into real images. Under the leather is a piece of slate. If I'm banging on a straight piece of wood, you can hear it all over the house. Slate really absorbs the sound.

After the picture gets beveled, I go back with the swivel knife and do other work: hair, clothes, stuff like that. Books on leather don't advise you doing hair like that. They got a special tool they rec-ommend, but I scratch my hair with the swivel tool. I could make a

whole picture with just two tools—the swivel knife and the bevel—but I use other tools too. I use the pear shader to unflatten the face and to make muscles. Leatherwork is a thinking man's thing. You have to have an imagination. You have to have pictures in your head and make your tools accommodate you. You have to figure out what your tools do and what you can do with the tools you have. I get a scrap piece of leather and I play with my tools, just to see what they can do. I surprise myself sometimes, and I don't think I've discovered everything my tools can do. Before I had some of these tools, I used knives and forks and spoons from the kitchen. Or a nail.

When I'm finishing with the tooling, I get ready to dye. Red and turquoise are my two favorite colors to use. There is a lot of color there. I like orange too, and blue, though I'm still trying to figure out how to use blue and have brightness to it. Contrast is important too. I don't think the bright reds and turquoise make a good picture by themselves without some darker colors.

You have to be real skillful in the painting stage. You can't make a mistake. You don't want your dye to go out of one place into another where it's not supposed to be. You have to be precise, or you'll get into trouble and you're going to find yourself having to go over your picture and maybe change a color into something you didn't want to use.

When I go from one color to another, my brush has got to be clean. I use the same brush, with a lot of water to clean it, unless I've got a big picture. If I've got a big picture and I'm going to be using a lot of color, I may use eight or ten brushes. I let each brush stay in the dye bottle, so when I pick it up, I'm ready to dye and I don't have to wash my brush. It's very important to have a clean brush. If the dyes mix together, they'll give a different color. Red won't be a real red when it's got another color mixed with it.

There's only one brush that won't let go of the dye. I mean, there's only one brush that can pick up the dye and not drip—a camel-hair brush. The camel-hair brush holds the dye. You have to mash real hard on your brush for it to let go. Ain't that something?

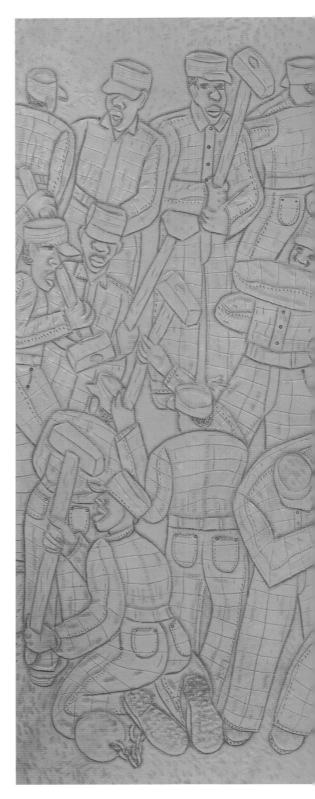

Chain Gang (All Me)

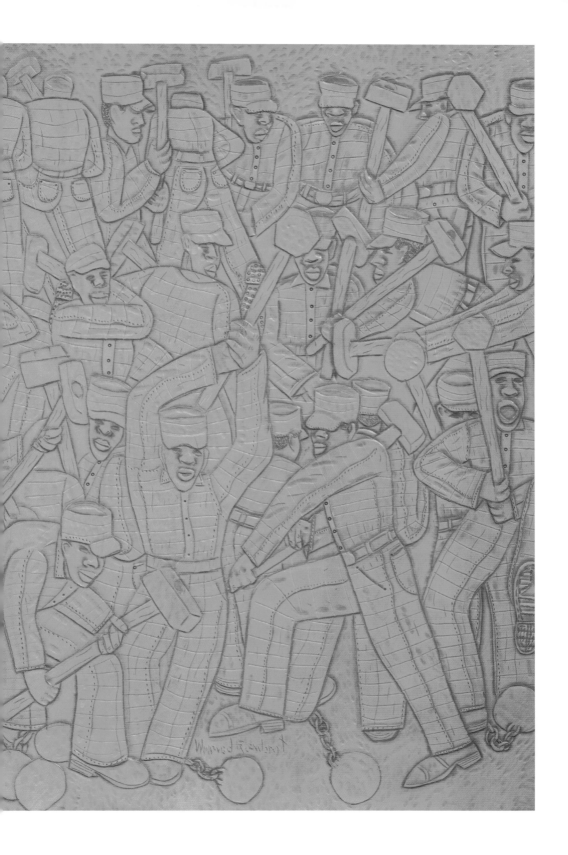

Loading Watermelons

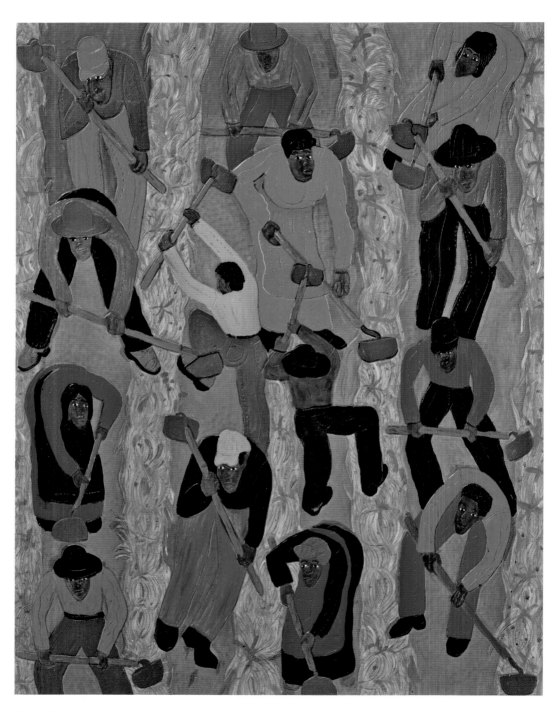

Chopping Peanuts

*

It seems to me that when you got your pictures hanging in the Yale University Art Gallery, you've somewhat made it as an artist. If Yale says your work is good, who's going to argue with that? I was meeting these people, doctors from out of town and other collectors. After seeing the show, they would come to the house and buy pictures. A week after the show closed, in December, the *New York Times* ran another article in some of their regional editions about me and my art.

Yale bought a triptych. The triptych was a painting—three paintings—about a lynching. When I lived on the plantation with Mama, she had a good friend named Mr. Xavier Alexander. I would say he was Mama's boyfriend. He was a big potbellied guy that wore overalls and smoked a cigar, kind of a playboy guy, so sure of himself, and proud to go around with his mule and wagon. He would come and sit on the porch with Mama in the summer and they would have a big conversation. One day when he come by, he was screaming to Mama to come out of the house. He wanted to show us something. I was maybe five years old. He had the mule running with the wagon, which was something people didn't do much. Usually they walk the mule, not run him fast, but Mr. Xavier's mule was running fast. Mama said, "Let me get my apron." She put on her apron and jumped on the wagon. I jumped on the back and hung my feet off.

I think we must have gone a few miles. There was a little settlement out there in the country with old broken-down homes. We get there and see all these folks crying and going on. Several people had been killed, I believe. They had been hanged. The bodies had just been taken down out of the trees. A couple of ladies looked like they had one or two of them in their arms. I don't know who those boys were or why they got killed. I don't remember being upset about it. I was just a little boy, and I didn't think about what it really meant. I believe the two oldest were brothers from the Moses family. I'm not sure about the others.

I was sick to God working on those paintings. I barely made it through the second one. First, I'd start feeling choky, like someone's

got their hand around my throat. Then I started coughing and throwing up. I'd go to the bathroom every fifteen or twenty minutes until I was dry-heaving. I ended up in the hospital. They couldn't diagnose me.

The same thing happened when I worked on *Flour Bread*. *Flour Bread* is a picture of Mama baking a cake. It brought back memories of the price she paid to bake a cake or biscuits for me and Loraine. Mama was allergic to flour. She couldn't breathe when that flour got in her lungs. She'd be coughing and wheezing. She couldn't catch a breath. When I did the picture of her, the same thing started happening to me. I couldn't stop thinking about what Mama had to go through just to get me and Loraine a piece of bread to eat, and I couldn't get my breath.

I didn't realize at first that it was my work that was making me sick, but Patsy noticed that I was getting sick every time I worked on certain pictures. She started getting worried about losing me. I said, "That may happen, but look what I'm going to leave with you." I told Patsy that I was going to do those pictures, sick or well. Sometimes I'd have to stop for a week or so, but then I'd start again. I wanted to do pictures of what I had experienced even if it killed me. I wanted people to know what I had been through. Even if they didn't believe me, I wanted to tell the story. I had gotten to a point where I wasn't holding back anymore. *You don't have to believe me. I'm going to tell you what happened. I'm going to tell you the truth. If it makes me sick, if I don't ever leave the hospital, I'm telling it. I'm going to tell it like it was.*

It was Sharon's idea for me to see a psychiatrist. I thought to myself, *Black folks don't need no psychiatrist. They been getting shit on ever since they been in this world and they know how to deal with stuff. Why do I need a psychiatrist?* I felt like I was doing the best I could do. I'm getting to be an old man, and you're going to send me to a psychiatrist? What is a psychiatrist going to do for me? I didn't see

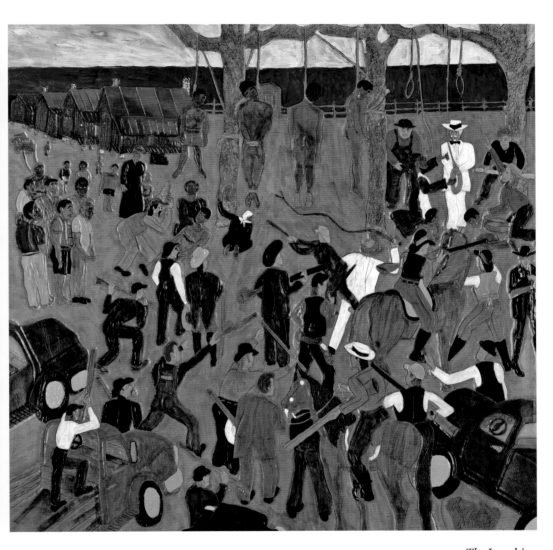

The Lynching

After the Lynching

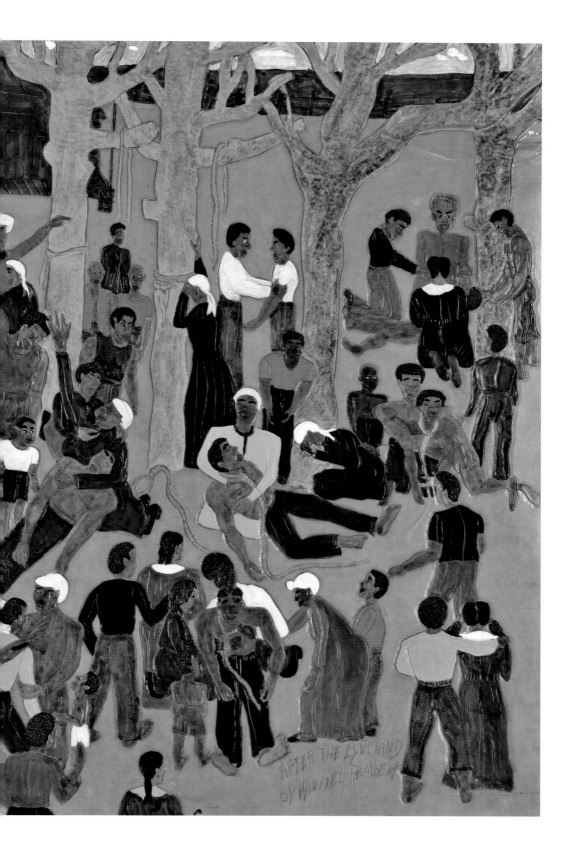

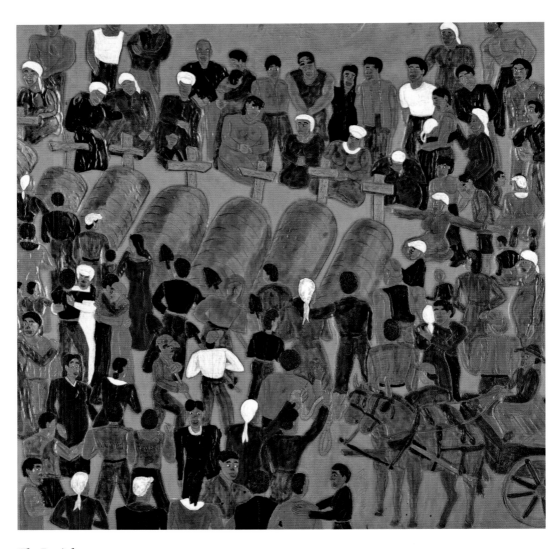

The Burial

nothing in it, but I went to satisfy the McBlains, because they had a lot of faith in it.

I'm in Dr. Orrok's office and I'm just sitting there. If you don't say anything, she will sit right there and not ask you any questions. She just sits there. If you sit there, she's going to sit there, waiting for you to say something. If you do, then she'll respond to you. She'll ask you questions. I thought, *Damn, this is just a waste of time.* But, finally, I told her what was happening to me and she helped me. I wasn't the first person with PTSD she had treated. She talked with me and she figured out some medicine to give me that makes it easier for me to do my work.

In 2002, a woman named Claire Simler arranged for me to come to a private school near Waterbury, Connecticut, in the country, where her son was a student. When I got done talking to the students, Claire said she wanted me to meet someone named Peter Tillou. She introduced us, and he wanted to see some of my pictures. He had his son with him. They stepped into the room at the school where I had my work. They looked at it, they looked at each other, and Peter's son said, "Dad, we have to purchase some of this."

Peter asked me if I had more of it and I told them to come to McBlain Books in Hamden. He followed me to the bookstore and looked around. I think he bought five pictures, and after he bought them, he muttered out loud, "Much too cheap." Then he said, "How about you work for me—you sell me the pictures and I'll take care of you. I'll give you some money for each picture up front. You do two or three pictures a month and I'll give you more when I sell them." Peter also promised that he would arrange a big exhibition when he thought I was ready. He said he did business on a handshake, so we shook on it.

I started making a lot of pictures—people singing in the cotton fields, shooting pool in the poolroom, a chain gang picking cotton, folks dancing in church, and baptisms. I remember my own baptism

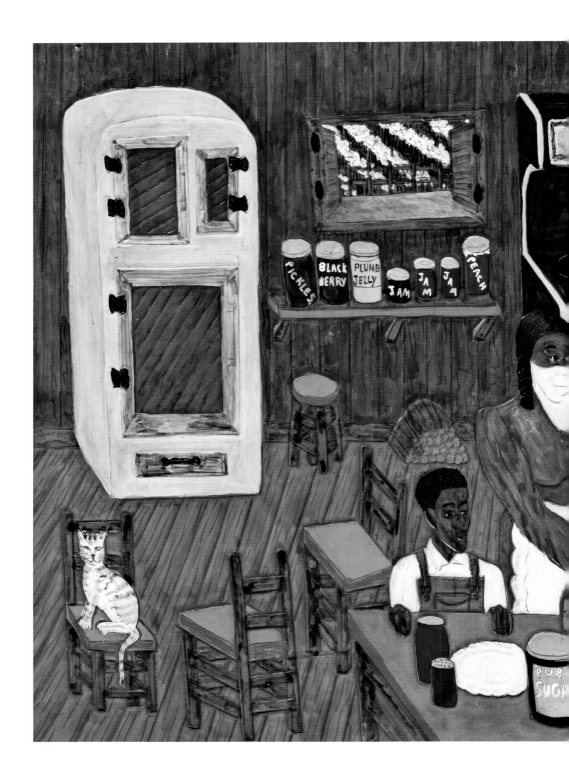

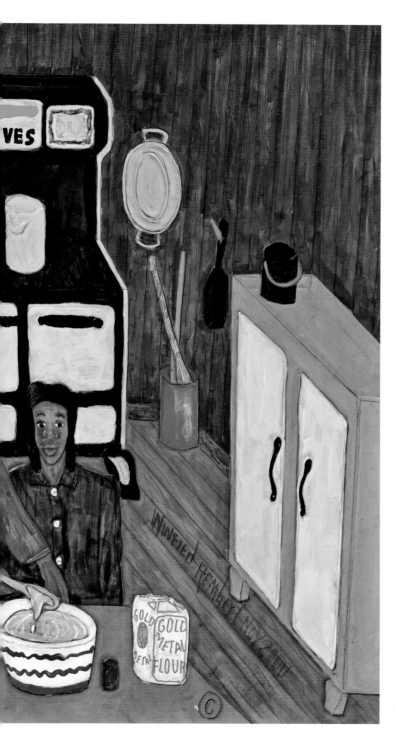

Flour Bread

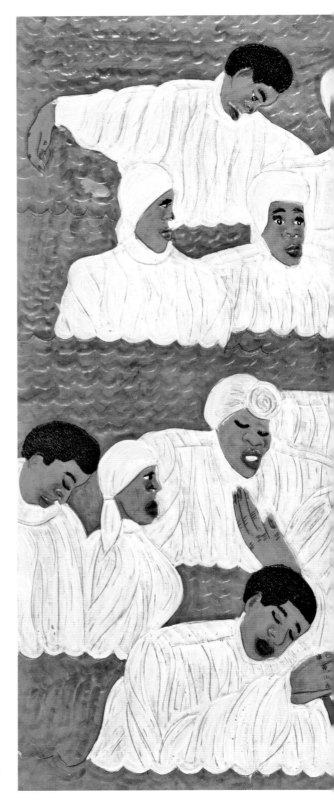

The Baptism

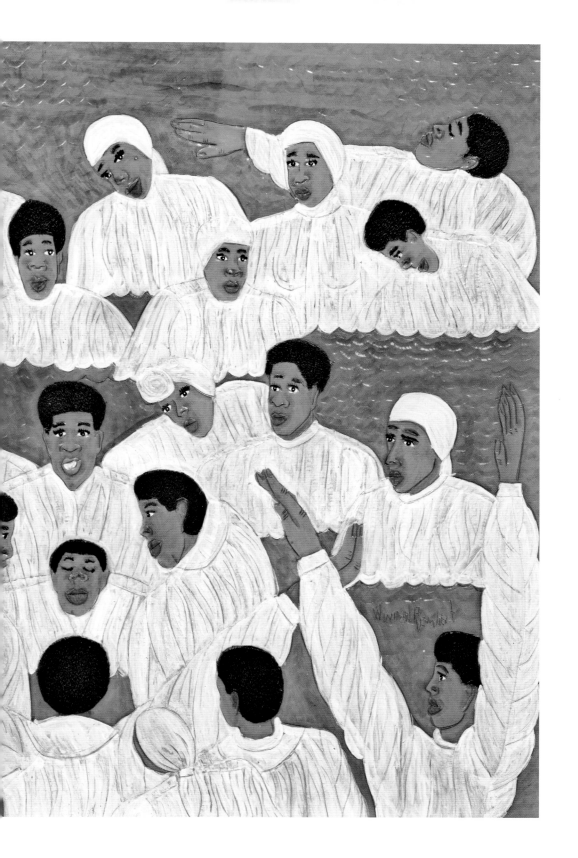

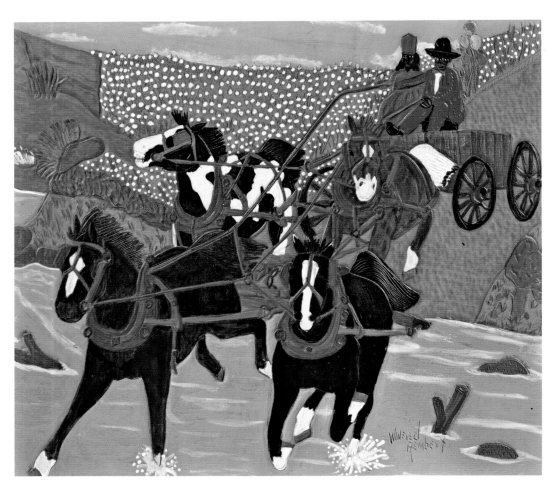

Going to Church Late

well. I remember getting up that morning, and I also remember the night before getting up that morning. Mama was telling me, "I'm going to warm some water here in front of the fireplace so I can bathe you off tonight and you won't have to worry about that in the morning." So that's what she did. It was important for me to be real clean. The next morning she put me in a gown and we went down to the church. There were a lot of people down there, including fifteen to twenty people getting ready to be baptized. I was wearing the gown Mama gave me, with no clothes on under it, no drawers or nothing. Mama took me down to the water's edge and two deacons caught me, one on each side. They walked me into the water, to where the preacher was waiting. The water was about chest high and I was scared. The preacher put his hand on my forehead and said, "I baptize you in the name of the Father, the Son…," and when he said "the Holy Ghost," he dipped me down underneath the water. I came up sputtering. When I got back to the edge of the river, the first somebody I saw was Mama. She was laughing. She said to me, "Well, Winfred, you all protected now. The devil won't get you."

I've had shows and been asked to talk about my art and life all over the country—Connecticut, New York, New Jersey, Massachusetts, Pennsylvania, Ohio, Illinois, Michigan, Colorado, California, Virginia, Alabama, and Georgia—sometimes with Vivian Ducat, for screenings of her documentary about my life: *All Me: The Life and Times of Winfred Rembert*. My "coming out" show was held at Adelson Galleries, in association with Peter Tillou Works of Art. It opened in New York City on April 7, 2010. When it was time for the opening of my show, a limousine came to pick me up. Oh my goodness. They picked up me and Patsy, Phil and Sharon, and our friend Nancy Lewis. Nancy and her husband, Yale professor R.W.B. Lewis, loved my work and bought several pictures. I had on a tuxedo and we all headed to New York City.

We were cruising slow in the limousine through the city. I thought about all the drug dealers out there selling drugs, hustling, running back and forth, and I said to myself, *Boy, that used to be me. But now I got something else.*

When we got to the gallery, it was full of people. Everybody wants to greet you and shake your hand. Everybody wants to touch you. They wanted me to speak. "Speak, Winfred, speak!" I started my speech, and when I was into it, I thought about the Wilson brothers. I thought about them telling Mama I'd never be a damn thing. "He'll never be nothing," they said. But look at him now. I said, "Boy, I wonder where the Wilson brothers are now. They said I'd never be a damn thing. That's what they said to Mama: 'That boy will never be *nothing*.' Wilson brothers, I don't know where you are now, but I wish you were here. I am somebody." Chills came over my body when I said that.

After my speech, they said to me, "Sing a song, Winfred." There was change in my life, so I began to sing "A Change Is Gonna Come." Then I sang "Moon River." While I was singing, I heard another voice with me and I felt a hand on my shoulder. I looked around. It was Andy Williams, the crooner—one of the most famous singers in the world, and it seemed to me he was singing with me. Andy and me, singing together.

So I've crossed some bridges, and I would think that I'm headed toward the successful side of the art world. In that way, things have turned out just the opposite of what I pictured they would be. I had always thought negative about my artwork. Why would anyone want a picture of me riding on my mama's cotton sack? What would anybody want that for? Why would anybody want a picture of me shooting pool in the poolroom? I don't know. So when people bought the pictures and hung them in their homes…To see these people buying my pictures and hanging them on their walls, it was out of the realm of anything I thought would ever happen.

Phil took me to Vermont early on in my career as an artist. He has some business there. A bookseller had bought one of my pictures a year earlier and I forgot all about it. When we walked into his house and down the hallway, I looked up and there goes my painting. It was

a picture of some pool players. There it was—my picture, up on the wall, and I said to myself, *Damn, this guy has my picture hanging in his place.* That just blew me away. My work is hanging in this White man's house in Vermont. In Vermont! You know what I'm saying? Vermont just isn't a place with a lot of Black folks.

My pictures are about how Black people were treated and how they lived. What is it about the White world that makes people want to know about Black life? I don't know. It's amazing to me. I feel like I am putting my audience in another world when I get them interested in Black life.

HOMECOMING

I was invited to Cuthbert by Andrew College in 2011. There weren't too many people left in Cuthbert who had known me, because so much time had passed, but there were a few. Some of the guys who were in the dance group with me were still there, still living. Eddie C. Howard—Juicy—he was there. Poonk was there; he met me at the airport. Hog wasn't there because he was in jail in Tallahassee, Florida. I don't know why he was locked up.

I had been reunited with Eddie C. and Poonk the year before, in October 2010, in Albany, Georgia. It was the first time I had seen them since I was arrested in 1965. Ray Segal and Vivian Ducat found Eddie C. and Poonk when they were interviewing people for Vivian's film, *All Me*. Vivian arranged an exhibition of my work at the Albany Area Arts Council. Poonk and Eddie C. were there on opening night. It was great.

Going back to Cuthbert was even better. Cuthbert was what I had been dreaming of most. Andrew College hosted a celebration of my life and my artwork. They also gave me a place to stay. The name of the place was the McDonald House—not the burgers, though. The McDonalds were the richest people around. I used to cut their grass. When they died out, the house went to Andrew College. So I slept in the McDonald House and they gave my boys and me a suite and room service, 24-7. Anything I wanted, all I had to do was tell somebody, they didn't care what time of day it was.

I asked for steak—porterhouse steak—and they went and grabbed four or five of them. When they came back they asked me, "You want them on the grill or you want us to cook them?" I said, "On the grill would be nice." The kids got what they wanted and we

ate like kings. That house was just fantastic, with all the great pillars and tall ceilings, and all the way around in the house was a kind of bench with pillows that you could sit on. I said to myself, *I used to cut the grass, and I couldn't even come up to the front door—I had to go to the back door when the McDonald family was living here—and now I am living here. I can't believe this. Maybe they are going to take me and hang me again!*

At the college that night, the mayor got up and said something sort of apologetic about what had happened to me, and then he said, "September Eighteenth we are going to honor as Winfred Rembert Day. Winfred, you are welcome to Cuthbert anytime you want to come home. We are happy to have you." He gave me the keys to the city and a big plaque. The plaque said, "Winfred has emerged as a nationally known self-taught artist, using the art of leather tooling to depict memories of his life in Cuthbert in most of his work. He refuses to allow the chains of hatred for injustice to hold him a prisoner of the past."

I had no idea that the mayor was going to do that. And you should have seen those people gathering around on Winfred Rembert Day. There were a lot of White people. I couldn't believe it, and I'm still cautious. Everybody says, "It's Winfred Rembert Day." But what is Winfred Rembert Day, Mr. Mayor? Winfred Rembert Day is on the books in Cuthbert, Georgia, to go down in history. Why are you doing that, Mr. Mayor? What does it mean to you to give Winfred a day? Are you just putting that on a piece of paper, or does it really mean that this guy deserves to have a day in the city of Cuthbert, Georgia? I would love to know what was on his mind. I think maybe he was trying to show some remorse, but I'm not sure. His demeanor seemed good and on the right track.

Patsy thinks about it a little differently. She says she knows why he did what he did. "He knows they were wrong for what they did to you, Winfred, parading you around the city and all that. Giving you a day was his way to keep you from asking them to give an account of the wrong they done. It's a way to hide it."

Just as we got ready to leave, here comes someone from one of the most prejudiced families in Cuthbert, Georgia. They were just terrible. They used to hate Black folks *to the max*. He walked up to me that night and he said, "Winfred, do you remember when we used to play together? We used to swing in a swing together. Do you remember that?" I didn't. Then he said, "How about you come to breakfast at my place? I just built a new house out in the country, and I'd like to invite you and your boys to breakfast. I just got married, and I'll have my wife fix breakfast for everybody."

This man had bought the house where Mama and I had lived in the country. When we lived there, it was a shack with two rooms—a bedroom and the kitchen—right next to the cotton fields. He bought the house and had turned it and the surroundings into a hunting club. When his wife was fixing breakfast for us, I said to myself, *I just can't believe that this White woman, here in Cuthbert, Georgia, is saying to me, "Winfred, do you have enough ham on your plate? Do you have enough bacon?"* We had just about everything you could think about eating. I'm not used to White folks serving me, *especially* White women in Cuthbert, Georgia, and he was telling her what to do, to serve us this and that. I got a little restless. This White woman was giving me so much attention in front of her husband, I thought maybe they were setting me up. It crossed my mind that this guy might get his pistol and start shooting. I'm getting all this attention from a White lady in Cuthbert, Georgia. My boys were there, together with this man and his two sons, who all had on guns. So I didn't feel too comfortable, though I would have felt more comfortable if it hadn't been for the woman going out of her way to be so nice.

I don't know why he had me there. I guess it was because the other White people were showing some love, though not all of them did. The night before, we were at the Randolph County high school and I showed some of my artwork to the students. Some of the people I went to school with were there too. We were leaving the event, and when we got outside, here comes an old White man in a wheelchair. He rode his wheelchair up fast to me and he said, "I don't care

how good an artist you is, *you still a nigger.*" I think he was one of the guys who lynched me. Who else would roll up to me and say that?

My folks, my Black people, gave me a welcome, a red-carpet welcome. A lot of younger people came to the house, and I didn't know who they were. They thought what I did was for the advancement of Black folk, and I was happy to hear that. They were talking about what I did for civil rights and what I went through. They didn't know the artwork side of me. A young Black guy, about fifty years old, came up to me and said, "You are my hero. We know what you done." When they paraded me through the town square in chains, he was a little bitty boy, five or six years old. He remembered seeing me that day.

In 2013, there was a celebration in Americus, Georgia. It was the fiftieth anniversary of the beginning of the Americus movement, where I got in trouble in 1965. I was invited as a special guest who had been part of the movement. Jimmy Carter was one of the guests too. He got up and said president things and we had dinner together. I enjoyed having dinner with the president and, most of all, talking with his wife, Rosalynn. I was running late to the dinner and she was all over the place wondering where I was. She couldn't wait for me to get there. She said she wanted to meet me so bad. At the dinner table, Jimmy was pretty smooth, and we talked about old times and the civil rights march. I got up and spoke at the dinner too, and told my story about the march. Everything went well and I have a few signed pictures that I took with Jimmy and Rosalynn.

While I was talking with Jimmy over dinner about things he did before his presidency, cotton fields, peanuts, and all that, my mind went across Mr. Robinson and his family, and a few other people I knew around Americus who were kind to me. There was the Austin family and the Tyson family, who let me stay with them sometimes. I was a high school basketball player and they were basketball fans. I

made it known that I didn't want to travel back to Leslie every night. They made me the offer to stay and I took it. It meant a lot to me to think about them at the dinner that night.

Being honored in Albany and Americus, that was fantastic, and so was the New York crowd—you know, all the high-society people and everything. I couldn't ask for anything better. But it wasn't like going back to Cuthbert. My homecoming in Cuthbert was different from anything else. The people I knew in that little country town, those people that made my life complete—they still made a difference when I went back there. Being celebrated like they celebrated me, that outplayed everything else that was happening.

I left Cuthbert all locked up in chains with a twenty-seven-year sentence. I left there as a jailbird, a nothing, somebody who would never be anything in his whole life. I wanted to rectify that. I wanted to go back and show people that I didn't commit a crime worthy of the time I had served. I wanted to show the people I went to school with, danced with, and played basketball with who I am and what I do. I wanted to tell them that I'm a somebody, not a nobody. I didn't know whether people in Cuthbert knew why I went to jail, or whether they cared, until I showed up on that day, forty-six years later. I found out they weren't looking down on me. They were looking up. They were happy to see me and happy that I was out of jail.

Deep down inside of me, out of all the places I've been and of all my desired places to go, there was nothing but Cuthbert, Georgia. It was home. When I got back there, it felt like what I had dreamed of and more. It felt like something I'd been wishing for my whole life, just like opening up the pages of your favorite book. It was the highlight of everything that's ever happened to me. Just like I wished it— that's the way it came out.

SEARCHING FOR THE RIVERBANKS

I was watching *Roots*, back in the day, and Kunta Kinte said one thing that stuck with me so hard. He was in the ship, and he woke up and said, "Where are the riverbanks?" He had never seen no oceans and there was nothing but water. "What kind of place is this?" No land. "They got me somewhere I've never been in my life. What are they going to do with me? Why they got me shackled up like this?" He had never seen those braces before, nothing that holds you down. He looked at those shackles and tried to shake them off.

In my life, I might have thought, *Where are the riverbanks? What am I doing here? Why am I being treated this way? Why is life so hard for me?* I got shackled—that's the way my life went. I'm looking back where I came from. I'm lucky to be here, from what I've been through. I see the mob. I'm looking at them, right now, hitting me with their axe handles and guns. I'm looking at them right now. I see them shackling me. Those shackles—they're still on me. I'm still wearing them. No one has a key to the shackles that are holding me. I don't. I don't think I'll ever be set free.

I'm on the run. I don't know if people know what I mean when I say that. I'm still running. I don't know if I can say words to make people understand. My life—16, 17, 18, 19, 20, 21—those were tough years. I'm running from the police and not just physically. I'm running, and I think they'll be chasing me for the rest of my life.

I get up three or four times every night thinking about these things. I'm dreaming about them too, and I'm fighting. Sometimes I fall out of bed, I'm fighting so hard. And it's so real in my sleep. I'm getting chased and beat up, not for crimes I committed, but crimes that, in my dreams, they say I've committed. The police are chasing

me and trying to lock me up. Sometimes they catch me and sometimes they don't. Sometimes I'm in a fight and sometimes I'm not. I think they'll be chasing me until I'm in my grave. It will be over then.

I'm thankful to God to wake up, and I hope I keep waking up, but I'm so scared there's going to be a time when somebody hits me with an axe or gun handle and I won't wake up. I'm so close to getting killed in my sleep. I'm afraid one day they'll kill me and I'll die in my bed. I want to wake up, but I don't know if I will. I hope I will continue living and that I can outlive those thoughts. I really hope so.

Some things are hard to talk about until you get ready to spill them. Once you get ready to really talk, then you just tell it all. It seems like that's the way it was for me. I began to relive a lot of things I had buried. My memories began to come out, to flow, and I started doing pictures. All that stuff started coming out of my head. I didn't realize it would be like that. When I started talking about my life, I just started telling it and telling it and telling it. More memories come back, but I'm sure I've missed a lot.

When I was a boy, I met a man named Buck Ross, who was good to me, like a father. One time, J.T. was beating on me and Buck came and put me on his plow while he was plowing his mule. Buck Ross's birth name was Fletcher Foster. He worked some on the plantation, but his real money job was as a moonshiner. He had a still out in the woods. I never saw Buck's still, but if it was anything like J.T.'s, it had big barrels and was near a stream—a whiskey still has got to be near running water. You put cornmeal, sugar, syrup, and yeast into a vat, build a fire around the vat, and let the mash rot down. It ferments for a few days and then you bring it to a slow boil. The steam comes off the vat and goes down a big old copper pipe and through the water, where it cools. Once it passes through the water, it turns into a drip. It drops down into a five-gallon jug and it's whiskey. People loved Buck's whiskey.

According to Buck, he was making 100 to 250 gallons of moonshine every day. Everything was fine for him while he kept quiet

about having any money, but buying himself a big top-of-the-line Buick Roadmaster started his trouble with the law. That's a car that no one around town is driving. Even White folks aren't driving a car like that. It drew a lot of attention. Everyone knew Buck had money when they saw that big Buick Roadmaster. The next thing they were probably thinking is, *Where is he getting his money from?*

The revenuers found Buck's still. That's what they do. They ramble the woods and search for stills. They grabbed Buck in nearby Quitman County and brought him to the old county jail in Cuthbert. Buck refused to identify a White man who was seen with him at the still. When Buck was arrested, the White man escaped by hiding behind a tree and crawling away. It seemed like Buck had made up his mind not to tell who that White man was. They probably had a fifty-fifty thing going. They might have built that still together.

When you make up your mind you ain't going to snitch, you just ain't going to tell no matter what the consequences. Sheriff Faircloth questioned Buck about it a few days later and Buck said he didn't know who the man was. Faircloth tried to hit Buck, Buck dodged, got the sheriff by the belt, and bumped him against the wall. Faircloth grabbed Buck and accused him of trying to bust his brains. Think about that. You put your hands on the sheriff and you're a Black guy. Faircloth could have really messed Buck up for that, right then and there, but he didn't. That tells me he was invested in Buck. I think he loved chasing Buck down. Anything he could get Buck on, that made his day.

Faircloth came to Buck's cell again that evening and said, "I'm going to kill you and you're going to rot in my jail." Buck chuckled to himself because one of the bars in the cell window was loose and he had been crawling out at night. Buck was a skinny guy. Once he pulled that bar out, he was probably just squeezing and turning and wiggling until he got hisself out of there. He went to visit his wife, Doll—he *loved* Doll—and, real early in the morning, he would come back and lock himself in. One night the jailers discovered Buck missing and the deputy had the bar welded. When Buck couldn't get back in, he stayed with a White man who told him he could come back and stay again the next night.

OVERLEAF: *Buck and Me*

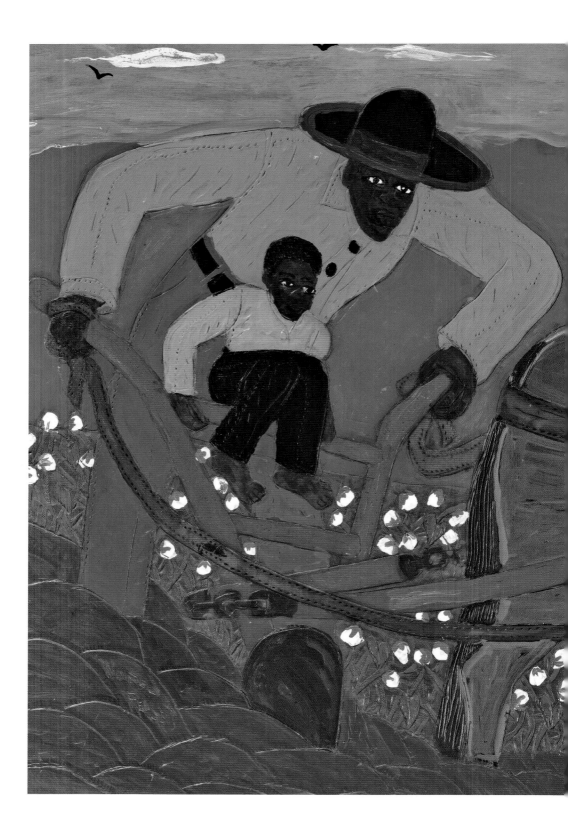

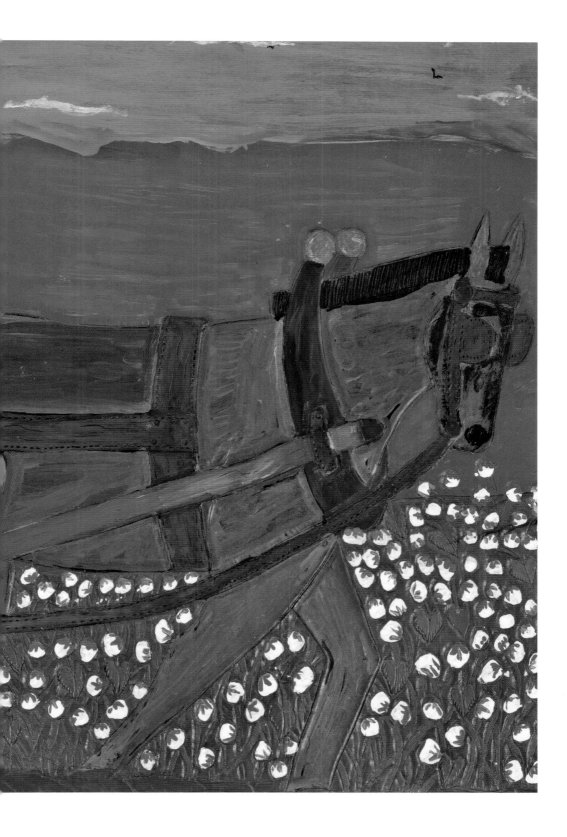

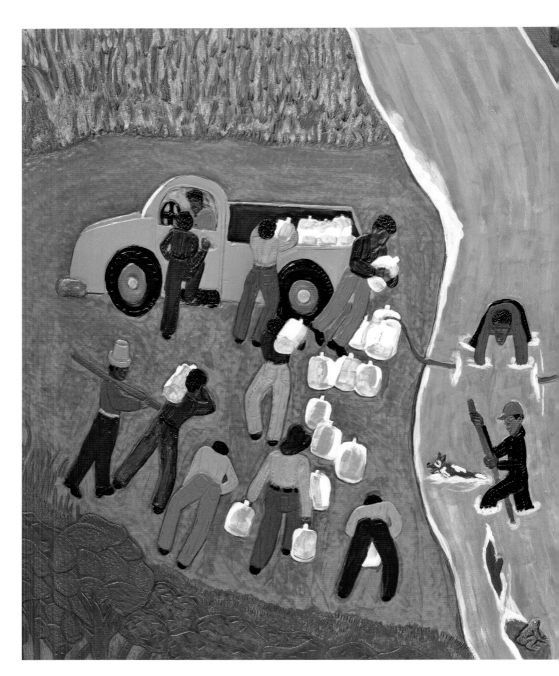

Buck Ross's Whiskey Still

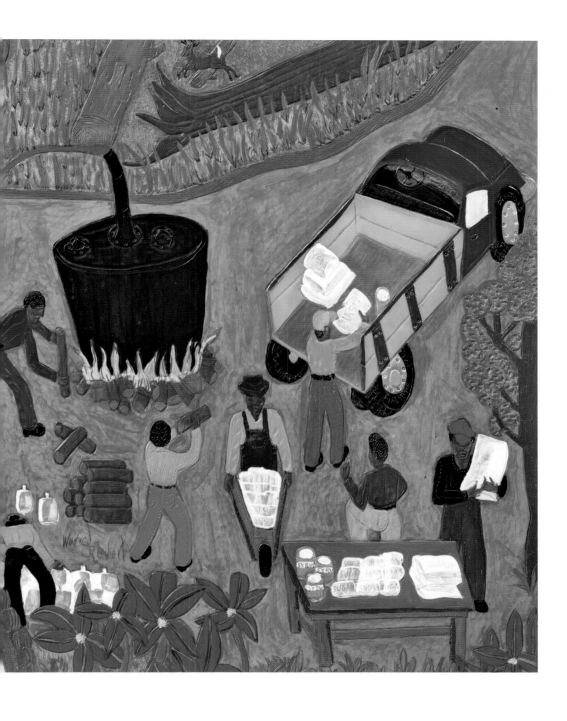

Someone saw Buck and ratted. When Buck stepped out the next day, six armed men and a deputy confronted him. Buck put his hands up and said, "I ain't gonna run," and the deputy yelled, "Hold your fire, I got him!" But the armed men paid the deputy all of no mind. They shouted, "Kill that nigger!" and lit Buck up. They shot Buck's fingers off and put a bullet in his brain.

They thought Buck was dead, but he wasn't. Ran Thomas's Funeral Home come to pick Buck up. Ran was the father. He had two sons. When they showed up, they discovered Buck wasn't dead and they took him to the hospital. Faircloth found out that Buck was alive. He went to the hospital and handcuffed Buck to the bed. As soon as the doctor dismissed Buck, Faircloth took him to jail, and the judge sent him to Reidsville. When Buck got there, he couldn't walk and he could only see out of one eye. Three years later, he was released and came back to Cuthbert.

Buck could have paid somebody off ahead of time, but he didn't want to. When I asked Buck why he didn't give up some of the money to get the authorities to leave him alone, he said, "I didn't have no money for them." Buck had his moonshine money, but he wasn't going to give it up.

You know, I tell stories and a lot of my stories are far-fetched. They're hard to believe. Sometimes I think people don't believe them. They just go along with what I say. They probably get behind my back and say, "Ah, shit. That ain't never happened." In May 2002, I was invited to participate in a ceremony at the King Center in Atlanta, honoring the victims of lynching. After the ceremony, my friends Phil and Sharon, and Patsy and I decided to drive down to Cuthbert. Next door to where me and Mama used to live was an older fellow named Robert Starling. He was still there. He had built a little shed in his backyard and he had all these antiques he had collected. He was showing them to me. He even had my marbles from when I was a little boy. I wanted them, but he wouldn't give them to me. We were standing there talking and he said, "Winfred, do you remember that barrel that they had downtown that you had to laugh

in when the White folks tell you a joke?" Phil was there with me, listening. I was so happy Phil heard that. It was proof that I wasn't lying about the laughing barrel. It proved my point.

Then we went to Buck's house—me, Phil, Sharon, and Patsy. We sat there with Buck and talked. Buck don't smile. He don't change facial expressions or nothing. He just sits there and sucks on his asthma pump. Buck holds up his hands. Some of his fingers are missing and he's saying, "I still got a bullet in my head." There I was, sitting and talking with Buck, and I had told that story back in Connecticut before we got there. Let me say this: To sit there, with the people that were with me, and to hear Buck talk about what happened to him—that meant the world to me. You don't know how that made me feel when Buck held up his shot-off fingers and told that story.

I say that Buck lived for me. He lived for me so that I could tell his story, and then I could get back to Cuthbert and he could tell it. These things really happened. They are part of Black history.

When I was a young boy, I felt like I was in the world alone, by myself. That's the way I felt. When I lay down at night, I'd think about a lot of stuff, especially when I was sleeping in the cemetery. If you can't sleep nowhere but in a cemetery, you find yourself doing a lot of thinking, because there's no way you can sleep an entire night without waking up. You can't sleep on a stone all night long. You just can't do it. I found myself, at some point, maybe around fourteen—I'm guessing when I say fourteen—saying to myself, *I'm in a prejudiced world and I really don't have no one to talk to about it. I just got to figure out my next step, on my own, in a White world.*

When I was locked up on the chain gang, I thought about a lot of things then too, in those seven years. That's all you do, especially at night in your bunk, lying there. *What if? What if?* I thought that I could have had a better life if I had been raised up with my birth mother. Most of her kids went to college, and I felt like that could

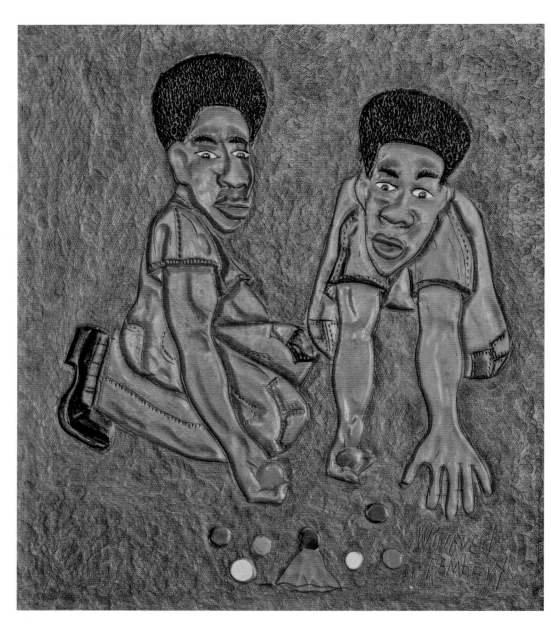

Winfred's Marbles

have been me. I believe I could have been a doctor, and not just a doctor, a *great* doctor. That would have been a challenge to me, and I love challenges—that kind of challenge—I do. But I don't think I should have to be beat up to get there, or shackled up to get there. I shouldn't have to be an Uncle Tom to get there. I should be able to get there on my knowledge. But here I am. I missed all that.

Patsy always talks about when she first saw me. It was 1969 or 1970. I was sitting on the back of the truck with my prison uniform on and a pair of shades and a baseball cap. She talks about that even now. *"When I saw you…"* It makes me feel kind of good, but I still don't understand it. There I am on the chain gang. I don't understand how you can get any love out of that. I don't understand how she could have had any love for me at all. What did I have going? I didn't have *nothing* going. I'm in prison and I don't know when I'm going to get out. I'm scared to tell her, and I don't want her to ask me because I don't have no answer.

I had a little love from my family, but nothing like what I got from Patsy. I got Patsy in my corner. She's someone I can depend on, and there's no doubt about that. She loves me for who I am, not what I got. She made that plain, and Patsy never had anything—I mean, really nothing. When we were sleeping in her parents' house in Georgia, we could look up and see the sky. When it rained, we had to put pots and pans down to catch the water. I'm telling you, we've had it hard. We've had it real hard.

But things worked somehow, and loving Patsy is just the greatest thing. There's no comparison. I don't know how much life we have left together, but I know, whatever it is, we got to make the best of it. And, as Johnnie Taylor sang, that calls for showing love for each other every day. Patsy is…

> *Sweeter than apple pie*
> *More precious than gold*
> *I'm talking about you, lady*
> *You're the woman of my dreams*
> *And my whole world is you.*

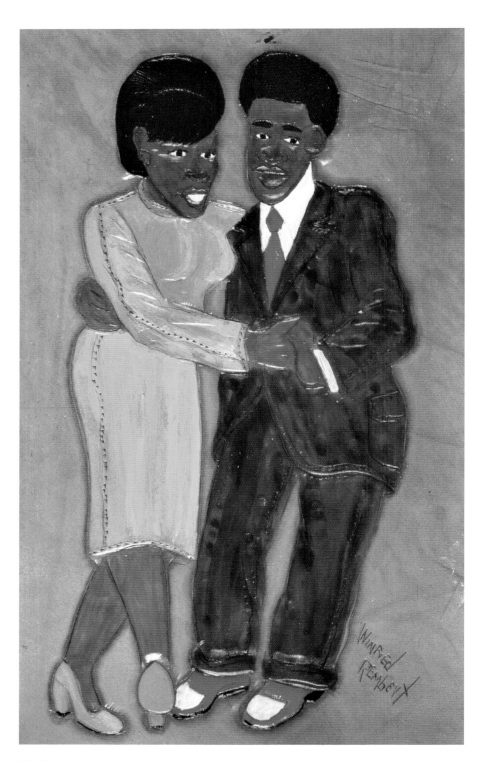

The First Dance

Heaven ain't so far away
It's right there where you lay
And lucky me, I get to go there
Each and every day.
My whole world is you.

One more thing…
There ain't ever gonna be
Another woman in this world
Like you for me…
My whole world is you.
Oooooh, Patsy
My whole world is you.

In December 1974, I sang for Patsy when I went to her house in Ashburn, Georgia. I stood under a tree in the yard. All Patsy's boyfriends were standing around and I grabbed Patsy by the hand. There were all looking at me, Patsy's sisters and brother too, and her mama and daddy, and I broke out and sang "I Believe in You." Her boyfriends said, "Oh shit, we don't stand a chance," and Patsy's daddy said, "That bighead rascal can sing." We got a forty-six-year bond and Patsy act like we just got married yesterday. She thinks that's the way love should be, always renewing itself and remaining the same, or getting deeper. Every day I get up and Patsy is showing love, all day. She says love hides a lot of faults.

I can't promise anything anymore. Promises are gone. What I want to do for Patsy probably won't ever get done. I really want to get her a house. It doesn't have to be a big house, just a nice home where, when you go in and turn on the heat, the heat comes on. You turn the air conditioner on, and the air-conditioning comes on. No windows are broken. Everything is working and painted. I probably won't ever get it done, but that's what I'd like to do, for Patsy. She's put up with a lot of things. She's used to not having anything, and she don't complain. She don't ask for nothing. She deserves more than what I've done for her. A lot more.

I've always wanted Patsy to know how much I care about her. It's just that I'm old now. I can't sing her the songs like I used to. We used to go fishing out in the river on a little boat I rented. While we were floating along, fishing, she wanted me to sing songs to her. I'd say, "Patsy, that'll run the fish away." But she didn't care. She wanted me to sing, so I sang every song I knew. And sometimes we'd sit on the rocks at the banks of the fish creek, singing.

It was Patsy's idea for me to become an artist. I knew I could draw, but I never thought I could do it on a professional level. I don't know what talent is. When you got talent, how do you know you've got it? You need other people to prove it. Patsy kept telling me, *Listen, you can do it,* and she kept pushing me. She kind of convinced me that day at the dinner table when she told me that I could leave some things behind for other people to see when I leave this world. I could tell the truth about what I lived through and what it was like to live in Cuthbert back then.

Me and Patsy do a lot of talking about down home. That brings things back to me. Then I might do a sketch, and I'll talk with Patsy about it to see if that's something I want to do. Patsy always said I would do the railroad tracks, and I wondered for a long time whether I should do it. My mind was all crazy about that picture. I wanted to do it for so long—twenty years and coming. I just kept putting it aside. I didn't do it. You know what I would do? I would get out my leather and get ready to draw it down and have some kind of conversation about it, and then I would throw it aside. I put other stuff ahead of it. I was really worried about the kind of picture it would turn out to be. The meaning of it is what had me worried. I knew that when I do that painting, I've got to confront my birth mother, Nancy Mae Johnson. I've got to come face-to-face with me being her son.

My mother was only twenty-one years old when she gave me to her aunt. Whose advice was she taking? Her mother couldn't have been advising her, because her mother was sick. Bigdy, her father, could have, or maybe there was somebody, a friend, or someone she knew in church. There are a thousand possibilities. It would mean

something to me to know, like when I asked her who my father was. I never heard, out of her mouth, who my father was.

"Is Willie B. Wright my daddy?"

"Maybe."

After I climbed out of that mattress, ran out that back door and hit them tracks, I said to myself, *I'm gonna look for my birth mom. I'm going to look for Nancy Mae. Who would I rather face, Nancy Mae or the jail?*

When I do a picture, I always think about the angle you are looking from—nine o'clock, ten o'clock, twelve o'clock. Imagine you're the sun and you're looking down. Twelve o'clock high is straight down over the railroad tracks. One o'clock tilts the perspective a little bit. A six-o'clock-high angle is low. You could only see a little bit of the track because you'd be looking straight down it, like you're standing on it. In my mind I see the picture from all those angles.

For the railroad tracks, I chose three o'clock because I wanted to show the whole track and how far it goes. It's just me on those railroad tracks. No other people and no animals. No buildings. Just those railroad tracks in front of me. If you look at the person—me—in the picture, you can tell how you're looking at him. You're behind me from a three o'clock angle and I'm moving forward. I'm going to see my mother. If I can make it to her, I think I'll be all right. So I jump on that railroad and I look down and I don't see nothing. It's just a long, lonesome railroad just as far as I can see, but I'm not going to let that stop me.

Here we go. Me and her. I'm walking down the railroad tracks and I'm getting closer and closer. You know, when railroad tracks come to a crossing, they go every which way. When those railroad tracks start parting—one, two, three—I got to make up my mind which one of them is leading to Leslie, Georgia. Me and directions got a good relationship. My directions have always been good. I kept going east, the way the morning sun is shining. So I'm painting those

railroad tracks and all kind of possibilities are going through my mind—the way things could have been, or the way my mother could have been thinking at the time she gave birth to me—and it changed my perspective about her. I had mercy on her a little bit. Mercy is when you forgive people for what they've done, or for what you feel they've done. You say, well, I'm not going to hold that against them anymore. I'm just going to be lenient, and just go with it, like, from the good side.

Now that I've done the picture, I look at it and I think about stories. Me and Patsy sit down and talk about my mother. I think my mother had a way of showing her love. For a long time I didn't understand it, but now I think she showed love the best way she could. By opening the door and letting me in.

It means something when you're in trouble and you open up the door and your mother is standing there. That *means* something. It was important to me to look for her. I *am* looking for her. I never thought about my mother so much as now, after I did this picture. And that's a good thing for me. I like to think about her. I like to think that when I'm gone from this world, my mother will live. When people look at the picture and read what I've said about it, my mother will be remembered. She don't know it. She's gone, but she's remembered.

OPPOSITE: *Looking for My Mother*

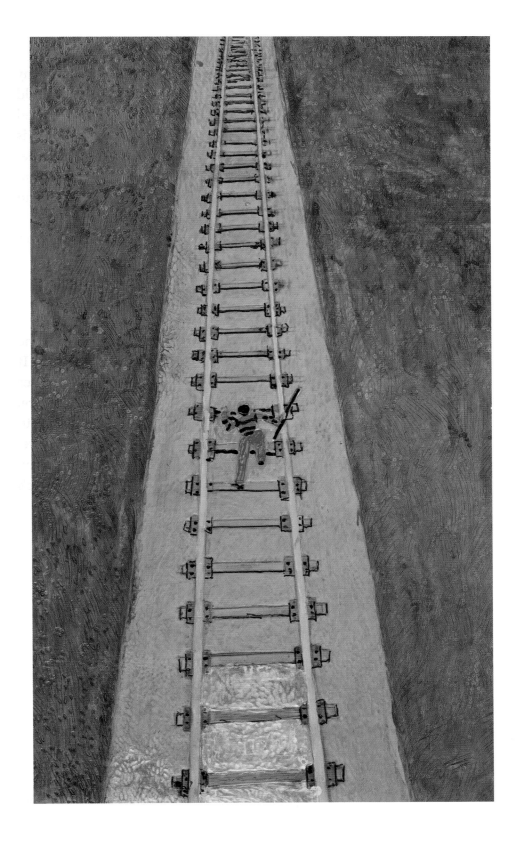

ACKNOWLEDGMENTS

I am grateful to Erin Kelly for working tirelessly with me to put this book together. She wanted me to decide what to talk about and what to include. She had patience, care, and a feel for what I had to say. Discussing my life in such depth was a challenge and even upsetting. But the project grew and grew, and it turned out well. If it hadn't been for Erin, the book would never have happened.

Sharon and Phil McBlain have been there, long before this book. I think about the time, almost twenty-five years ago, when I met Sharon and she introduced me to Phil. When Phil became my friend, he had no idea that I could do any art whatsoever. He didn't know that I could do anything like that. Then I did some art and we went on a journey. I love Phil, I really do, and Sharon too. They kept a lot of documents about my art career and they provided information for the manuscript. More than that, I owe Phil and Sharon McBlain a great deal of appreciation for just being there in my life.

I thank my agent, Stephanie Steiker. She is my very own Mandalorian. She had a real passion for the project and paid attention to important details of the writing and book design. We appreciate her and her efforts. She also introduced me to my lawyer, Sekou Campbell, who has been terrific.

From the start, the Bloomsbury team showed so much interest in the book and making it happen. They jumped on board and we took off. Callie Garnett was a great editor. Erin and I are thankful to her and her Bloomsbury colleagues, especially Nancy Miller and Marie Coolman, and also Emily Fisher, Nicole Jarvis, Laura Keefe, Michael O'Connor, Laura Phillips, Valentina Rice, and Sara Stemen. They had a vision for this book and how to get it into the world. I'm really happy about that.

Bryan Stevenson's work with the Equal Justice Initiative is something I admire tremendously. To be honored by the EJI in 2015 was one of the highlights of my life. I'm grateful for Bryan Stevenson's magnificent foreword. It's just beautiful.

I want to thank the early supporters of my artwork, including Lonnie Garris, the principal at the Hillhouse High School in New Haven. Right from the beginning he thought my work was going somewhere. Greg Seaman and Lois Smith bought my first large picture. They were big supporters and kept early records of my artwork. Nancy Lewis and her husband, R.W.B. Lewis, bought my work and hung it in their home, next to the work of famous artists. Nancy even bought a picture for every one of her children. Micky Pratt was another important early supporter who purchased and promoted my work. She has been a good friend.

Jock Reynolds, the former director of the Yale University Art Gallery, has treated me very well ever since I met him in 2000 at the Yale Graduate Club. He showed interest in my work right away. He and Mary Kordak, the curator of education at the Yale University Art Gallery, got my show going at Yale. I've had a good relationship with Jock ever since.

Claire Simler was the one who introduced me to Peter Tillou. If she hadn't invited me to the school where she works, I would never have met Peter and his son Jeffrey. Peter encouraged my talent and invested in my art. He helped me to buy my house and he introduced me to Warren and Jan Adelson, of the Adelson Galleries. The Adelsons, with Peter Tillou, gave me a top-shelf show in New York City, in 2010, and an exhibition in Albany, Georgia. That was fantastic. Adam Adelson was very helpful in providing photographs for the book and details about my artworks. I'd also like to thank the Hudson River Museum for giving me a wonderful exhibition, in 2012, curated by Bartholomew F. Bland, that traveled around the country.

Vivian Ducat has shown me a lot of love ever since I met her ten years ago. We've had Q&As together all over the country for screenings of her movie *All Me: The Life and Times of Winfred Rembert*. I

thank Vivian and her husband, Ray Segal, for sharing images for the book proposal and beyond. Ray has been very kind to me. He found some of my old friends from Cuthbert, Georgia, and brought them to my Albany celebration. Vivian and Ray treat me like family, and their sons, Hugo and Oscar, adopted me as their granddaddy.

I met Dr. Shirley Jackson Whitaker at an event where I talked about my life. Later she invited me to sit on a panel at one of her events, where she introduced me to documentary filmmaker Taylor Rees. I thank Dr. Shirley and also Taylor Rees for inviting me to participate in their film, *Ashes to Ashes*. Taylor has been really supportive ever since I met her in 2016.

There are a number of people in New Haven I'd like to mention because they helped me and my family over the years. Gitu, Mahandra, and Situ Patel gave me work, paving driveways, and were good to us. My pastor, Dr. Boise Kimber, from the First Calvary Baptist Church on Dixwell Avenue is a real troubleshooter when you need it. June Schafer, from the Unitarian Church, used to bring food to our house every two weeks, and we are grateful. Ben Hunter, the assistant principal at the Hillhouse High School, helped my family and gave my kids jobs when we were down and out.

My psychiatrist, Dr. Barbara Orrok, has been very caring and worked out the right medication to help me deal with my trauma. Since I've been on her regimen I've been doing well. I also want to acknowledge my physician, Dr. Peter Ellis, his colleagues at the Yale New Haven Hospital, and Dr. Suzanne Lagarde, my gastroenterologist, who saved my life at least twice.

My appreciation to The Artists' Fellowship, Inc. for a grant I received in 2020, and to the United States Artists and the Barr Foundation for awarding me a 2016 USA Barr Fellowship.

There are a lot of people from Georgia I'd like to thank for just being part of my life, like Alex "Buddy" Perkins and Jeff Solomon. I want to mention Albert Bass, Annette Blount, James Braswell Jr., Lucille Braswell, Charlie Brookins, Robert Carter, Yolanda Carter, Faustine Clemons, Minnie Cooper, Jessie "Poppa Screwball"

Deloney, Annie Laura Dukes (aka Tot Saul), Fletcher Foster (aka Buck Ross), Edgar Gammage, Mary Belle Gammage, Lillian Greene, John Arthur Grooms Jr., Eddie C. Howard, Johnny Frank James, Nelson Johnson, Annie Bell Jordan, Butch Jordan (aka Joe Mack), Mayo Rita (Etheridge) Jordan, Lottie Kaigler, Will Kaigler, Octivia Keith, Grayceda Prather, Ottilie Prather, Raincoat Red, Candy Lee Rembert, J.T. Rembert, Willie James "Tank" Robinson, Ben Shorter Jr., Wesley Shorter, Homer Clyde Smith, Robert Starling, Sylvester Starling, Lee Walker (aka Black Masterson), Bubba Duke and Feet (the Wiggins brothers), and there are more. I can't name them all. I even thank the Wilson brothers—three White men who told Mama I would never be nothing. That stuck with me all of my life and gave me the determination to prove them wrong.

I always wanted to be an example of something great to my children. My son Edgar has passed on but is still an important part of my life. My daughter Nancy has been a lot of help during the time I've been working on this book, driving me to appointments and helping Patsy and me with chores. I love all my kids—Winfred Jr., Lillian, Edgar, John, Mitchell, Nancy, Patrick, and Robby.

I want to thank my sister, Loraine Reaves, for being the most beautiful and kindhearted person in the world. She's been there for me ever since I was a little boy, up until this very moment.

I love my mother, Nancy Mae Johnson. I'm glad I walked the railroad. If I hadn't done that, I don't know what kind of relationship I would have had with her.

My heart belongs to Patsy. I still mean everything I said in those early prison letters about my love for her. And nobody shows me more love than she does. She's always stood by me, right or wrong.

Now, Mama, Lillian Rembert. Mama was born in 1894. She was fifty-one years old when my mother gave me to her. She loved me until the end of her life. When I was locked up in Ashburn, Georgia, she came to visit me and she said, "I will not die, I will not be in my grave, until I see you a free man." And she lived to see me free.

COLLABORATOR'S NOTE

I knew Winfred had a story, but I didn't know where it would take us. Each chapter of this book began with Winfred talking and me listening. I asked questions when I didn't understand or wanted to know more. Then I read out loud each chapter draft I stitched together from his words. Winfred corrected and elaborated, which led into a cycle of expanding, reading, and revising.

I am a philosophy professor. In 2015, I interviewed Winfred at McBlain Books in Hamden, Connecticut, when I was working on a book about the philosophy of criminal justice. Later Winfred told me he was looking for a collaborating writer for his memoir. His age and poor health meant the project could not wait. We decided to try working together.

From March 2018 to March 2020, we met twice a month at Winfred and Patsy's home in New Haven. Each recorded interview lasted two to three hours. I was astonished by Winfred's courage to revisit his past, just as I have been awed by his art ever since I first encountered it in 2015. I was impressed by his passion, his openness, his lively sense of humor, and his commitment to telling his life story. Patsy sometimes joined us in the living room, or on the front porch, and I realized how her voice could expand the book.

I thank Winfred and Patsy from the bottom of my heart for inviting me into their home and trusting me enough to work with me. I would also like to acknowledge Winfred's friends, his family, and his peers from Cuthbert, Georgia, who supported and encouraged our work on this book: Charlie Brookins, Beverly Burks, Robert Carter, Faustine Clemons, Vivian Ducat, Dorrie Fletcher, Eddie C. Howard, Naomi Jenkins, Mayo Rita Jordan, Octivia Keith, Sam

Mahone, Robert Martin III, Horace Murphy, Daphne Muse, Barbara Orrok, Renan Ozturk, Karan Pittman, Grayceda Prather, Loraine Reaves, Taylor Rees, Marsha Reid, John Rembert, Lillian Rembert, Mitchell Rembert, Nancy Rembert, Patrick Rembert, Jock Reynolds, Ray Segal, Wesley Shorter, and Murrie Bell Simmons. I especially thank Phil and Sharon McBlain, whose contributions and thoughtfulness at every stage of this project have been invaluable.

I am indebted to colleagues, family, and friends of mine who read chapters and offered advice: Sarah Baker, Nell Porter Brown, Deborah Chasman, Junot Díaz, Kendra Field, Elizabeth Graver, Kerri Greenidge, Constance Hale, Ann Kelly (mom), David Kelly-Hedrick, Heather Kelly-Hedrick, Tommie Shelby, and Stacy Sherman.

My gratitude to Jason Stanley for his early support of the book and for introducing me to Stephanie Steiker, literary agent extraordinaire. I would not have imagined Stephanie's dedication to this project.

I greatly appreciate Bloomsbury's unbridled commitment to this book. Callie Garnett has been a wonderful editor and champion of this project. I am also thankful to Laura Phillips for her skillful and caring attention throughout the production process.

My deep appreciation to Bryan Stevenson for contributing his powerful foreword.

Finally, to my family, Rayha, Iman, and Lionel McPherson. I could not have undertaken this project without your love and support. Lionel, your confidence in me was especially important, and for that I am very grateful.

LIST OF ILLUSTRATIONS

All artworks by Winfred Rembert, unless otherwise noted, are dye on carved and tooled leather.

Photographs of original works of art by Winfred Rembert are used courtesy of the Adelson Galleries, Inc. and the following photographers:

A NOTE ON THE AUTHORS

WINFRED REMBERT (1945–2021) was an artist from Cuthbert, Georgia. His paintings on carved and tooled leather have been exhibited at museums and galleries across the country, and compared to the work of Jacob Lawrence, Romare Bearden, and Horace Pippin. Rembert was honored by the Equal Justice Initiative in 2015, awarded a United States Artists Barr Fellowship in 2016, and is the subject of two award-winning documentary films, *All Me* and *Ashes to Ashes*. In the last decades of his life, he lived and worked in New Haven, Connecticut. He was posthumously awarded the 2022 Pulitzer Prize in Biography for *Chasing Me to My Grave*. The Winfred Rembert Estate is co-represented by Fort Gansevoort and Hauser & Wirth.

ERIN I. KELLY earned her PhD from Harvard and is the Fletcher Professor of Philosophy at Tufts University. She specializes in ethics and criminal law and is the author of *The Limits of Blame: Rethinking Punishment and Responsibility* (Harvard University Press, 2018). She was awarded the 2022 Pulitzer Prize in Biography for *Chasing Me to My Grave*.

erinikelly.com

WE, AS A PEOPLE
A Note from Patsy Rembert

My late husband, Winfred Rembert (1945–2021), was an artist from Cuthbert, Georgia, which is not far from Ashburn, my hometown.

As a child, Winfred didn't have an opportunity for schooling. Like so many Black Americans, he worked in the fields. The experience of working in the cotton fields doesn't come near to the beauty with which Winfred presents it in his artwork. He made work look beautiful. Through his art, he took a bad situation and made it look good.

I found Winfred beautiful from the moment I first saw him. He was sitting in the sunshine on the back of a pickup truck. A cupid's arrow went through my heart. I was dying to meet him, but I had to be secretive about it, since he was a prisoner. When I met him, he won me over. He was easy to talk to, and when he was talking, I wanted to hear more. He had that winning combination. I've always loved that man beyond reason.

He was full of life. Oh, my Lord. His sense of humor made me feel giddy. He dropped his eyeball on the table and the kids found that hilarious when they realized it was fake. His big laugh filled the room and drew people to our house. Someone was always coming by, and Winfred opened our door.

Winfred had a way of making you feel special. Runaway kids had a place at our kitchen table. Winfred understood their needs because he was a runaway himself. His adoptive mother, Lillian Rembert, loved him dearly, but he didn't have a family structure, with a mother and a father. I think all his life Winfred yearned to hear either of his birth parents say they wished they had kept him. If

he could have heard those words, it would have made a great difference in his life. But I tried to assure him that I loved him, and that his kids loved him, and he tried hard to motivate those stray kids, to help them learn, to back them, and to teach them to love themselves.

We had a life together full of tenderness. We had that same feeling all the way through, including the very last night we were together, when he kissed me and put my head on his chest and told me to sleep. "You've been running all day," he said, "I want you to rest." I didn't know it was our last night, but I always showed him my affection and lived my life with him as though tomorrow could be our last day. I wanted to get the most that I could out of the time we had together. We shared so many intimate moments. He had a home with me and I was at home with him. We went through all the tears and the laughs and the sorrow and bore it together.

Winfred loved all our kids and wanted them to have an understanding of history. He showed them not to turn away from it. The struggle that Winfred went through and the life that he lived were not his alone. Winfred's story represents a whole lot of other Black men who had to deal with the same thing. His story touches on the lives of people who didn't live to tell their story. Winfred was able to tell it, with his art and in his voice, and I think we need to talk about it.

We've got to teach our children about the past so we don't keep repeating it. We all want the same freedom. Violence against Black people in this country is ongoing and we, as an American people, have got to do something about it. To keep our democracy, we've got to change. We need to teach our children, not only in school, but out of school. We've got to love our children, and when I say "our children" I mean not just the children you birth, but the children out there in the street.

Winfred's art is being noticed more now and is finally getting worldwide recognition. My husband had a hard life. I hope and believe we have come to a moment in this country when we can begin to look at our past with a fresh understanding.

Winfred's art and memoir teach us to view the past with love for Black Americans who lived through Jim Crow and still lack freedom. I think Winfred was put on earth to write this book. His work, his dreams, his hopes—they're all alive in this book. He was magnificent.

Patsy Rembert, with Lillian Rembert and Winfred Rembert Jr.
February 2023

CHASING ME TO MY GRAVE
WINFRED REMBERT AS TOLD TO ERIN I. KELLY

READING GROUP GUIDE

The following questions are intended to enhance your discussion of *Chasing Me to My Grave*.

About this book

Winfred Rembert grew up in a family of Georgia field laborers and joined the Civil Rights Movement as a teenager. He was arrested after fleeing a demonstration, survived a near-lynching at the hands of law enforcement, and spent seven years on chain gangs. During that time he met the undaunted Patsy, who would become his wife. Years later, at the age of fifty-one and with Patsy's encouragement, he started drawing and painting scenes from his youth using leather tooling skills he learned in prison.

Chasing Me to My Grave presents Rembert's breathtaking body of work alongside his story, as told to Tufts Philosopher Erin I. Kelly. Rembert calls forth vibrant scenes of Black life on Hamilton Avenue in Cuthbert, Georgia, where he first glimpsed the possibility of a life outside the cotton field. As he pays tribute, exuberant and heartfelt, to Cuthbert's Black community and the people, including Patsy, who helped him to find the courage to revisit a traumatic past, Rembert brings to life the promise and the danger of Civil Rights protest, the brutalities of incarceration, his search for his mother's love, and the epic bond he found with Patsy.

Vivid, confrontational, revelatory, and complex, *Chasing Me to My Grave* is a searing memoir in prose and painted leather that

celebrates Black life and summons readers to confront painful and urgent realities at the heart of American history and society.

For discussion

1. This memoir was composed through a collaborative process of conversation, transcribed interviews, writing, and editing between Winfred Rembert and Erin I. Kelly. How does Rembert's direct, conversational tone impact your experience of his story?

2. What did you learn from Rembert's experience as a Black American living in the Jim Crow South in the twentieth century that you didn't know before? Did your reading change any previously held beliefs or assumptions? Did the book impact your understanding of how the legacy of slavery persists today?

3. Describing the conditions of prison labor he experienced, Rembert refers to a law in Georgia that was supposed to prohibit prisoners from working in temperatures under 32 degrees. However, he says: "It was a law that was just a law. They didn't care about laws when you were working on the chain gang." Throughout this memoir, when and why are laws distorted or ignored? What does *Chasing Me to My Grave* reveal about the American criminal justice system?

4. When he is nearly lynched, Rembert recalls Mama's philosophy of survival: "Mama's idea was to stay alive, and she was passionate about that...Her idea was to please White people." When does Rembert adopt Mama's mentality, and when does he take a different course? How does the tension between different modes of survival affect his story?

5. Throughout the memoir, how does Rembert describe the experience of being a Black male under Jim Crow?

6. The fifteenth chapter of *Chasing Me to My Grave* is told from Patsy's perspective. How does her point of view change your sense of Rembert's story?

7. After Rembert describes the doubt he experienced at the beginning of his art career, he repeatedly refers to Patsy's assurances that his perspective and medium are singular. She told him: "There is nobody doing this. Nobody tells their life story on leather. *Nobody.*" What might individual narratives offer that a broader depiction of history cannot? What might tooled and dyed leather pictures offer that more traditional paintings do not?

8. How does Rembert's experience of Blackness—from his childhood in Cuthbert, to his time spent in prison and in chain gangs, to his short career as a drug dealer in Connecticut, to his life as an artist—shift through time and space? What dynamics remain consistent? What changes?

9. How does Rembert grow over the course of his life, in his telling? In what ways were his creativity, self-belief, and intelligence evident from his early life?

10. When Rembert recounts watching J. T. lose his eye while being beaten by the police, he considers, "I carried this all of my life, all of these things that happened to me," but says, "I didn't realize that by keeping my story inside so long, it would change my life and make me sick." When and how does the trauma of the violence he endured surface? What compels him to eventually share his story, and to do so in prose and pictures?

11 . Consider the title of the memoir. How does the title *Chasing Me to My Grave* frame Rembert's story? To what extent did Rembert's encounters with White violence influence the rest of his life?

12. While the leatherworks featured in *Chasing Me to My Grave* depict moments from Rembert's early life, he made them all after the age of fifty. The book itself began to take shape in 2018, when Rembert was in his early seventies. How does the perspective of hindsight influence his visual art and verbal narrative?

13. Consider works like *Winfred's Pool Room* (p. 61), *Doll's Head Baseball* (p. 86–87), *Georgia Justice* (p. 122), or *All Me* (p. 144–145). How did these enrich your understanding of Rembert's life and the world he lived in? How would you describe his style as an artist, and how do you see it changing from work to work?

14. Rembert remembers figures from Cuthbert's Black community with fondness and love. How do these memories sustain him? What do you find most powerful about the love between Winfred and Patsy?

15. Why is it important to Rembert to tell about his life and the lives of other Black Americans who lived in Georgia under Jim Crow?